WORKING
DRAWING
MANUAL

WORKING
DRAWING
MANUAL

Fred A. Stitt

McGraw-Hill

New York San Francisco Washington, D.C. Auckland Bogotá
Caracas Lisbon London Madrid Mexico City Milan
Montreal New Delhi San Juan Singapore
Sydney Tokyo Toronto

McGraw-Hill

A Division of The McGraw-Hill Companies

1 2 3 4 5 6 7 8 9 0 DOC/DOC 9 0 3 2 1 0 9 8

ISBN 0-07-061554-3

The sponsoring editor for this book was Wendy Lochner.

Printed and bound by R. R. Donnelley & Sons Company.

TABLE OF CONTENTS

v

FLOOR PLANS AND INTERIOR ELEVATIONS 75

Thanks to those who make books like this happen:
Penny Burbank, Yasmina Dedijer-Small, Chandler Vienneau,
Elisabeth Winnen, and those hundreds of conscientious architects
and engineers who are always willing
to share their drawings
and expertise.

To
Nathaniel,
my best teacher

WHY CHECKLISTS?

The architectural profession has a serious attitude problem.

In architecture schools, and in most larger offices, working drawing production is the least prestigious aspect of professional life. Schools teach virtually nothing on the subject. In the offices, working drawings are the aspect of work that most graduates work hardest to avoid.

Yet this is the aspect of work that involves the most money, the greatest number of personnel, the most office space and resources, and the greatest risks for project delays, high construction costs, client alienation, building failures, and general liability.

Until the profession decides to face this dangerous situation head on, offices need all they help they can get. One handy tool that can help enormously is a simple one, the instruction sheet or checklist.

Checklists help with a variety of problems, such as:

The memory problem. It's very hard to remember every element that should be included in a set of drawings. Even when a drafter or supervisor is well experienced with drawing content, the back-and-forth work distractions of the office make lapses almost inevitable.

The education problem. Most of those hired for drafting or CADD input have had very limited exposure to working drawings in their schools.

The supervision problem. Bosses and supervisors are overloaded and distracted and don't have time to provide comprehensive instruction, training, and drawing checking for staff members.

The coordination and quality control problem. Studies of completed construction documents find an average of three to six significant errors or omissions in almost every sheet of drawings.

Checklists have been used for years in some offices as reminders of drawing content and procedures, for drafter training, and supplementary supervision; and for coordination and checking . . . all in one package.

My publishing company, GUIDELINES, has compiled and refined working drawing checklists and assignment sheets for many years. Now, thanks to McGraw-Hill, we can now provide them in this convenient, illustrated handbook format.

If you haven't used checklists before, one use will convince you. If you have your own checklists, this handbook will most likely include everything you've assembled on your own, and a lot more. In the next few pages, you'll find many hints and techniques for enhancing efficiency and quality control. You can only fully appreciate them as you use them, so start providing this information to your staff on your very next project. You'll start seeing positive results almost immediately.

Fred A. Stitt, Architect. Editor/Publisher GUIDELINES.
Director, San Francisco Institute of Architecture.

HOW THE CHECKLIST FORMAT WORKS

Here's a typical checklist entry and an explanation of what each entry means:

 √ Dbl√

(1) __ __ FLOOR DRAINS (15421)

(2) __ slope floor to drain

(3) __ locations __ detail keys __ notes/refs

(4) __ coord check: __ struct __ hvac

Explanation:

 √ Dbl√

__ __ You can check an item that should be in the drawings. And then later double check that it is in the drawings as it should be.

Item (1) Identifies the working drawing component with its CSI Masterformat specification number in parenthesis.

Item (2) A note of related requirements.

Item (3) Reminders to show or note the following:

 ___ Materials (often noted by not relevant in this example).

 ___ Sizes, heights, locations, or object dimensions as appropriate.

 ___ Detail keys if required.

 ___ Identification note and, sometimes, a reference to other drawings or documents.

Item (4) The "Coordination Check" refers both drafter and checker to other construction components that may relate to this one, to other drawings that may reference the same component, and to other parts of the documents that may need to be checked for conflicts or interferences. In this example, since drains are sometimes positioned badly relevant to under-floor structural or mechanical work, this "coord check:" note provides a reminder of possible conflicts.

Elaborate or simplify the process in any way you see fit. Everyone has their own style, and this system is adaptable to suit any special needs.

MORE USES FOR THE CHECKLIST PROCESS:

As the list develops simultaneously with the working drawings, you'll have a checklist of specifiable items complete with their CSI Masterformat identification numbers. Updated copies of the list can go to the spec writer as specifications/working drawing coordination memos.

Also, as the drawings and the list develop through various checking phases, you'll have a checklist of the details to be included. Flag the detail items and use as a guide for your detail drafting staff. If you have a standard or reference detail library, you'll have the CSI coordinated index numbers necessary to retrieve the details from your files.

Give special attention to the introductory notes in each chapter about what to avoid on the drawings, on coordination among different drawings, and about the best applications of systems drafting. Review these early in the game for maximum benefits.

4

LEXICON OF ABBREVIATIONS

Abbreviations used in these lists:

acoust	Acoustical treatment drawings
anch	Anchor. The most common oversights in working drawings and construction are related to anchors and connectors between elements of a building. The importance of checking these is emphasized repeatedly and given special reference in these checklists in terms of "fl anch" for floor anchor, "clg anch" for ceiling anchor, etc.
civil/soil	Civil engineering drawings for grading and drainage
clg	Ceiling
clg anch	Ceiling anchors
code	Building code, fire code, or other applicable regulations
const site	Construction work site plans
cross sect	Cross sections
drain	Drainage drawings; usually a part of site plans
elec	Electrical
ext elev	Exterior elevations
fin sched	Finish schedules
fl plan	Floor plans
fl anch	Floor anchors
frame	Framing; either structural or non-structural wall framing
furn	Furniture
hdwr	Hardware
hvac	Heating Ventilation and Air Conditioning
int elev	Interior elevations
mech	Encompasses both HVAC and plumbing
plumb	Plumbing
ref clg	Reflected Ceiling
sched	Schedules
sect	Sections
site	Sitework
specs	Specifications
struct	Structural
sup	Support; implying anchorage of an item of construction with curbs, pedestals, or added structural support
util	Utility; combination of water, gas, sewer and electrical
vent	Ventilation; part of HVAC or mech -- air distribution

WORKING DRAWING SHEET FORMAT AND CONTENT

Standard architectural sheet sizes: 18" x 24", 24" x 36", 30" x 42".

Standard engineering sheet sizes: A = 8-1/2" x 11", B = 11" x 17", C = 17" x 22", D = 22" x 34", E = 34" x 44".

Standard margins: 1-1/2" left-hand binder margin, 1/2" at top, bottom, and right-hand side.

1/2" or more trim space around outer border of sheets. (This is a way to eliminate edge damage prior to final printing.)

Drawing sheets created at double size for later photo reduction and 50% size printing usually start at 30" x 42" or 34" x 44"; they reduce to final sizes of 15" x 21" and 17" x 22" (or less if sheets are trimmed.)

Recommended maximum drawing size: To meet limits of microfilm blowback system at bidding pools, maximum size may be 30" x 42".

√ Dbl√

__ __ TITLE BLOCKS AT LOWER RIGHT OR DOWN RIGHT-
HAND SIDE OF DRAWING

__ __ GENERAL NOTES AND/OR KEYNOTE STRIP 3" TO 4" WIDE
ON RIGHT-HAND SIDE (Size varies depending on overall
drawing module you use.)

__ __ DETAIL MODULE RECOMMENDED: 5-3/4" HIGH X 6"
LONG CAN BE ADJUSTED TO FIT MOST STANDARD
DRAWING SHEET SIZES WHEN USED IN COMBINATION
WITH VARIABLE SIZE RIGHT-HAND TITLE BLOCKS
AND/OR KEYNOTE STRIPS

__ __ SCHEDULE ON LEFT-HAND TRIM MARGIN TO RECORD
DATES AND TIMES OF WORK PERIODS ON SHEET BY
INDIVIDUAL STAFF MEMBERS (This may be recorded
separately on drawing schedule sheets.)

__ __ TICK MARKS PRINTED AT BORDER EDGES TO GUIDE
FOLDING OF DRAWINGS INTO APPROXIMATE 8-1/2" X 11"
PACKETS FOR MAILING OR STORAGE

__ __ GRAPHIC SCALE (Some drawings are noted at original scale
with an added note that some final print sets may be at a reduced
size. When all final prints are at reduced size, it's common to note
only the final scale on the "double size" original sheet instead of
making any reference to reduced sizes.)

WORKING DRAWING SHEET FORMAT AND CONTENT continued

J + F NO. 9506

☐ For Construction

☐ Review Set

☐ Not For Construction

☒ Bid Set

All drawings and copies thereof are instruments of service and as such remain the property of the architect. They are to be used only with respect to this project. With the exception of one complete set for each party to the contract, all copies are to be returned or suitably accounted for to the architect upon completion of the work.

COPYRIGHT 1996
ALL RIGHTS RESERVED

Issue Date:

9.1.96

Set Number:

Drawing Title:

COVER SHEET

Revisions:

Sheet Number:

C 1

WORKING DRAWING SHEET FORMAT AND CONTENT continued

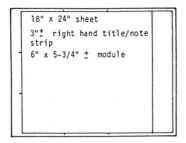

```
18" x 24" sheet
3"± right hand title/note
strip
6" x 5-3/4" ± module
```

```
24" x 36" sheet
4" right hand title/note strip
6" x 5-3/4" ± module
```

```
30" x 42" sheet
4" right hand title/note strip
6" x 5-3/4" ± module
```

TITLE BLOCK CONTENT

√ Dbl√

__ __ PRIME DESIGN FIRM'S NAME, ADDRESS, TELEPHONE
AND FAX NUMBERS

__ __ ASSOCIATED OR JOINT VENTURE FIRM NAMES,
ADDRESSES, TELEPHONE AND FAX NUMBERS

__ __ REGISTRATION NUMBERS OR OFFICIAL STAMPS OF
PRIME AND ASSOCIATED FIRMS

__ __ PROJECT NAME AND ADDRESS

__ __ OWNER'S NAME AND ADDRESS

__ __ CONSULTANTS' REGISTRATION NUMBERS, NAMES,
ADDRESSES, TELEPHONE AND FAX NUMBERS (Include on
title block if list is small. Otherwise list all data on the General
Information sheet.)

__ __ DRAWING TITLE AND SCALE

__ __ MINI KEY PLAN OF BUILDING

__ __ CONTACT PEOPLE IN THE PRIMARY DESIGN FIRM (This
data may be on the General Information sheet instead of the title
block.)
> __ principal in charge
> __ chief or project architect
> __ job or team captain
> __ office phone number and extension, plus alternate or
> after hours phone number of primary contact for
> client, bidders, and contractor

__ __ DESIGNERS AND DRAFTERS (A growing preference is to
provide full names of job participants on the General Information
sheet as well as the usual specific staff initials on individual sheets.)

__ __ INITIALS OR NAME OF DRAWING CHECKER

__ __ SPACE FOR REVISION DATES AND REVISION REFERENCE
SYMBOLS

__ __ PROJECT NUMBER

__ __ FILE NUMBER

__ __ SPACE FOR GENERAL NOTES (General notes are usually
placed in a separate note or keynote strip on the right hand side.)

TITLE BLOCK CONTENT content

KEY PLAN

SECTION KEY

TITLE BLOCK CONTENT continued

√ Dbl√

__ __ COPYRIGHT NOTICE OR NOTE ON RIGHTS AND
RESTRICTIONS OF OWNERSHIP AND USE OF DRAWINGS

__ __ BUILDING AND PLANNING PERMIT AUTHORITIES,
ADDRESSES, TELEPHONE AND FAX NUMBERS

__ __ PERMIT NUMBERS

__ __ SPACE FOR APPROVAL STAMPS OR INITIALS

__ __ DATES OF APPROVAL

__ __ PRIVATE BUILDING CODE CHECKING SERVICE

__ __ CHECKING DATES

__ __ JOB PHASE COMPLETION DATES

__ __ CLIENT APPROVALS

__ __ FINAL RELEASE DATE

__ __ DRAWING SHEET NUMBER AND TOTAL NUMBER OF
DRAWINGS

__ __ SHEET NUMBER CODING FOR CONSULTANTS' DRAWINGS

__ __ CODING FOR SEPARATE BUILDINGS OR PORTIONS OF
PROJECT

NOTES Date/Initials

COVER SHEETS/INDEX SHEETS

√ Dbl√

__ __ PROJECT NAME

__ __ OWNER'S NAME

__ __ PRIME DESIGN FIRM

__ __ ASSOCIATED OR JOINT VENTURE DESIGN FIRMS

__ __ PERSPECTIVE RENDERING OR PHOTO OF MODEL
(Some firms now use photos of people such as users of the
building, clients, or the design team.)

__ __ CONSULTANTS (Names, addresses, telephone and fax numbers.
Include on title block if list is small. Otherwise list all consultants
and related data on the General Information sheet.)
 __ structural
 __ HVAC
 __ plumbing
 __ electrical
 __ lighting design
 __ soils
 __ civil
 __ landscaping
 __ interiors
 __ acoustical
 __ auditorium
 __ kitchen/food service
 __ design management
 __ construction management
 __ energy
 __ solar
 __ fire safety
 __ barrier free handicap access

__ __ INDEX OF ARCHITECTURAL AND CONSULTANTS'
DRAWINGS

__ __ GENERAL NOTES

__ __ LEXICON OF ABBREVIATIONS AND NOMENCLATURE

__ __ LEGEND OF CONSTRUCTION MATERIALS INDICATIONS
AND DRAWING CONVENTIONS

__ __ LEGEND OF SITEWORK, STRUCTURAL, ELECTRICAL,
PLUMBING, AND HVAC SYMBOLS AND CONVENTIONS
(If not shown on other drawings.)

COVER SHEETS/INDEX SHEETS continued

SHEET NO. DESCRIPTION

S-1	SITE PLAN
D 1	DEMOLITION PLAN
A 1	FIRST FLOOR PLAN
A 2	SECOND FLOOR PLAN
A 3	ELEVATIONS
A 4	BUILDING SECTIONS
A 5	WALL SECTIONS
A 6	ENLARGED TOILET PLANS
A 7	ENLARGED STAIR PLANS
A 8	PLAN DETAILS
A 9	FIRST FLOOR REFLECTED CEILING
A 10	SECOND FLOOR REFLECTED CEILING
A 11	ROOF PLAN
A 12	SCHEDULES, DOOR & WINDOW DETAILS
A 13	CABINETS, MISC. DETAILS
S 101	FOUNDATION PLAN
S 102	SECOND FLOOR FRAMING PLAN
S 103	ROOF FRAMING PLAN
S 201	FOUNDATION & SLAB DETAILS
S 202	FOOTING & FRAMING DETAILS
S 301	FRAMING DETAILS
S 302	FRAMING DETAILS
P 1	FIRST FLOOR PLUMBING PLAN
P 2	PLUMBING DETAILS AND SCHEDULES
M 1	FIRST FLOOR HVAC PLAN
M 2	SECOND FLOOR HVAC PLAN
M 3	HVAC DETAILS
E 1	FIRST FLOOR POWER
E 2	SECOND FLOOR POWER
E 3	FIRST FLOOR LIGHTING PLAN
E 4	SECOND FLOOR LIGHTING PLAN

COVER SHEETS/INDEX SHEETS continued

LEGEND

SYMBOL DESCRIPTION

FULL HEIGHT (TO ROOF STRUCTURE ABOVE) NO. 25 GA. METAL STUDS (OR 2X6 WOOD STUDS) @ 24" O.C. W/ ONE LAYER OF 5/8" TYPE "X" GYP. BD. ON EACH SIDE TO BE APPLIED IN ACCORDANCE W/ TABLE 43-B ITEM 66 (OR 71) OF THE 1985 U.B.C. APPLY R-11 BATT INSULATION @ DUCT SHAFTS.

10'-0" HIGH 2X4 WOOD STUDS WITH ONE LAYER OF 5/8" TYPE "X" GYP. BD. ON EACH SIDE TO BE APPLIED IN ACCORDANCE W/ TABLE 43-B ITEM 71 OF THE 1985 U.B.C. IN ROOM 1212, THE WALL DIRECTLY BENEATH STAIRWELL LANDING 221 DIES @ UNDERSIDE OF RATED CEILING, @ 7'-4" +/-.

FULL HEIGHT (TO ROOF STRUCTURE ABOVE) 2X6 WOOD STUDS W/ ONE LAYER OF 5/8" GYP. BD. ON EACH SIDE TO BE APPLIED IN ACCORDANCE W/ TABLE 43-B ITEM 71 OF THE 1985 U.B.C.

10'-2" HIGH 2X4 WOOD STUDS WITH ONE LAYER OF 5/8" GYP. BD. ON EACH SIDE TO BE APPLIED IN ACCORDANCE W/ TABLE 43-B ITEM 71 OF OF THE 1985 U.B.C. NOTE: ALL GYP. BD. @ INSIDE FACE OF TOILET ROOMS TO BE MOISTURE RESISTANT.

3'-6" HIGH AFF 2X6 WOOD STUDS W/ ONE LAYER OF 5/8" GYP. BD. ON EACH SIDE W/ OAK CAPPING.

10'-0" HIGH U.S.G. ULTRAWALL — ONE HOUR RATED.

10'-0" HIGH U.S.G. ULTRAWALL.

10'-0" HIGH U.S.G. TEMPERED GLASS ULTRAWALL. PANEL. GEORGIAN WIRED GLASS @ 1-HOUR CORRIDOR.

U.S.G. TEMPERED GLASS ULTRAWALL PANEL, FROM 42" AFF TO 10'-0".

10'-0" HIGH U.S.G. ULTRAWALL 18" SIDELIGHT

EXTERIOR WALL, N.I.C.

AREA OF 1 HOUR FIRE RATED CORRIDOR. CEILING IS EXTENSION OF ONE HOUR RATED 2' X 4' CEILING. FLOOR SLAB IS 5" CONCRETE AND RATES 1 HOUR. THE WALLS FACING THIS AREA ARE ALL 1 HOUR RATED. ALL DOORS IN THIS AREA ARE 1 HOUR RATED. ALL WINDOWS IN THIS AREA ARE 1 HOUR RATED.

ROOM NUMBER

DOOR IDENTIFICATION SYMBOL

COVER SHEETS/INDEX SHEETS continued

√ Dbl√

__ __ LEGEND OF SYMBOLS:
 __ elevation point
 __ level line
 __ revisions
 __ column or module grid key
 __ building cross section or partial section key
 __ wall section key
 __ detail key
 __ window number key to window schedule
 __ door symbol key to schedule
 __ room or area number key to finish schedule
 __ stair key
 __ equipment key
 __ existing work, work to be removed, new work

__ __ EXPLANATION OF SYSTEMATIC PRODUCTION ELEMENTS
 __ keynote system
 __ fixture heights schedules instead of interior elevations
 __ simplified door, window, finish schedule, and detail keys
 __ wall construction schedule key symbol if wall materials
 indications aren't shown
 __ explanation of screened shadow print background printing

__ __ EXPLANATION OF LAYERING IDENTIFICATION SYSTEM

NOTES Date/Initials

MATERIAL DESIGNATIONS

EARTH

ROCK

GRAVEL

REGULAR

REGULAR BLOCK

LW BLOCK

STEEL

ALUMINUM

OTHERS

RE-BARS

STEEL STUD PARTITION

FACE

COMMON

FIRE

PARTITION

FACING TILE

CERAMIC OR QUARRY

CUT

CAST

MARBLE

FINISH

DIMENSION

STUD PARTITION

PLASTER

BLOCK

SOLID PARTITION

LARGE SCALE

SMALL SCALE

BATTS OR LOOSE

RIGID

SITE PLANS

CHAPTER CONTENTS

SITE PLAN PROCEDURAL CHECKLIST

SITE PLAN LAYOUT AND DRAFTING, STEP BY STEP

PHASE 1 -- "OUTLINE" INFORMATION

AND INFORMATION REQUIRED BY CONSULTANTS

__ Update and verify site plan layout completed during the Design Development phase.

__ Decide on the desirable scale, size, and positioning of site plan on the working drawing sheet. Consider locations of Keynote legend, General Notes, Symbols Legend (if any), Landscaping Legend (if any), Vicinity and Location maps, and sitework details.

__ Plan positioning of other drawings if provided, such as Soil Test Boring Map and Log, Grading Plan, Cut and Fill profile, Landscaping Plan, Sprinkler plan, Septic field plan. For small residential work these are usually included on the building Site Plan.

__ Using the updated design development plan as your guide, proceed with the following steps.

__ Have the original survey reproduced at an architectural scale if it hasn't already been so reproduced.

__ Double check the accuracy of the survey.
(Surveys often have errors and major site features should have been personally confirmed by the designer before starting Schematics or Design Development Drawings. Whether they were confirmed or not, they should be checked before possibly false assumptions become part of the working drawings.)

Layout & Linework

__ Use the checked and corrected site survey as base layer for the architectural site plan.

__ Confirm and show setback lines and easements.

__ Draw the floor plan outline or "footprint" of the building on a layer atop the survey contour map base sheet.

__ Compare outline floor plan with site plan to confirm that building walls are within required set-back limits relative to property lines and other limitations.

SITE PLAN PROCEDURAL CHECKLIST continued

PHASE 1 -- "OUTLINE" INFORMATION continued

__ Recommended alternative: Reduce the ground floor plan to site plan scale
and include it on the site plan.
(Showing the ground floor plan on the Site Plan is often helpful for
accurately routing utilities, drains, and sewers to their best hookup
points.)

__ Outline driveway and street locations.
(Double check that slopes of driveways or ramps are not excessive.)

__ Outline parking areas.
(Parking spaces tend to be under-sized; double check parking
allowances and car turning radii.)

__ Check site contours, existing and new relative to the building, drive,
and parking areas.

__ Create a cross-section profile of the property to show where cuts and
fill are required.

__ Confirm and note location of existing trees and other site features.

__ Confirm and fix the building location.
(Confirm ground floor elevation relative to existing and finish
grade elevations.)

__ Rough in new contour lines.
(Normally shown as solid line to contrast with existing contours
shown in dash line.)

__ Add deck and balcony lines.

__ Show roof overhang lines.

__ Rough in likely routes of utility lines.

Construction Elements

__ Show likely locations of utility meters.

__ Show dash lines for relevant hidden construction below or above.

__ Show walks, patios, and planters.

__ Rough in site furniture and peripheral structures such as pools, gazebos,
etc.

SITE PLAN PROCEDURAL CHECKLIST continued

PHASE 2 -- "HARDLINE" INFORMATION continued

__ Where elements or dimensions are highly repetitive, note or dimension one and add"Typical" or "Unless Noted Otherwise" notes.

__ Add final clarification reference notes regarding finishes, fixtures, furnishings, and equipment.

__ Edit and update the Keynotes legend; add final notes and keynotes.

__ Add, edit, and update any General Notes that pertain to overall sitework.

Dimensioning

__ Confirm and add final dimension numbers to locate the building and site construction elements.

__ Start building location dimensions from a reliable reference source point and coordinate with Foundation Plan.

__ Add small dimensions such as for wing walls, furred walls, etc.

Referencing & Symbols

__ Show arrow references to Exterior Elevations.

__ If showing partial or complete roof plan, add roof slope direction arrows and check coordination of roof drainage with site drainage.

__ Add references to special areas shown elsewhere in special plans such as irrigation or septic field drawings.

__ Add detail bubbles, reference lines, and wall and cross section reference keys.
(Check that there is no conflict and no confusion of these lines with dimension lines.)

__ Add final partial paving patterns, textures, and landscaping indications.

__ Make photo-reductions of the building shown on the site plan to use as the key plan on this and other drawings.

__ Include photos if useful to clarify site features.

__ Add references to other drawings (see below).

SITE PLAN PROCEDURAL CHECKLIST continued

PHASE 2 -- "HARDLINE" INFORMATION continued

Related Drawings on the Site Plan Sheet or Related Sheets

__ Soil test boring map.
__ Grading Plan.
__ Landscaping Plan.
__ Sprinkler plan.
__ Septic field plan.

__ Add sitework details as appropriate.

NOTES Date/Initials

SITE PLAN PROCEDURAL CHECKLIST continued

PHASE 3 -- CHECKING

__ Use transparency prints to cross check and coordinate Survey, Site, Landscaping, Grading, and Drainage plans.

__ For check prints, attach a blank transparency on the Site Plan and mark changes and additions in red and data that's correct in yellow.

__ In each later phase of checking, remove the transparency from the first check print and attach to the next phase check print. Verify that required changes and additions have been completed as required, and mark with yellow over the red marks.

__ To minimize oversights, checking for errors and incompletions should be separate from checking for progress.

__ Checking for changes and additions is likely to be more thorough and fruitful if done by a third party who has not been working on the project.

NOTES Date/Initials

SITE PLAN PROCEDURAL CHECKLIST continued

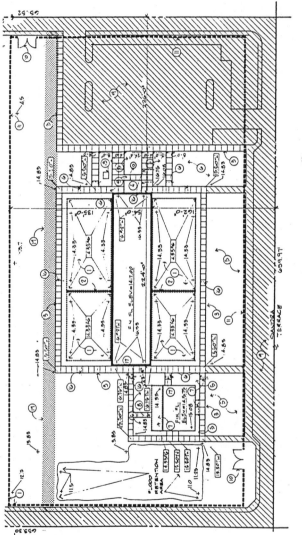

SITE PLAN

SITE PLANS -- CONTENT

You can sometimes do double duty with architectural site plans for smaller projects by also showing the roof plan. Otherwise, a building outline or "footprint" (or the ground floor plan) is shown in combination with paving, landscaping, site furniture, and auxiliary construction. Grading, drainage, sewerage, paving, electrical, finish landscaping, and other work are often let as distinctly separate subcontracts. Therefore, a series of separate sitework drawings may be necessary to sufficiently separate out the different types and layers of work.

WORK THAT SHOULD BE AVOIDED ON SITEWORK DRAWINGS

__ The site survey is often traced or redrawn from scratch. This is done either to change its scale from an engineering scale to the architectural site plan scale, or to enhance an otherwise badly drawn survey, or because all that's available is an old nonreproducible print. None of these reasons are justified for this very time-consuming operation. Proportional rescaling is possible as a reprographic service or on a large format copier.

__ Foliage and ground cover tend to be overdrawn. Simple outlined indications are more readable, and they reduce the chances of obscuring or crowding out other data.

COORDINATION

__ The first and most important coordination device is a double check on the accuracy of the survey. Surveys are very often in error. All major features should be checked and measured on the site before starting any design or feasibility studies. For projects of significant scope, obtain aerial or satellite photos of the site. Have them made to working drawing scale for overlay comparison with the engineer's survey. (Because of angular distortion common to most aerial photo views, the overlay match with a survey plan may not be precisely accurate. But it will allow review of major features in the photo that may or may not be shown accurately on the survey.)

__ Instruct the client to have the survey drawn and printed at an architectural scale so that it will be directly reusable by the design firm.

__ Use overlay comparisons of all sitework plans to correlate trenching for foundations, utility lines, grading, and landscaping work.

__ Compare the site plan with the (usually larger scale) roof plan to coordinate site drainage and building drainage.

ITEMS SUITED TO SYSTEMATIC PRODUCTION

___ As cited above, have the original survey provided at a usable scale and as a reproducible print on polyester film. After making appropriate revisions, make a screened shadow print of the survey as a contour map background sheet or base sheet for further work.

___ If only a print of the survey is available -- possibly damaged, or at the wrong scale -- it can be turned into a clean and/or resized reproducible on a large format photocopier.

___ Make a floor plan outline or "footprint" of the building and apply a copy as a paste-up on an overlay atop the survey floor plan base sheet. Or you can have the ground floor plan photo-reduced to site plan scale and use it as the paste-up. This latter alternative is often helpful for accurately routing utilities, drains, and sewers to their best hookup points at the building.

___ In final printing, consider showing each sitework contract as a solid line image combined with a multi-layer screened shadow print of all other contracts. That is, trenching for the water lines is printed as solid on one sheet while all other work is screened. Drainage and storm sewers are solid on another sheet with all other contracts show in screened image, and so on. This shows all subcontractors how their work may be coordinated with others and where potential points of overlap and conflict may exist. That helps avoid delays from duplicate excavations and/or trenching into previously installed underground utilities.

___ All sitework drawings -- Landscaping, Grading, Site Improvements, etc. -- are well suited to keynoting. Use keynote strip legends at the right side of the drawings, and bubble-reference all notes to the legend. Site construction detail references can also be linked to the keynote legend as a further coordination device. If landscape drawings include large numbers of repetitive and lengthy Latin botanical terms, they should certainly be keynoted.

___ Photograph any special site features such as rock outcrops, trees requir-ing special protection, existing work to be removed, etc. Include the photos adjacent to site plans with added linework and notation.

___ Sitework, drainage, paving, and landscaping details are very standard. Most such detailing on most projects could be provided from a standard or reference detail library.

CHECKLIST OF SITE PLAN DRAWINGS

Site plans may incorporate individual or combined sheets, including the
following:

√ Dbl√

_ _ SURVEY

_ _ STAKING PLAN

_ _ TEST PIT AND BORING PLAN

_ _ GRADING PLAN

_ _ DEMOLITION PLAN

_ _ EXCAVATION PLAN

_ _ CONSTRUCTION WORK AND TEMPORARY FACILITIES

_ _ ARCHITECTURAL SITE PLAN
 _ general construction
 _ paving, walkways and parking
 _ site furniture and appurtenances

_ _ DRAINAGE PLAN

_ _ LANDSCAPING PLAN

_ _ ELECTRICAL
 _ supply
 _ outdoor lighting

_ _ HVAC

_ _ PLUMBING
 _ supply
 _ irrigation
 _ sprinkler

SITE PLANS -- GENERAL REFERENCE DATA

√ Dbl√

__ __ DRAWING TITLE AND SCALE

__ __ ARROWS SHOWING COMPASS NORTH AND REFERENCE NORTH

__ __ SMALL-SCALE LOCATION OR VICINITY MAP SHOWING NEIGHBORING STREETS AND NEAREST MAJOR HIGHWAY ACCESS
(Can be copy of a portion of the local road map)

__ __ NOTE REQUIRING BIDDERS TO VISIT SITE AND VERIFY CONDITIONS BEFORE SUBMITTING BIDS

__ __ WORK NOT IN CONTRACT

__ __ PROPERTY SIZE IN SQUARE FEET OR ACRES

__ __ CONTRACT LIMIT LINES

__ __ LOCATION AND DIMENSIONS OF CONSTRUCTION

__ __ DETAIL KEYS

__ __ DRAWING CROSS REFERENCES

__ __ SPECIFICATION REFERENCES

__ __ LEGAL SETBACK LINES

__ __ EASEMENTS

__ __ SITE PHOTOS (Usually printed adjacent to the site plan drawing with connecting arrow lead lines to show the exact areas of site represented by photos.)

__ __ LEGENDS OF SITE PLAN SYMBOLS AND MATERIAL INDICATIONS

__ __ LANDSCAPE CONSULTANT
__ address __ phone number

__ __ SURVEYOR
__ address and phone number __ registration number

__ __ CIVIL ENGINEER
__ address and phone number __ registration number

__ __ SOILS ENGINEER
__ address and phone number __ registration number

SITE PLANS -- GENERAL REFERENCE DATA continued

√ Dbl√

__ __ SOIL TEST LAB
 __ address and phone number
 __ registration number

__ __ TEST BORING CONTRACTOR
 __ address and phone number

__ __ DESCRIPTION OF SOIL TYPE AND BEARING

__ __ PERCOLATION TEST PLAN

__ __ SOILS TESTING BORING SCHEDULE AND PROFILE

__ __ TEST BORING LOCATIONS

__ __ BORING TEST PROFILE FROM SOILS ENGINEER
 (May be separate drawing.)

NOTES Date/Initials

SITE PLANS -- GENERAL REFERENCE DATA continued

SITE PLAN LEGEND

+ 1025.33	*Existing Spot Elevation*
+ 1025.33	PROPOSED SPOT ELEVATION
- — —1200— — —	*Existing Contour Elevation*
——1200——	PROPOSED CONTOUR ELEVATION
——Stm——	*Existing Storm Sewer*
——STM——	PROPOSED STORM SEWER
——San——	*Existing Sanitary Sewer*
——SAN——	PROPOSED SANITARY SEWER
——W——	*Existing Water Line*
——W——	PROPOSED WATER LINE
——G——	*Existing Gas Line*
——G——	PROPOSED GAS LINE
——E——	*Existing Electric Line*
——E——	PROPOSED ELECTRIC LINE
——T——	*Existing Telephone Line*
——T——	PROPOSED TELEPHONE LINE
——CT——	*Existing Cable T.V. Line*
——CT——	PROPOSED CABLE T.V. LINE

SITE PLANS
CONSTRUCTION WORK & TEMPORARY FACILITIES

(Most or all of these items will be designed and located by the contractor as part of the construction contract.)

√　Dbl√

__ __ TEMPORARY EROSION CONTROL　(015168/02270)
　　　　__ materials __ dimensions __ detail keys __ notes/refs
　　　　coord check: __ civil/soil

__ __ TEMPORARY RETAINING WALLS　(01569/02151)
　　　　__ materials __ dimensions __ detail keys __ notes/refs
　　　　coord check: __ civil/soil __ struct

__ __ SHORING　(02151)
　　　　__ materials __ dimensions __ detail keys __ notes/refs
　　　　coord check: __ civil/soil __ struct

__ __ TEMPORARY DRAINAGE　(01563)
　　　　__ materials __ dimensions __ detail keys __ notes/refs
　　　　coord check: __ civil/soil

__ __ TEMPORARY FENCE　(01531)
　　　　__ materials __ dimensions __ detail keys __ notes/refs
　　　　coord check: __ code

__ __ GATES　(01531)
　　　　__ materials __ dimensions __ detail keys __ notes/refs

__ __ PROJECT SIGN　(01580)
　　　　__ materials __ dimensions __ detail keys __ notes/refs

__ __ FIELD OFFICE　(01590)
　　　　__ materials __ dimensions __ detail keys __ notes/refs

__ __ WATCHMAN'S STATION　(01545/01590)
　　　　__ materials __ dimensions __ detail keys __ notes/refs

__ __ MAIN SECURITY GUARD STATION　(01545)
　　　　__ materials __ dimensions __ detail keys __ notes/refs

__ __ TIME CLOCK PUNCH STATION　(01545)
　　　　__ locations __ notes/refs

__ __ FIRST AID STATIONS　(01517)
　　　　__ locations __ notes/refs
　　　　coord check: __ code

__ __ TOILETS AND SANITATION　(01516)
　　　　__ locations __ notes/refs

SITE PLANS
CONSTRUCTION WORK & TEMPORARY FACILITIES continued

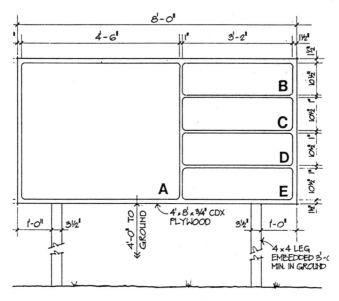

CONSTRUCTION SIGN

SEE SHEET 1.2 FOR LOCATION

SITE PLANS
CONSTRUCTION WORK & TEMPORARY FACILITIES continued

√ Dbl√

__ __ BARRICADES (01533)
 __ materials __ dimensions __ detail keys __ notes/refs
 coord check: __ code

__ __ TEMPORARY BARRIERS OR PARTITIONS BETWEEN
 CONSTRUCTION AREAS AND OCCUPIED AREAS (01533)
 __ materials __ dimensions __ detail keys __ notes/refs

__ __ TESTING AREA (01620)
 __ dimensions

__ __ SAMPLES STORAGE SHELTER (01620)
 __ materials __ dimensions __ detail keys __ notes/refs

__ __ MATERIAL AND EQUIPMENT STORAGE AREAS (01620)
 __ dimensions

__ __ PLATFORMS (01519)
 __ materials __ dimensions __ detail keys __ notes/refs

__ __ BRIDGES FOR PROTECTION OF PAVING, WALKS, CURBS
 FROM CONSTRUCTION EQUIPMENT AND TRUCKS (01519)
 __ materials __ dimensions __ detail keys __ notes/refs
 coord check: __ paving __ util

__ __ CONSTRUCTION CRANES
 __ location
 coord check: __ util

__ __ TEMPORARY ROADS (01551)
 __ materials __ dimensions __ notes/refs
 coord check: __ civil/soil __ site drain __ util

__ __ TEMPORARY PARKING (01552)
 __ dimensions __ notes/refs
 coord check: __ civil/soil __ site drain

__ __ TEMPORARY WALKWAYS (01519)
 __ materials __ dimensions

__ __ EXCAVATION SOIL STORAGE AREAS AND SPOIL AREAS
 (01620/02200)
 __ dimensions __ notes/refs
 coord check: __ civil/soil __ landscape

__ __ TOPSOIL STOCKPILE AREAS (01620)
 __ dimensions __ notes/refs
 coord check: __ civil/soil __ landscape

SITE PLANS
CONSTRUCTION WORK & TEMPORARY FACILITIES continued

√ Dbl√

__ __ PLANT STORAGE YARD (016120/02480)
 __ dimensions __ notes/refs
 coord check: __ landscape

__ __ PLANT STORAGE GREENHOUSE (02482)
 __ materials __ dimensions __ detail keys __ notes/refs
 coord check: __ landscape

__ __ TREE AND PLANT PROTECTION (01532)
 __ locations __ notes/refs
 coord check: __ landscape

__ __ CONSTRUCTION POWER POLE AND METER (01511)
 __ locations __ notes/refs
 coord check: __ elec

__ __ CONSTRUCTION TELEPHONE LINE AND POLES (01514)
 __ locations __ notes/refs
 coord check: __ elec

__ __ SITE ILLUMINATION (01512)
 __ locations __ notes/refs
 coord check: __ elec

__ __ CONSTRUCTION WATER SUPPLY HYDRANTS (01515)
 __ locations __ notes/refs
 coord check: __ plumb

__ __ TEMPORARY HOSE BIBBS (01515)
 __ locations __ notes/refs
 coord check: __ plumb

__ __ FIRE HOSE RACKS (05532)
 __ locations __ notes/refs
 coord check: __ code

__ __ WASTE CHUTE (01566)
 __ locations __ notes/refs

__ __ TRASH AND DEBRIS STORAGE (01566)
 __ locations __ notes/refs

__ __ SOIL TEST BORINGS (02011)
 __ locations __ notes/refs
 coord check: __ civil/soil

__ __ SOIL TEST PITS (02011)
 __ locations __ notes/refs
 coord check: __ civil/soil

NOTES

Date/Initials

SITE PLANS -- DEMOLITION & REPAIR

√ Dbl√

__ __ EXISTING FENCES AND WALLS
 __ to remain __ to be repaired __ to be removed

__ __ EXISTING STRUCTURES
 __ materials __ dimensions __ notes/refs
 __ to remain __ to be repaired __ to be removed

__ __ ACCESS TO ADJACENT STRUCTURES

__ __ PROTECTION FOR ADJACENT STRUCTURES

__ __ EXISTING PAVING, WALKS, STEPS, AND CURBS
 __ to remain __ to be repaired __ to be removed
 coord check: __ paving __ landscape

__ __ EXISTING ON-SITE UTILITIES, SEWERS, AND DRAINS
 __ to remain __ to be repaired __ to be removed
 coord check: __ util __ site drain

__ __ EXISTING TREES, SHRUBS, AND UNDERGROWTH
 __ to remain __ to be removed __ to be relocated
 coord check: __ landscape __ util

__ __ AREAS FOR CLEARING AND GRUBBING
 coord check: __ landscape

__ __ EXISTING TRASH TO BE REMOVED

__ __ STUMPS TO BE REMOVED

__ __ ROCK OUTCROPS TO REMAIN
 coord check: __ util __ landscape

__ __ ROCK TO BE REMOVED (02211)
 coord check: __ landscape

NOTES

SITE PLANS -- GRADING

√ Dbl√

__ __ EXISTING AND NEW SITE CONTOURS

__ __ EXISTING AND NEW FINISH GRADES

__ __ ELEVATION POINTS

__ __ NEW BENCH MARK AND/OR BOUNDARY MARKERS

__ __ EXISTING HOLES AND TRENCHES
__ which to remain __ which to be filled in
coord check: __ landscape __ site drain

__ __ NEW FILL (02221)
coord check: __ landscape

__ __ NOTE ON SOIL COMPACTION (02250)

__ __ CUT AND FILL PROFILE (May be a separate drawing sheet.)

NOTES Date/Initials

SITE PLANS -- GRADING continued

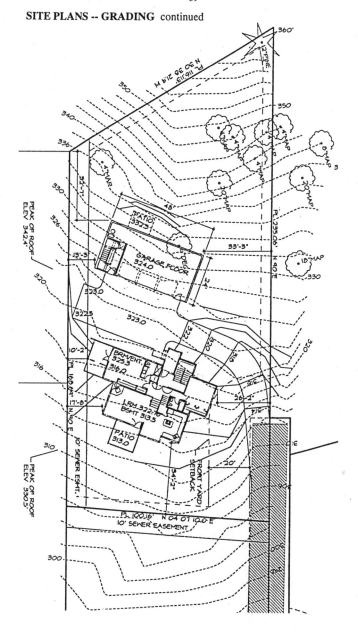

SITE PLANS -- DRAINAGE

√ Dbl√

__ __ FRENCH DRAIN (02401)
 __ materials __ dimensions __ detail keys __ notes/refs
 __ slopes __ depths
 coord check: __ civil/soil __ util __ paving __ landscape

__ __ PAVEMENT UNDERDRAIN (02410)
 __ materials __ dimensions __ detail keys __ notes/refs
 __ slopes __ depths
 coord check: __ civil/soil __ util __ paving __ landscape

__ __ TRENCH DRAIN (02410)
 __ materials __ dimensions __ detail keys __ notes/refs
 __ slopes __ depths
 coord check: __ civil/soil __ util __ paving __ landscape

__ __ SUBDRAINS (02410)
 __ materials __ dimensions __ detail keys __ notes/refs
 __ slopes __ depths
 coord check: __ civil/soil __ util __ paving __ landscape

__ __ STORM DRAINS (02420)
 __ materials __ dimensions __ detail keys __ notes/refs
 __ slopes __ depths
 coord check: __ civil/soil __ util __ paving __ landscape

__ __ AREA DRAINS (02420)
 __ materials __ dimensions __ detail keys __ notes/refs
 __ slopes __ depths
 coord check: __ civil/soil __ util __ paving __ landscape

__ __ DRAINAGE FLUME/SPILLWAY (02420)
 __ materials __ dimensions __ detail keys __ notes/refs
 __ slopes __ depths
 coord check: __ civil/soil __ util __ paving __ landscape

__ __ SLOTTED DRAIN PIPE AND SLOT (02420)
 __ materials __ dimensions __ detail keys __ notes/refs
 __ slopes __ depths
 coord check: __ civil/soil __ util __ paving __ landscape

__ __ DRAIN AT PAVING EDGE (02420)
 __ materials __ dimensions __ detail keys __ notes/refs
 __ slopes __ depths
 coord check: __ paving

__ __ CATCH BASINS (02431)
 __ materials __ dimensions __ detail keys __ notes/refs
 __ slopes __ depths
 coord check: __ civil/soil __ util __ paving __ landscape

SITE PLANS -- DRAINAGE continued

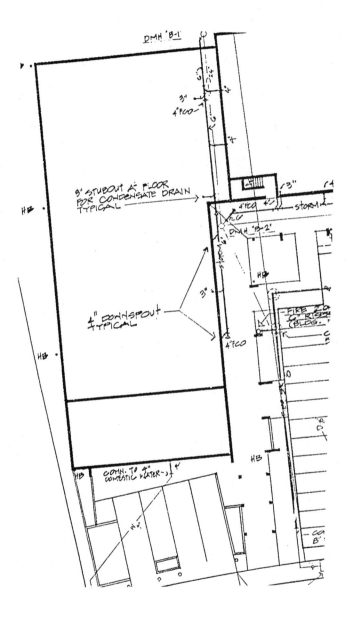

42

SITE PLANS -- DRAINAGE continued

√ Dbl√

__ __ CURB INLET (02432)
 __ materials __ dimensions __ detail keys __ notes/refs
 __ slopes __ depths
 coord check: __ paving

__ __ CULVERTS (02434)
 __ materials __ dimensions __ detail keys __ notes/refs
 __ slopes __ depths
 coord check: __ civil/soil __ util __ paving __ landscape

__ __ EROSION CONTROL (02270)
 __ materials __ dimensions __ detail keys __ notes/refs
 coord check: __ civil/soil __ paving __ landscape

__ __ RIP RAP (02271)
 __ materials __ dimensions __ detail keys __ notes/refs
 __ slopes __ depths
 coord check: __ civil/soil __ paving __ landscape

__ __ HEAD WALLS (02420)
 __ materials __ dimensions __ detail keys __ notes/refs
 coord check: __ civil/soil __ util __ paving __ landscape

__ __ DRY WELLS (02420)
 __ materials __ dimensions __ detail keys __ notes/refs
 coord check: __ civil/soil __ util __ paving __landscape

__ __ BUILDING PERIMETER FOUNDATION DRAINAGE (02411)
 __ slope
 __ depth
 __ direction of drain to dry well or storm sewer
 __ materials __ dimensions __ detail keys __ notes/refs
 coord check: __ civil/soil __ util

__ __ BUILDING RAIN LEADER DRAINAGE (15406)
 coord check: __ roof drain __ ext elev

__ __ DRIP DRAINAGE BELOW ROOF EDGES (02436)
 coord check: __ roof drain __ ext elev

__ __ SPLASH BLOCKS (02435)
 __ materials __ dimensions __ detail keys __ notes/refs
 coord check: __ roof drains __ landscape __ ext elev

SITE PLANS -- DRAINAGE continued

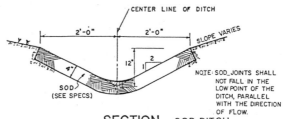

CENTER LINE OF DITCH

2'-0" 2'-0" SLOPE VARIES

12" 2
 1

4"

SOD
(SEE SPECS)

NOTE: SOD JOINTS SHALL
NOT FALL IN THE
LOW POINT OF THE
DITCH, PARALLEL
WITH THE DIRECTION
OF FLOW.

SECTION – SOD DITCH
N.T.S.

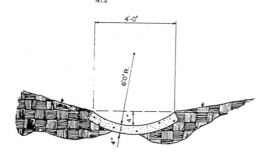

4'-0"

6'-0" R.

4'

4"

SECTION : CONCRETE SPILLWAY

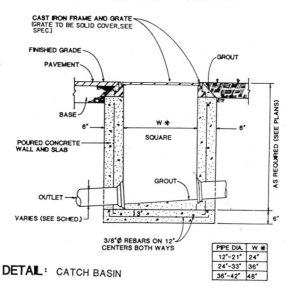

CAST IRON FRAME AND GRATE
(GRATE TO BE SOLID COVER, SEE
SPEC.)

FINISHED GRADE

PAVEMENT

GROUT

BASE

6' W ✳ 6'

SQUARE

POURED CONCRETE
WALL AND SLAB

GROUT

OUTLET

VARIES (SEE SCHED.)

AS REQUIRED (SEE PLANS)

3'

6'

3/8"∅ REBARS ON 12"
CENTERS BOTH WAYS

DETAIL : CATCH BASIN

PIPE DIA.	W ✳
12"-21"	24"
24"-33"	36"
36"-42"	48"

NOTES

SITE PLANS -- CONSTRUCTION

√ Dbl√

__ __ PORTIONS OR SURFACES OF EXISTING STRUCTURES TO
BE REMOVED
 __ materials __ dimensions __ detail keys __ notes/refs

__ __ NEW BUILDING AND RELATED STRUCTURES
 __ overall exterior wall dimensions
 __ dimensions to property lines
 __ outline of future building additions
 __ building layout line
 __ building finish floor elevation at ground floor or basement
 __ site drain
 __ materials __ dimensions __ detail keys
 __ notes/refs
 coord check: __ zoning __ util __ struct __ civil/soils

__ __ NEW FINISH GRADE ELEVATIONS AT BUILDING CORNERS
 coord check: __ survey __ civil __ site drain

__ __ GRADE SLOPE AT BUILDING LINE
 (Slope grade away from building on all sides.)
 coord check: __ survey __ civil __ site drain

__ __ FOUNDATION OR BASEMENT EXCAVATION LIMIT LINES
 coord check: __ civil __ struct

__ __ RETAINING WALLS OR WELLS FOR EXISTING TREES
AFFECTED BY CHANGES IN FINISH GRADE (02491)
 __ materials __ dimensions __ detail keys __ notes/refs
 __ elevation points
 coord check: __ landscape __ civil/soils __ struct

__ __ FENCES AND GATES
 __ CHAIN LINK (02444)
 __ WIRE (02445)
 __ WOOD (02446)
 __ heights or elevation points
 __ gate swings
 __ powered gates
 __ fence and gate lights
 __ alarms
 __ materials __ dimensions __ detail keys __ notes/refs
 coord check: __ ext elev __ landscape __ elec

SITE PLANS -- CONSTRUCTION continued

√ Dbl√

__ __ YARD WALLS
 __ CONCRETE (03300)
 __ BRICK (04210)
 __ CONCRETE BLOCK (04220)
 __ STONE MASONRY (04400)
 __ heights or elevation points
 __ wall lights
 __ alarms
 __ materials __ dimensions __ detail keys __ notes/refs
 coord check: __ ext elev __ landscape __ elec

__ __ RETAINING WALLS
 __ WOOD (02447)
 __ CONCRETE (03302)
 __ CONCRETE BLOCK (04228)
 __ STONE MASONRY (04400)
 __ materials __ dimensions __ detail keys __ notes/refs
 __ heights or elevation points
 coord check: __ landscape __ civil/soil __ struct __ drain

__ __ RETAINING WALL CONCRETE FOOTINGS (03305)
 __ dimensions __ detail keys __ notes/refs
 __ heights or elevation points
 coord check: __ civil/soils __ struct __ site drain

__ __ RETAINING WALL FOOTING DRAINAGE (02411)
 __ materials __ dimensions __ detail keys __ notes/refs
 __ sizes __ slopes __ depths
 coord check: __ civil/soils __ struct __ site drain

__ __ RETAINING WALL RELIEF DRAINS OR WEEP HOLES
(02415)
 __ materials __ dimensions __ detail keys __ notes/refs
 coord check: __ site drain

NOTES Date/Initials

SITE PLANS -- CONSTRUCTION continued

SITE PLANS -- APPURTENANCES & SITE FURNITURE

Often combined with Landscaping Plan. Most items can be assumed to require coordination checking with any separate Landscaping Plans.

The "paving" reference on the coordination checklists may refer both to the location of paving relevant to the item of construction and to necessary correlated pavement anchors, curbs, pedestals, footings, etc.

√ Dbl√

__ __ PONDS (02590)
 __ materials __ dimensions __ detail keys __ notes/refs
 coord check: __ civil/soil __ plumb __ drain __ paving

__ __ SWIMMING/WADING POOLS (13151)
 (Nonslip paving.)
 __ equipment
 __ equipment enclosure
 __ materials __ dimensions __ detail keys __ notes/refs
 coord check: __ civil/soil __ plumb __ drain
 __ paving __ elec

__ __ FOUNTAINS (02443)
 (Fountains located away from wind channels.)
 __ materials __ dimensions __ detail keys __ notes/refs
 coord check: __ civil/soil __ plumb __ drain
 __ paving __ elec

__ __ PLANTERS
 __ BRICK (04203)
 __ CONCRETE (03303)
 __ CONCRETE BLOCK (04220)
 __ WOOD (02447)
 __ materials __ dimensions __ detail keys __ notes/refs
 coord check: __ plumb __ drain __ paving

__ __ PLANT TUBS (02474)
 __ materials __ dimensions __ detail keys __ notes/refs
 coord check: __ plumb __ drain

__ __ PLANTER DRAINAGE (02447)
 __ dimensions __ detail keys __ notes/refs
 coord check: __ plumb __ drain

__ __ PEDESTALS, CURBS, OR SUPPORT SLABS (03337)
 __ materials __ dimensions __ detail keys __ notes/refs
 coord check: __ struct/slab __ paving

__ __ SIGNAGE (02452/10440)
 __ location/size __ detail keys __ notes/refs
 coord check: __ paving __ elec

SITE PLANS -- APPURTENANCES & SITE FURNITURE continued

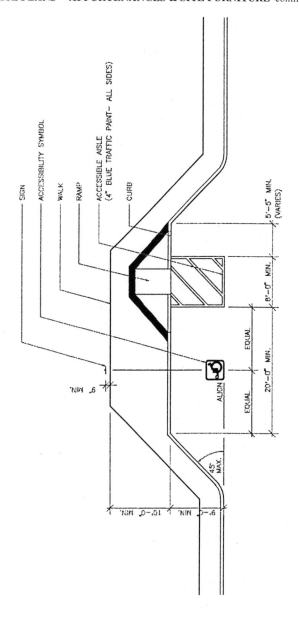

SITE PLANS -- APPURTENANCES & SITE FURNITURE continued

√ Dbl√

__ __ FREESTANDING LOCATION-MAP STANDS (10412)
 __ location/size __ detail keys __ notes/refs
 coord check: __ paving __ elec

__ __ FREESTANDING DIRECTORIES (10411)
 __ location/size __ detail keys __ notes/refs
 coord check: __ paving __ elec

__ __ FREESTANDING BULLETIN BOARDS (10415)
 __ location/size __ detail keys __ notes/refs
 coord check: __ paving __ elec

__ __ KIOSKS (02452)
 __ location/size __ detail keys __ notes/refs
 coord check: __ ext elev __ paving __ elec

__ __ WALKWAY AND PARKING LIGHT STANDARDS AND
PEDESTALS (16530)
 __ location/size __ detail keys __ notes/refs
 coord check: __ paving __ elec

__ __ BENCHES (02471)
 (Usually set 2' back from walkways.)
 __ materials __ dimensions __ detail keys __ notes/refs
 coord check: __ paving __ elec

__ __ TABLES (02472)
 __ materials __ dimensions __ detail keys __ notes/refs
 coord check: __ paving __ elec

__ __ TRASH RECEPTACLES (02475)
 __ location/size __ detail keys __ notes/refs
 coord check: __ paving

__ __ ASH RECEPTACLES (02476)
 __ location/size __ detail keys __ notes/refs
 coord check: __ paving

__ __ PERGOLAS, LATTICES, ARBORS, AND TRELLISES
 __ CONCRETE (03450)
 __ METAL (05725)
 __ WOOD (06450)
 __ materials __ dimensions __ detail keys __ notes/refs
 coord check: __ fl plan __ ext elev __ roof __ landscape
 __ elec

__ __ COVERED WALKWAYS (10531)
 __ materials __ dimensions __ detail keys __ notes/refs
 coord check: __ fl plan __ ext elev __ roof
 __ landscape __ elec

SITE PLANS -- APPURTENANCES & SITE FURNITURE continued

√ Dbl√

__ __ DRINKING FOUNTAINS, AT EXTERIOR WALL (02479)
 __ location size __ detail keys __ notes/refs
 coord check: __ fl plan __ ext elev __ paving
 __ plumb __ drain

__ __ FREESTANDING DRINKING FOUNTAINS (02479)
 __ location/size __ detail keys __ notes/refs
 coord check: __ paving __ plumb __ drain

__ __ HANDICAP DRINKING FOUNTAINS (02479)
 __ location/size __ detail keys __ notes/refs
 coord check: __ code __ paving __ plumb __ drain

__ __ CHILDREN'S DRINKING FOUNTAINS (02479)
 __ location/size __ detail keys __ notes/refs
 coord check: __ paving __ plumb __ drain

__ __ PET DRINKING FOUNTAINS (02479)
 __ location/size __ detail keys __ notes/refs
 coord check: __ paving __ plumb __ drain

__ __ PAVEMENT DRAINS AT DRINKING FOUNTAINS (02420)
 __ location/size __ detail keys __ notes/refs
 coord check: __ paving __ plumb __ drain

__ __ BICYCLE RACKS (02457)
 __ location/size __ detail keys __ notes/refs
 coord check: __ paving

__ __ PRAM RACKS (02466)
 __ location/size __ detail keys __ notes/refs
 coord check: __ paving

__ __ NEWSPAPER RACKS (02476)
 __ location/size __ notes/refs
 coord check: __ paving

__ __ FREESTANDING TELEPHONE BOOTHS (10751)
 __ location/size __ detail keys __ notes/refs
 coord check: __ paving __ elec

__ __ FREESTANDING EMERGENCY PHONES (10754)
 __ locations __ detail keys __ notes/refs
 coord check: __ paving __ elec

__ __ LOW PHONES FOR HANDICAPPED OR CHILDREN
(10755)
 __ location/size __ detail keys __ notes/refs
 coord check: __ paving __ elec

SITE PLANS -- APPURTENANCES & SITE FURNITURE continued

√ Dbl√

__ __ FREESTANDING FIRE ALARM BOXES (16721)
 __ location/size __ notes/refs
 coord check: __ code __ paving __ elec

__ __ FREESTANDING PUBLIC MAILBOXES (10552)
 __ slot for handicapped
 __ location/size __ detail keys __ notes/refs
 coord check: __ paving __ elec

__ __ FLAGPOLES (10350)
 __ location/size __ detail keys __ notes/refs
 coord check: __ paving __ elec

__ __ BUS OR SHUTTLE STOP (02477)
 __ benches
 __ signs
 __ shelter
 __ waste receptacle
 __ newspaper rack
 __ materials __ dimensions __ detail keys __ notes/refs
 coord check: __ paving __ ext elev __ elec

__ __ TURNSTILES (10450)
 __ location/size __ detail keys __ notes/refs
 coord check: __ paving

__ __ INFORMATION OR GUARD BOOTH (02473/02478)
 __ materials __ dimensions __ detail keys __ notes/refs
 coord check: __ paving __ ext elev __ elec

__ __ PAID PARKING (11150)
 __ ticket dispenser
 __ parking gate
 __ tire spike barrier
 __ materials __ dimensions __ detail keys __ notes/refs
 coord check: __ paving

__ __ PARKING ATTENDANT SHED (02473/02478)
 __ materials __ dimensions __ detail keys __ notes/refs
 coord check: __ paving __ ext elev __ elec

__ __ TRASH YARD AND ENCLOSURE
 (See Walls/Fences in "Construction.")
 __ materials __ dimensions __ detail keys __ notes/refs
 coord check: __ paving __ ext elev __ plumb
 __ drain __ elec

SITE PLANS -- APPURTENANCES & SITE FURNITURE continued

√ Dbl√

__ __ MAINTENANCE YARD AND ENCLOSURE
 (See Walls/Fences in "Construction")
 __ storage racks
 __ shelters or storage sheds
 __ fuel storage tanks
 __ fuel tank inlet, valve and pump
 __ materials __ dimensions __ detail keys __ notes/refs
 coord check: __ paving __ ext elev __ plumb
 __ drain __ elec

__ __ PLAY FIELDS (02460)
 __ materials __ dimensions __ detail keys __ notes/refs
 coord check: __ civil/soil __ drain

__ __ FENCES PLAY YARD (02460)
 __ materials __ dimensions __ detail keys __ notes/refs
 coord check: __ paving __ drain

__ __ PLAYGROUND EQUIPMENT (02461)
 __ location/size __ detail keys __ notes/refs
 coord check: __ paving

__ __ GAZEBO, GREENHOUSE, LATH HOUSE, STORAGE SHED
 __ materials __ dimensions __ detail keys __ notes/refs
 coord check: __ landscape __ paving __ plumb __ elec

NOTES Date/Initials

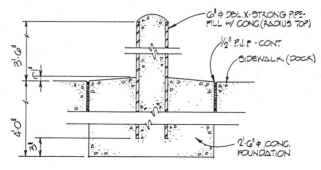

6" Ø DBL. X-STRONG PIPE-
FILL W/ CONC (RADIUS TOP)

½" P.J.F - CONT.

SIDEWALK (DOCK)

3'-6"

1"

4'-0"

3"

2'-6" Ø CONC.
FOUNDATION

(5 / A·2) **PIPE GUARD**
3/4'' 1'-0''

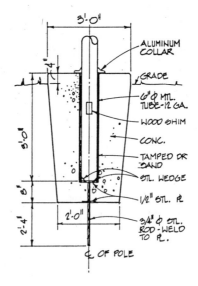

3'-0"

ALUMINUM
COLLAR

4"

GRADE

6" Ø MTL.
TUBE-12 GA.

WOOD SHIM

CONC.

5'-0"

TAMPED OR
SAND

STL. WEDGE

8"

½" STL. PL.

2-4"

2'-0"

3/4" Ø STL.
ROD - WELD
TO PL.

℄ OF POLE

(9 / A·2) **FLAGPOLE
BASE**
3/8'' - 1'-0''

SITE PLANS -- UTILITIES

√ Dbl√

___ ___ UTILITY CONNECT POINTS TO EXISTING MAINS
 ___ elevation points
 ___ locations ___ detail keys ___ notes/refs
 coord check: ___ survey

___ ___ MANHOLES AND CLEANOUTS (02601)
 ___ elevation points
 ___ materials ___ dimensions ___ detail keys ___ notes/refs
 coord check: ___ civil/soil ___ drain

___ ___ WATER SUPPLY MAIN (02713)
 ___ elevation points
 ___ location markers
 ___ materials ___ dimensions ___ detail keys ___ notes/refs
 coord check: ___ civil/soil ___ plumb ___ gas ___ steam
 ___ sewer ___ drain ___ elec

___ ___ WATER METER (15181)
 ___ enclosure
 ___ location ___ notes/refs
 coord check: ___ plumb ___ paving

___ ___ WATER SHUTOFF BOX AND COVER (15181)
 ___ location ___ detail keys ___ notes/refs
 coord check: ___ plumb ___ paving

___ ___ FIRE HYDRANTS (02644/15530)
 ___ locations ___ notes/refs
 coord check: ___ code ___ plumb ___ paving

___ ___ HOSE BIBBS (02640)
 ___ locations ___ notes/refs
 coord check: ___ plumb ___ landscape

___ ___ STANDPIPES (15530)
 ___ identifying markers for fire department
 ___ locations ___ detail keys ___ notes/refs
 coord check: ___ code ___ plumb ___ paving

___ ___ STEAM MAIN (15602)
 ___ materials ___ dimensions ___ detail keys ___ notes/refs
 coord check: ___ civil/soil ___ hvac ___ sewer
 ___ water ___ drain ___ elec ___ phone ___ tv

___ ___ GAS MAIN (02711)
 ___ elevation points
 ___ location markers
 ___ dimensions ___ detail keys ___ notes/refs
 coord check: ___ civil/soil ___ hvac ___ sewer ___ steam
 ___ water ___ drain ___ elec

SITE PLANS -- UTILITIES continued

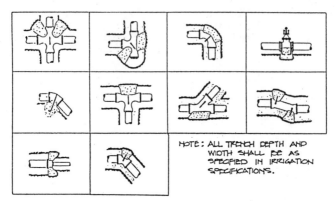

NOTE: ALL TRENCH DEPTH AND WIDTH SHALL BE AS SPECIFIED IN IRRIGATION SPECIFICATIONS.

⑤/③ TYPICAL THRUST BLOCK DETAILS
NOT TO SCALE

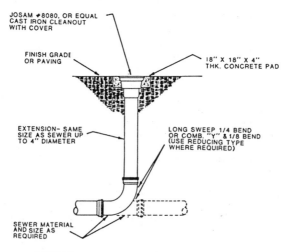

JOSAM #8080, OR EQUAL CAST IRON CLEANOUT WITH COVER

FINISH GRADE OR PAVING

18" X 18" X 4" THK. CONCRETE PAD

EXTENSION- SAME SIZE AS SEWER UP TO 4" DIAMETER

LONG SWEEP 1/4 BEND OR COMB. "Y" & 1/8 BEND (USE REDUCING TYPE WHERE REQUIRED)

SEWER MATERIAL AND SIZE AS REQUIRED

DETAIL EXTERIOR CLEANOUT

NO SCALE

SITE PLANS -- UTILITIES continued

√ Dbl√

__ __ GAS METER (02711/15182)
__ enclosure
__ location __ detail keys __ notes/refs
coord check: __ paving

__ __ GAS SHUTOFF VALVE AT BUILDING (02640/02711)
__ conspicuous location for shutoff, with identifying sign
__ lighting
__ location __ notes/refs
coord check: __ paving __ elec

__ __ EXTERIOR ELECTRICAL OUTLETS AND LIGHTS AT
BUILDING AND AT AUXILIARY STRUCTURES (16520)
__ locations __ notes/refs
coord check: __ paving __ ext elev

__ __ OVERHEAD CABLES
(Overhead cables to clear walks, driveways, trees, and structures.)
__ ELECTRICAL (02811)
__ TELEPHONE (02821)
__ TV (02823)
__ locations __ notes/refs
coord check: __ landscape __ paving __ ext elev

__ __ BURIED CABLES
__ ELECTRICAL (02812)
__ TELEPHONE (02821)
__ TV (02823)
__ elevation points
__ location markers
__ locations __ detail keys __ notes/refs
coord check: __ civil/soil __ gas __ water __ steam
__ drain __ sewer

__ __ SATELLITE DISH ANTENNA (11800)
__ antenna platform
__ enclosure
__ materials __ dimensions __ detail keys __ notes/refs
coord check: __ paving __ elec

__ __ ELECTRICAL METER (16430)
__ enclosure
__ location __ detail keys __ notes/refs
coord check: __ paving __ elec

__ __ TELEPHONE AND POWER POLES (02802)
(Overhead cables to clear walks, driveways, trees, and structures.)
__ materials __ locations __ detail keys __ notes/refs
coord check: __ paving __ landscape __ ext elev

58

SITE PLANS -- UTILITIES continued

√ Dbl√

__ __ SERVICE ENTRANCE (16420)
 __ locations __ detail keys __ notes/refs
 coord check: __ fl plan __ ext elev __ roof

__ __ TRANSFORMERS (16460)
 __ vault
 __ materials __ locations __ detail keys __ notes/refs
 coord check: __ paving __ struct __ drain

__ __ ALL UTILITY TRENCHES: MINIMUM AND MAXIMUM
DEPTH LIMITS (02221)
 __ locations __ notes/refs
 coord check: __ civil/soil __ landscape

__ __ TRENCHING LOCATED TO AVOID DAMAGE TO TREE
ROOTS AND NEIGHBORING STRUCTURES (02221)
 coord check: __ civil/soil __ landscape

__ __ EXCAVATION WARNING SIGNS/MARKERS ALONG
ROUTES OF BURIED UTILITY LINES (02452)
 __ locations/sizes __ detail keys __ notes/refs
 coord check: __ code __ survey

__ __ FUEL OIL OR LIQUIFIED GAS (13410)
 __ storage tank
 __ fuel line to building
 __ vent
 __ gauge box
 __ fill box
 __ manhole
 __ materials __ dimensions __ detail keys __ notes/refs
 coord check: __ code __ civil/soil __ hvac

__ __ WATER WELL AND PUMP HOUSING (02730)
 __ location/size __ detail keys __ notes/refs
 coord check: __ plumb __ elec __ sewer __ drain

__ __ CISTERNS (02720)
 __ materials __ dimensions __ detail keys __ notes/refs
 coord check: __ civil/soil __ plumb __ sewer __ drain

__ __ SEWER MAIN (02722)
 __ vent and cleanout
 __ direction of slope
 __ elevation points
 __ location markers
 coord check: __ civil/soil __ gas __ steam __ water
 __ drain __ elec

SITE PLANS -- UTILITIES continued

√ Dbl√

__ __ PACKAGE SEWAGE TREATMENT TANK AND HOUSING
(02722)
__ materials __ dimensions __ detail keys __ notes/refs
coord check: __ code __ civil/soil __ struct __ plumb
__ elec __ drain

__ __ SEPTIC SYSTEM (02740)
__ septic tank
__ siphon tank
__ distribution boxes
__ seepage pit
__ leaching field
__ materials __ dimensions __ detail keys __ notes/refs
coord check: __ code __ civil/soil __ landscape __ plumb
__ drain

NOTES Date/Initials

60

SITE PLANS -- UTILITIES continued

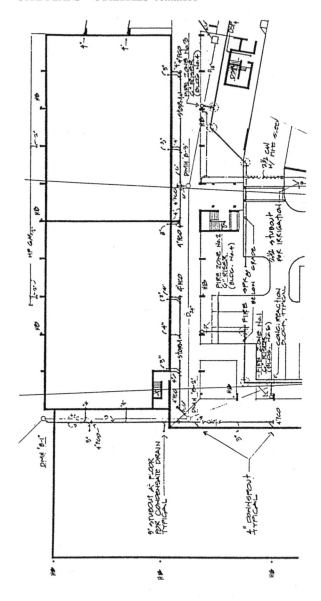

SITE PLANS -- PAVING, WALKWAYS, & PARKING

√ Dbl√

__ __ EXTERIOR PARKING LOCATED MINIMUM 5' FROM
WALLS AND OTHER STRUCTURES

__ __ PARKING SPACES LOCATED OUTSIDE TREE DRIP LINES
coord check: __ landscape

__ __ PARKING SPACES LOCATED OUTSIDE OF ICICLE OR
ROOF SNOW DROP LINES

__ __ WIDE SPACE PARKING FOR HANDICAPPED
coord check: __ code

__ __ TACTILE WARNING SURFACES FOR THE BLIND (02539)
__ materials __ dimensions __ detail keys __ notes/refs

__ __ NEW PUBLIC CURBS AT DRIVEWAY ENTRIES
__ GRANITE (02525)
__ PRECAST CONCRETE (02526)
__ ASPHALT (02527)
__ CONCRETE (02528)
__ dimensions __ detail keys __ notes/refs
__ elevation points
coord check: __ civil/soil __ site drain

__ __ DRIVEWAYS
__ CRUSHED STONE (025211)
__ ASPHALTIC CONCRETE (02513)
__ BRICK (02514)
__ CONCRETE (02515)
__ ASPHALT BLOCK (02516)
__ STONE (02517)
__ CONCRETE BLOCK (02518)
__ dimensions __ detail keys __ notes/refs
__ elevation points __ slopes
coord check: __ civil/soil __ site drain __ landscape

__ __ EXISTING AND NEW GRADE ELEVATIONS AT PAVING,
NOTED AT CENTER LINES AND SIDES OF DRIVEWAYS
coord check: __ civil/soil

__ __ CROSS SECTION DIAGRAMS THROUGH ROADWAYS OR
DRIVEWAYS
coord check: __ civil/soil __ site drain

__ __ DRIVEWAY DRAINS (02420)
__ materials __ dimensions __ detail keys __ notes/refs
__ elevation points __ slopes
coord check: __ civil/soil __ site drain

SITE PLANS -- PAVING, WALKWAYS, & PARKING continued

√ Dbl√

__ __ DRIVEWAY AND PARKING AREA GRADES
 (Minimum 1/2%, maximum 5% at crowns)
 coord check: __ civil/soil __ site drain

__ __ PAVEMENT AND WALKWAY ICE MELTING EQUIPMENT
 (15700/16850)
 __ location/size __ detail keys __ notes/refs
 coord check: __ elec

__ __ ASPHALT PAVEMENT HUMPS (02516)
 __ materials __ locations __ detail keys __ notes/refs

__ __ WARNING SIGNS TO SLOW THROUGH TRAFFIC (02452)
 __ locations __ detail keys __ notes/refs

__ __ TRAFFIC CONTROL LIGHT STANDARDS (02453)
 __ locations __ detail keys __ notes/refs
 coord check: __ elec

__ __ LOCKABLE POSTS OR CHAIN BARRIERS AT RESTRICTED
 ACCESS (02450)
 __ materials __ dimensions __ detail keys __ notes/refs

__ __ DRIVEWAY GATE (02444--02450)
 __ materials __ dimensions __ detail keys __ notes/refs

__ __ DRIVEWAY FENCING (02444--02450)
 __ materials __ dimensions __ detail keys __ notes/refs

__ __ PAVEMENT MARKING (02577)
 __ parking spaces
 __ handicapped parking
 __ no parking areas
 __ traffic control lines or markers
 __ direction arrows
 __ pedestrian cross walks
 __ pavement stop signs
 __ slow or speed limit zones

__ __ PARKING BUMPERS (02455--02456)
 __ materials __ dimensions __ detail keys __ notes/refs

__ __ TRAFFIC CONTROL CURBS (02450)
 __ materials __ dimensions __ detail keys __ notes/refs

SITE PLANS -- PAVING, WALKWAYS, & PARKING continued

√ Dbl√

__ __ PROTECTIVE VEHICULAR CURBS, BUMPERS, OR GUARD
RAILINGS (02450--02451/02455--02456))
 __ garage entries
 __ walls
 __ ledges
 __ walkways
 __ steps
 __ light standards
 __ posts and columns
 __ materials __ dimensions __ detail keys __ notes/refs

__ __ HANDICAP RAMP (02458)
 __ materials __ dimensions __ detail keys __ notes/refs
 coord check: __ code

__ __ CONSTRUCTION JOINTS IN CONCRETE PAVING (02515)
 (1/2" joints each with 20' to 30' is typical, plus joints at
 connections with other construction.)
 __ materials __ dimensions __ detail keys __ notes/refs
 coord check: __ struct/slab

__ __ RAMPS FROM PARKING AREA TO ADJACENT SIDEWALKS
 __ CRUSHED STONE (02511)
 __ ASPHALTIC CONCRETE (02513)
 __ BRICK (02514)
 __ CONCRETE (02515)
 __ ASPHALT BLOCK (02516)
 __ STONE (02517)
 __ CONCRETE BLOCK (02518)
 __ dimensions __ detail keys __ notes/refs
 __ elevation points __ slopes
 coord check: __ site drain __ landscape

__ __ WALKS
 __ WOOD PLANK (02516
 __ ASPHALTIC CONCRETE (02513)
 __ BRICK (02514)
 __ CONCRETE (02515)
 __ ASPHALT (02516)
 __ STONE (02517)
 __ CONCRETE BLOCK/PAVERS (02518)
 __ GRAVEL (02519)
 __ dimensions __ detail keys __ notes/refs
 __ elevation points __ slopes
 coord check: __ site drain __ landscape

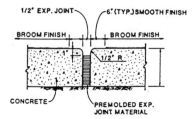

DETAIL EXPANSION JOINT
N.T.S.

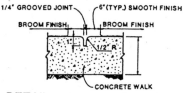

DETAIL: CONTROL JOINT
N.T.S.

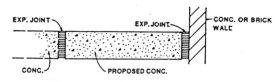

DETAIL: EXPANSION JOINT LOCATION
N.T.S.

SITE PLANS -- PAVING, WALKWAYS, & PARKING continued

√ Dbl√

__ __ STEPS AT WALKS
 __ BRICK (02514)
 __ CONCRETE (02529)
 __ STONE (02517)
 __ CONCRETE BLOCK/PAVERS (02518)
 __ WOOD (02523)
 __ TILE FINISH (09300)
 __ dimensions __ detail keys __ notes/refs
 __ elevation points __ slopes __ riser number and heights
 coord check: __ site drain

__ __ BICYCLE AND DISABILITY RAMPS ADJACENT TO
WALKWAY STEPS AND AT CURBS
 __ materials __ dimensions __ detail keys __ notes/refs
 __ elevation points __ slopes
 coord check: __ site drain

__ __ HANDRAILS AT STEPS OVER 3 RISERS (05520--05521)
 __ materials __ dimensions __ detail keys __ notes/refs
 coord check: __ code

__ __ 3 RISERS MINIMUM AT ANY POINT ALONG WALKS OR
RAMPS
 coord check: __ code

__ __ ROUGH, NONSKID SURFACES AT EXTERIOR WALKS,
STEPS, AND LANDING

__ __ HANDRAILS AT SLOPING WALKS OR RAMPS (05520--05521)
 (Maximum slope for walkway without handrails is 1 in 8.)
 __ materials __ dimensions __ detail keys __ notes/refs
 coord check: __ code

__ __ PIPE SLEEVES IN PAVEMENT FOR FENCING OR RAILING
POSTS (02444--02446)
 __ materials __ dimensions __ detail keys __ notes/refs

__ __ EXTERIOR STAIR, WALKWAY AND RAMP DRAINAGE
(02420)
 __ exterior stair identification numbers on plans
 __ treads sloped to drain
 __ side gutters at ramps, stairs, or steps
 __ catch basins or drains at base of stairs or ramps
 __ walkway low point sloped to drain
 __ materials __ dimensions __ detail keys __ notes/refs
 coord check: __ civil/soil __ site drain __ landscape

__ __ CONCRETE WALKWAY CONSTRUCTION JOINTS (02529)
 (1/2" joints each 30', tooled joints at 5'. Construction joints
 at connections with other construction.)
 __ materials __ dimensions __ detail keys __ notes/refs

SITE PLANS -- PAVING, WALKWAYS, & PARKING continued

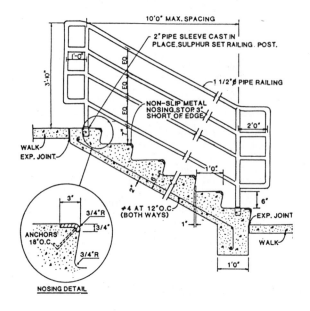

10'0" MAX. SPACING

2" PIPE SLEEVE CAST IN PLACE. SULPHUR SET RAILING. POST.

1'-0"

3'-10"

EQ. EQ. EQ. EQ.

1 1/2" ∅ PIPE RAILING

NON-SLIP METAL NOSING, STOP 3" SHORT OF EDGE

2'0"

WALK EXP. JOINT.

1'0"

6'

3"

3/4"R

3/4"

#4 AT 12" O.C. (BOTH WAYS)

EXP. JOINT

ANCHORS 18" O.C.

3/4"R

1"

WALK

NOSING DETAIL

1'0"

DETAIL: EXTERIOR STEPS W/RAILING
N.T.S.

SITE PLANS -- PAVING, WALKWAYS, & PARKING continued

√ Dbl√

__ __ PAVED TERRACES AND PATIOS
 (Open joint drainage or closed joint pavers. Solid paving
 sloped minimum 1" to 10' for drainage.)
 __ BRICK (02514)
 __ CONCRETE (02515)
 __ STONE (02517)
 __ CONCRETE BLOCK/PAVERS (02518)
 __ TILE (09300)
 __ WOOD DECKING (06125)
 __ materials __ dimensions __ detail keys __ notes/refs
 __ elevation points __ slopes
 coord check: __ civil/soil __ site drain __ fl plan __ ext elev

__ __ LAYOUT PATTERNS FOR PAVERS

__ __ OPENINGS OR GRATINGS AT TREES IN PAVED AREAS
 FOR WATERING SPACE (02491)
 __ materials __ dimensions __ detail keys __ notes/refs
 coord check: __ landscape __ site drain

__ __ SYNTHETIC GRASS OR TURF (02541)
 __ dimensions __ notes/refs
 coord check: __ site drain

__ __ SIDEWALK GRATING (05530)
 __ materials __ dimensions __ detail keys __ notes/refs
 coord check: __ util

__ __ SIDEWALK ELECTRICAL VAULT (16301)
 __ materials __ dimensions __ detail keys __ notes/refs
 coord check: __ elec __ struct __ util

__ __ SIDEWALK PAVING GLASS IN PRE-CAST CONCRETE FOR
 UNDERGROUND ROOMS (03412/04270)
 __ location size __ detail keys __ notes/refs

__ __ SIDEWALK ELEVATOR (14411)
 __ location size __ detail keys __ notes/refs
 coord check: __ struct __ elec

__ __ ACCESS FOR FUEL DELIVERY
 __ location size __ detail keys __ notes/refs
 coord check: __ hvac

__ __ SIDEWALK PLAQUES SPECIFYING PROPERTY
 OWNERSHIP AND LIMITS ON PUBLIC USE (10420)
 __ materials __ location size __ detail keys __ notes/refs

SITE PLANS -- PAVING, WALKWAYS, & PARKING continued

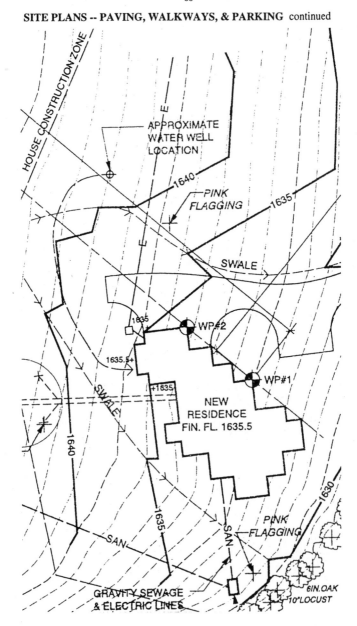

NOTES

SITE PLANS -- LANDSCAPING

√ Dbl√

__ __ EXISTING TREES, SHRUBS, AND UNDERGROWTH
(01532/02111/02481)
__ which to remain __ which to remove
__ which to relocate and store for transplanting
coord check: __ demolition __ construction site

__ __ TREES TO BE WRAPPED (01532/02491)
coord check: __ const site

__ __ TREE GUARDS FOR PROTECTION DURING
CONSTRUCTION (01532)
__ materials __ detail keys __ notes/refs
coord check: __ const site

__ __ NEW TOPSOIL STORAGE AREA (02483)
__ dimensions __ notes/refs
coord check: __ const site

__ __ EXCAVATION LOAM STORAGE AREA (02483)
__ dimensions __ notes/refs
coord check: __ const site

__ __ TEMPORARY EROSION CONTROL (01568/02270)
__ materials __ dimensions __ detail keys __ notes/refs
coord check: __ const site __ site drain

__ __ NEW LANDSCAPE DESIGN ROCK (02480)
__ location __ notes/refs
coord check: __ civil/soil

__ __ NEW LANDSCAPE AREA PLAN WITH LEGEND AND KEYS
TO IDENTIFY TREES, PLANTS, AND GROUND COVER
(02490)
__ all trees and shrubs shown at mature size
__ locations/sizes __ notes/refs
coord check: __ civil/soil __ util __ plumb __ site drain

__ __ LAWN AND GRASS AREAS (02485)
__ dimensions __ notes/refs
coord check: __ civil/soil __ plumb __ site drain

__ __ SLOPES AND DRAINAGE FOR GROUND COVER AREAS
(02420)
coord check: __ civil/soil __ site drain

__ __ ALL POCKETS AND STANDING WATER AREAS FILLED OR
PROVIDED WITH DRAINAGE (02420)
__ materials __ dimensions __ detail keys __ notes/refs
coord check: __ civil/soil __ site drain

SITE PLANS -- LANDSCAPING continued

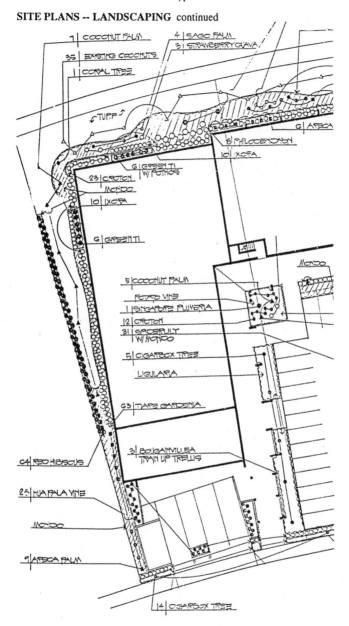

SITE PLANS -- LANDSCAPING continued

√ Dbl√

__ __ PLANTING BEDS
 __ AGGREGATE (02495)
 __ WOOD CHIP (02496)
 __ dimensions __ detail keys __ notes/refs
 coord check: __ paving __ site drain

__ __ WOOD CURBS OR BORDER BOARDS AT PLANTING BEDS
 (02521--02522)
 __ dimensions __ detail keys __ notes/refs
 coord check: __ paving

__ __ ROOT FEEDING PIPES (02490)
 __ dimensions __ detail keys __ notes/refs
 coord check: __ site drain

__ __ LANDSCAPE IRRIGATION AND/OR SPRINKLER SYSTEM
 (02441--02442) (May be shown on separate Plumbing Plan.)
 __ auto-timer
 __ valves
 __ hose bibs and hydrants
 __ sprinkler head locations
 coord check: __ plumb __ site drain

__ __ DECORATIVE YARD LIGHTING AND TIMER SWITCH
 (16530)
 (May be shown on Electrical Drawings.)
 __ locations __ detail keys __ notes/refs
 coord check: __ elec

__ __ LANDSCAPE MAINTENANCE STORAGE SHELTER (02499)
 __ materials __ dimensions __ detail keys __ notes/refs
 coord check: __ plumb __ elec

NOTES Date/Initials

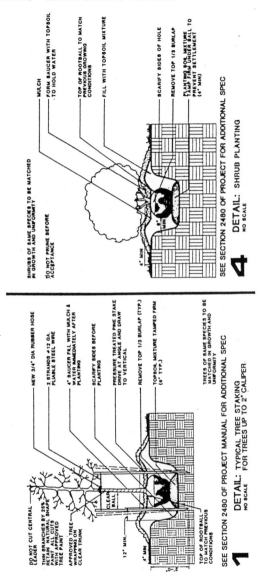

NOTES

FLOOR PLANS AND INTERIOR ELEVATIONS

CHAPTER CONTENTS

FLOOR PLAN PROCEDURAL CHECKLIST

FLOOR PLAN LAYOUT AND DRAFTING, STEP BY STEP

PHASE 1 -- "OUTLINE" INFORMATION

AND INFORMATION REQUIRED BY CONSULTANTS

First, update and verify room sizes in the floor plans completed during design. Using the updated design development plan as your guide, proceed with the following steps.

__ Decide on the desirable scale, size, and positioning of the Floor Plan(s) on the working drawing sheet(s). Consider locations of Keynote legend, Finish Schedule, General Notes, Symbols Legend (if any), Titles, Key Plan, and Floor Plan related details.

Layout & Linework

__ Draw the structural grid, if any.

__ Draw the modular grid, if any. Confirm if modular lines are to be consistently located at centerlines, wall finishes, or faces of wall framing.

__ Draw structural support members.

__ Finalize and draw the outline of perimeter walls of building. Compare outline floor plan with site plan to confirm that building walls are within required set- back limits relative to property lines and other limitations.

__ Draw "light line" layout of interior walls and partitions. Compare all room sizes with program requirements and check that sizes of minor rooms, such as corridors, closets, and other utility spaces, are adequate according to function and code.

__ Confirm locations of interior bearing walls. Overlay and compare upper and lower level floor plans for aligment of structural members.

__ Size and rough in door and window openings. Compare door and window locations with site conditions and requirements for fire safety.

__ Show changes in floor level.

__ Rough in stair locations and confirm tread/riser sizes relative to stair height.

__ Add ramps -- direction and upper and lower sub-floor elevations.

FLOOR PLAN PROCEDURAL CHECKLIST continued

PHASE 1 -- "OUTLINE" INFORMATION continued

Layout & Linework continued

__ Add ramps -- direction and upper and lower sub-floor elevations.

__ Indicate "light-line" locations and sizes of equipment and built-ins.

__ Indicate "light-line" locations of cabinets and shelves.

__ Door swings.
> Check door swings for conflicts with other doors, cabinet doors,
> and desired light switching.

__ Soffit lines.

__ Show dash lines for hidden construction below or above.

__ Rough in locations of exterior and interior dimension strings.
> Locate to avoid conflicts or confusion with reference linework,
> room names, notes, etc.

NOTES Date/Initials

FLOOR PLAN PROCEDURAL CHECKLIST continued

PHASE 2 -- "HARDLINE" INFORMATION

AND DETAILED ARCHITECTURAL CONSTRUCTION DATA

Construction Elements Some of these may be completed after Dimensioning and Notation. Some may be shown only on separate Electrical, Plumbing, or HVAC drawings.

___ Confirm wall locations and "hardline" the walls and partitions that are in "light line." Don't add extra lines to show wall finishes except for special veneer or tile walls.

___ Show floor tracks, saddles, sills, carpet strips, and changes of flooring.

___ Locate and show floor drains. Coordinate with Foundation and Plumbing Plan.

___ Show floor slopes to floor drains. Coordinate with relevant framing and/or slabs.

___ Add heater and vent symbols. Coordinate with HVAC plan.

___ Finalize and show sizes and locations of equipment, fixtures, and built-ins.

___ Add indications for closet and wardrobe pole and shelves, pantry, and cabinets.

___ If the Floor Plan includes Electrical, add outlets, switches, and light fixture symbols.

Dimensioning

___ Draw overall exterior wall dimension lines and dimensions. Confirm dimensioning system -- dimensions to frame, centerlines, or finishes (dimensions to face of framing is recommended for greatest accuracy and user convenience).

___ Draw interior wall dimension lines. Avoid duplicate strings of dimensions.

___ Add dimension numbers in feet and inches.
Avoid unrealistic small fractions of an inch; 1/2" is usually minimum, 4" increments preferred.

___ Show reference start points of dimension strings; reference for convenience of framer.

___ Cross check overall dimension strings with partial dimensions.

___ Add small dimensions such as for wing walls, furred walls, etc.

FLOOR PLAN PROCEDURAL CHECKLIST continued

PHASE 2 -- "HARDLINE" INFORMATION continued

__ If using structural or modular grids, add coordinate letters and numbers.

__ Label major rooms; add keys to identify rooms too small to show room names.

__ Show ceiling heights (usually added under room names).

__ Show room interior length & width dimensions or square footages under room titles. (This is a regional custom in many parts of the country as a convenience for the building department or to assist contractor take-offs.)

__ Add Floor Plan drawing title and scale:

__ Add materials and fixture Keynote numbers or identification notes.

Plans should be ready at this point as base-layer references for Reflected Ceiling Plan and drawings by Mechanical Engineering and Electrical Engineering consultants.

Layout & Linework

__ Confirm wall locations and "hardline" any previously undecided walls and partitions that are still in "light line."

Construction Elements

__ Complete partial floor patterns, textures, and wall materials indications.

__ Finalize wall materials and construction identifications.

Notation

__ Add reference notes to special areas shown elsewhere at larger scale. Use enlarged portions of plans sparingly and don't repeat all details of the space at both large and small scales; keep small scale area diagrammatic to avoid redundancy and possible contradiction.

__ Write identification notes or keynote reference numbers.

__ Where elements or dimensions are highly repetitive, note or dimension one and add "Typical" or "Unless Noted Otherwise" notes:

__ Write construction assembly notation and note references to specifications and details.

FLOOR PLAN PROCEDURAL CHECKLIST continued

PHASE 2 -- "HARDLINE" INFORMATION continued

Notation continued

__ Add final clarification reference notes regarding finishes, fixtures, furnishings, and equipment.

__ Edit and update the Keynotes legend.

__ Add, edit, and update any General Notes that pertain to overall interior and exterior construction.

Referencing & Symbols

__ Show ceiling or roof joist direction arrow with size and spacing notes. (Don't include framing indications if complete separate framing plans are provided.)

__ Show room Finish Schedule references. (Final number/code references may be held until final work on the finish schedule.)

__ Show arrow references to Interior Elevations.

__ Add detail bubbles, reference lines, and wall and Cross Section reference keys. Check that there is no conflict or possibility of confusion of these lines with dimension lines.

__ Add final Door and Window symbol reference keys. Final code numbers/letters may be incomplete until completing the door and window schedules.

__ Key equipment and fixtures to Equipment and Fixtures Schedules.

Related Drawings that may be included on the Floor Plan Sheet or Related Sheets

__ Finish Schedule.

__ Equipment and Fixtures Schedules.

__ Fixture Height Schedule.

__ Interior construction details.

FLOOR PLAN PROCEDURAL CHECKLIST continued

PHASE 3 -- CHECKING

__ Use transparency prints to cross check and coordinate Floor Plans with
 Foundation Plans, Structural Framing Plans, Electrical Plans,
 Plumbing Plans, HVAC, Roof
 and/or Ceiling Framing Plans.

__ For check prints, attach a blank transparency on the Floor Plan and
 mark changes and additions in red and data that's correct in yellow.

__ In each later phase of checking, remove the transparency from the first
 check print and attach to the next phase check print. Verify that
 required changes and additions have been completed as required,
 and mark with yellow over the red marks.

__ To minimize oversights, checking for errors and incompleteness should
 be separate from checking for progress.

__ Checking for changes and additions is often more complete and accurate
 if done by a third party who has not been working on the project.

NOTES Date/Initials

ABOUT FLOOR PLANS AND INTERIOR ELEVATIONS

The checklists in this chapter do double duty by covering interior elevation components as well as the floor plan items. One main point about the interior elevations: Those that mainly show fixtures and equipment rather than major design features may not have to be drawn at all. Consider using a fixture heights schedule that shows the appearance and heights of all typical fixtures and rely on the floor plans to show their locations.

Floor plans are the start point and reference point for most other drawings. Most drawings such as elevations and consultant's plans are derived directly from floor plans. Other drawings are derived indirectly, as when a window detail is referenced from the window schedule and the window schedule is derived from the floor plan. The final point of reference is still the floor plan.

Checking and coordination problems arise when work is created or referenced in some sequence that bypasses or duplicates the plans. For example, if door and window details are referenced directly from exterior elevations and also from the floor plans, there will be an unnecessary duplication of work and increased chance of error. ("Duplication leads to contradiction.")

Through all drafting, input, and checking processes, it's imperative that all staff work in reference to identical, up-to-the-minute plan data. To assure this, all coordination checking should be done using overlay transparencies whether the job is an overlay drafting or CADD job or not.

AVOIDING CROWDED, HARD TO READ FLOOR PLANS

The problem with floor plans is usually not so much one of overdrawing as one of crowded and uncoordinated drawing. Drafters tend to show too many separate layers or contracts on one sheet, especially in plans for smaller buildings. The alternative is to separate the layers of divergent data by using CADD or overlay drafting. Layering makes it very convenient to sort out consultants' work, built-ins, equipment, special finishes, and other categories of information, and print them as separate sheets. That reduces crowding on any particular sheet, makes it easier to do checking, corrections and revisions. And it keeps all data in direct correlation to exactly the same original base sheet floor plan information.

Floor plan drawings, especially for smaller projects, tend to be oversized. 1/4" scale is common for residential work, for example, when far more complex institutional building floor plans are done quite adequately at 1/8" scale. The larger scales require more elaboration, more drawing, and hence, more time.

Special rooms and spaces are sometimes segregated at larger scale for clari-fication. Apartment units, toilet rooms, commercial kitchens, and stair fire towers are frequently done this way. It's worth weighing the decision to duplicate these elements. They require considerable extra drafting, usually show no more or less than the smaller scale plans, and they're always a source of conflict as changes made on one scale drawing are not picked up on its counterpart. If you're using photoreduction/enlargement techniques, you can design special spaces at large scale and photoreduce them for smaller scale paste-ups. That cuts the duplicate drafting and helps assure consistency.

Notation is often redundant on floor plans. Any general condition can best be indicated in one general note of the type that says, for example, "All ceilings are 9'-0" high unless noted otherwise."

Textures, crosshatching, and materials indications are often overdone. Partial indications, such as a corner portion of tile pattern to show flooring, is faster and more readable than a complete grid of tile.

Wall construction is also frequently overdrawn. Wall construction can be shown with partial materials indications at corners; a general "unless noted otherwise" note if it happens that most construction is of one type; graphic tape patterns; or with wall identification bubbles referenced to a wall section detail drawing or schedule.

Symbols can often be simpler than those commonly used. A simple "T" with detail and sheet number is faster to make and just as clear as the usual, more elaborate detail or section reference bubble.

Dimensions without feet and inch marks are just as clear as those with such marks, and elimination of the marks helps clean up drawings considerably. Dimension arrowheads made with simple dots or slashes are just as readable as more elaborate symbols. And notation leader lines really need no arrow-heads at all.

FLOOR PLAN COORDINATION

The key to all coordination derived from floor plans is the use of direct, one-to-one layering of base sheets and overlays. CADD layered drafting, when managed and monitored correctly, guarantees 100% coordination among all consultants on the job.

Specific coordination checks are referenced throughout the floor plan checklists.

ITEMS SUITED TO SYSTEMATIC PRODUCTION METHODS

Floor plans for working drawings can be recycled directly from the floor plans created during design development. When making the original floor plans, avoid showing data other than just plain bare linework. Do all rendering, alternate schemes, furniture, notes, and dimensions on overlays or separate CADD layers. That keeps the original plan clean and clear, ready for later direct reuse in working drawings. (Some firms are always 20% finished with working drawings the day they start them by using this method.)

FLOOR PLANS & INTERIOR ELEVATIONS
GENERAL REFERENCE DATA

√ Dbl√

__ __ DRAWING TITLES AND SCALE

__ __ ARROWS SHOWING COMPASS NORTH AND REFERENCE
NORTH

__ __ MODULAR GRID OR STRUCTURAL COLUMN GRID WITH
NUMBER AND LETTER COORDINATES

__ __ SQUARE FOOTAGE TOTALS:
__ building
__ auxiliary structures
__ decks and balconies
__ rooms (name or number)
__ exterior areas

__ __ KEY PLAN

__ __ INTERIOR ELEVATION ARROW SYMBOLS AND
REFERENCE NUMBERS

__ __ EXTERIOR ELEVATION ARROW SYMBOLS AND
REFERENCE NUMBERS

__ __ OVERALL CROSS SECTION LINES AND KEYS

__ __ MATCH UP LINE, OVERLAP LINE, AND REFERENCE IF
FLOOR PLAN IS CONTINUED ON ANOTHER SHEET

__ __ SPACE FOR ITEMS N.I.C.

__ __ NOTE ON N.I.C. ITEMS TO BE INSTALLED, CONNECTED
BY CONTRACTOR

__ __ OUTLINE OF FUTURE BUILDING ADDITIONS

__ __ REMODELING
__ existing work to remain as is
__ existing work to relocate
__ existing work to be removed
__ existing work to be repaired or altered

__ __ GENERAL NOTES

__ __ BUILDING CODE/FIRE CODE REFERENCES

__ __ MATERIALS HATCHING

__ __ DETAIL KEYS

__ __ DRAWING CROSS REFERENCES

__ __ SPECIFICATION REFERENCES

FLOOR PLANS & INTERIOR ELEVATIONS
GENERAL REFERENCE DATA continued

BUILDING AREA SUMMARY

UNIT # BLDG #	BASEMENT FINISHED	1ST FLOOR FINISHED	2ND FLOOR FINISHED	TOTAL FINISHED	GARAGE	DECKS	BUILDING AREA AT FNDATION
1	20	584	599	1203	544	48	
2	20	584	599	1203	544	48	
BLDG 1	40	1168	1198	2406	1088	96	1127
3	20	584	599	1203	544	48	
4	20	584	599	1203	544	48	
BLDG 2	40	1168	1198	2406	1088	96	1127
5		1161		1161	300		
6		10	1172	1182	256		
BLDG 3		1178	1172	2343	556		1717
7	20	584	599	1203	544	48	
8	20	584	599	1203	544	48	
9	20	584	599	1203	544	48	
10	20	584	599	1203	544	48	
11	20	584	599	1203	544	48	
12	20	584	599	1203	544	48	
BLDG 4	120	3504	3594	7218	3264	288	3364
PROJECT TOTALS:	200	7018	7162	14371	5996	480	7335

FLOOR PLANS & INTERIOR ELEVATIONS
GENERAL REFERENCE DATA continued

UBC OCCUPANCY GROUP
R-1 (MULTIFAMILY) AND R-3 (DWELLINGS)

FIRE SPRINKLERS
BUILDING 4 ONLY

PARKING SPACES:

REQUIRED	2 PER UNIT = 2 X 12 = 24
PROVIDED	22 GARAGES + 2 OPEN = 24
HANDICAPPED	1 GARAGE + 1 OPEN = 2
	(INCLUDED IN TOTAL ABOVE)

NR. OF DWELLING UNITS
12

TYPE OF CONSTRUCTION:
V-N

CODE COMPLIANCE:
UBC - UNIFORM BUILDING CODE, 1994 EDITION
UPC - UNIFORM PLUMBING CODE, 1991 EDITION
UMC - UNIFORM MECHANICAL CODE, 1994 EDITION
UFC - UNIFORM FIRE CODE, 1994 EDITION
WEC - WASHINGTON STATE ENERGY CODE, 1994 EDITION
WASHINGTON STATE VENTILATION & AIR QUALITY CODE, 1994
WASHINGTON STATE BARRIER FREE CODE, WAC 51-30

DESIGN LOADS:
WIND EXPOSURE B
SEISMIC ZONE 3
ROOF LOADS

LIVE	25 LB/S.F. (SNOW)
DEAD	15 LB/S.F.

FLOOR LOADS

LIVE	40 LB/S.F.
DEAD	10 LB/S.F.

(SEE ALSO STRUCTURAL GENERAL NOTES, SHEET S-1,
AND ARCHITECTURAL GENERAL NOTES, SHEET A-1.1)

NOTES

FLOOR PLANS & INTERIOR ELEVATIONS
WALLS -- DRAWING COMPONENTS
INTERIOR ELEVATION COMPONENTS ARE IDENTIFIED FROM THE FLOOR
PLAN CHECKLIST

√ Dbl√

__ __ OUTLINE AND NOTED HEIGHTS
 __ low partitions
 __ screens
 __ prefab storage walls dividers
 __ planter walls
 __ door and window openings

__ __ OUTLINE OF CONSTRUCTED VENEERS
 __ paneling
 __ dados
 __ wainscots

__ __ BROKEN-LINE OUTLINES
 __ overhangs
 __ canopies
 __ overhead balconies
 __ coves
 __ valences
 __ other projections
 __ wall lines at framed openings
 __ thru-ceiling or upper floor openings
 __ hatchways, access panels or scuttles

WALLS -- DESIGN CONSIDERATIONS AND SPECIAL
COMPONENTS

√ Dbl√

__ __ PROTECTIVE RAILS, BUMPERS, OR CORNER GUARDS AT
 WALLS, GLAZING, COLUMNS, OR DOOR JAMBS SUBJECT
 TO DAMAGE

__ __ ANCHORS OR FRAMING CONNECTION FOR ALL WALL-
 MOUNTED FIXTURES AND EQUIPMENT

__ __ WATERPROOFING AND CAULKING AT ALL WALLS AND
 OPENINGS EXPOSED TO MOISTURE

__ __ THERMAL INSULATION AT ALL EXTERIOR WALLS

__ __ WEATHER STRIPPING AT ALL OPENINGS EXPOSED TO
 WEATHER

__ __ EXTERIOR WALL OPENINGS
 __ sill __ opening sizes __ detail keys __ notes/refs
 coord check: __ struct frame/lintels __ ext elev

FLOOR PLANS & INTERIOR ELEVATIONS
WALLS -- DRAWING COMPONENTS continued

PARTITION LEGEND

8" CMU WITH BRICK,
2-HOUR CONSTRUCTION

3 5/8" MTL. STUDS WITH 5/8"
TYPE X GWB AND BRICK

6" MTL. STUDS WITH 5/8" TYPE
X GWB AND BRICK

3 5/8" MTL. STUDS WITH 5/8"
TYPE X GWB, 1-HOUR CONST.
UL # U465

6" MTL. STUDS WITH 5/8" TYPE
X GWB, 1-HOUR CONST.

3 5/8" MTL. STUDS WITH 5/8"
GWB

6" GLAZED CMU

8" CMU, 2-HOUR CONST. UL #
U911

EXISTING CONSTRUCTION TO
REMAIN

BRICK SCREEN WALL - TWO
WYTHES BRICK WITH 4" AIR
SPACE. SEE STRUCT.

FLOOR PLANS & INTERIOR ELEVATIONS
EXTERIOR WALL CONSTRUCTION

√ Dbl√

__ __ EXTERIOR WALLS

 __ ADOBE (04212)

 __ BRICK (04210)

 __ BRICK CAVITY WALL (04214)

 __ BRICK VENEER (04215)

 __ CONCRETE BLOCK, REINFORCED (04230)

 __ CONCRETE, CAST-IN-PLACE (03316)

 __ CONCRETE, PRECAST (03450)

 __ CONCRETE, PRECAST PANELS (03411)

 __ CONCRETE, TILT-UP (03430)

 __ GLAZED CURTAIN WALLS (08900)

 __ STONE (04400)

 __ CUT STONE (04420)

 __ FLAGSTONE (04440)

 __ MARBLE VENEER (04451)

 __ NATURAL STONE VENEER (04450)

 __ ROUGH STONE (04410)

 __ METAL SIDING (07411)

 __ WOOD FRAMING AND SHEATHING (06110)

 __ WOOD SIDING (07461)

 __ STUCCO (09230)

 __ _____

 __ _____

 __ materials __ dimensions __ detail keys __ notes/refs
 coord check: __ struct footings/frame __ roof drain
 __ ext elev __ ref clg

FLOOR PLANS & INTERIOR ELEVATIONS
COLUMN & POST CONSTRUCTION

√ Dbl√

__ __ COLUMNS AND POSTS

 __ REINFORCED BRICK (04216)

 __ CONCRETE (03317)

 __ REINFORCED CONCRETE BLOCK (04230)

 __ STEEL WF (05110)

 __ TUBULAR STEEL (05123)

 __ WOOD (06101/06102)

 __ _____

 __ _____

 __ materials __ dimensions __ detail keys __ notes/refs
 coord check: __ struct footings/frame __ roof drain
 __ ext elev __ ref clg

__ __ FIREPROOFING AT COLUMNS AND POSTS (07250)
 __ materials __ locations __ detail keys __ notes/refs
 coord check: __ code __ int elev __ fin sched

__ __ COLUMN AND POST CORNER GUARDS (10260)
 __ materials __ locations __ detail keys __ notes/refs
 coord check: __ wall anchor __ int elev

NOTES Date/Initials

FLOOR PLANS & INTERIOR ELEVATIONS
COLUMN & POST CONSTRUCTION continued

1 REINFORCING SCHEDULE
(BEARING/SHEAR WALL THE SAME)

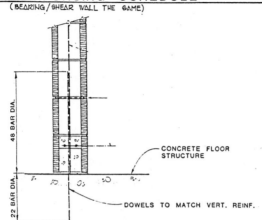

48 BAR DIA.

22 BAR DIA.

CONCRETE FLOOR
STRUCTURE

DOWELS TO MATCH VERT. REINF.

17 TYPICAL ANCHORAGE DETAIL
AT BOTTOM OF C.M.U. WALL
BEARING/SHEAR WALL

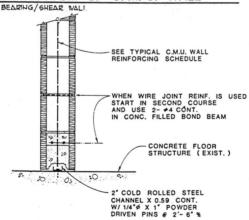

SEE TYPICAL C.M.U. WALL
REINFORCING SCHEDULE

WHEN WIRE JOINT REINF. IS USED
START IN SECOND COURSE
AND USE 2- #4 CONT.
IN CONC. FILLED BOND BEAM

CONCRETE FLOOR
STRUCTURE (EXIST.)

2" COLD ROLLED STEEL
CHANNEL X 0.59 CONT.
W/ 1/4"∅ X 1" POWDER
DRIVEN PINS @ 2'- 6" %

FLOOR PLANS & INTERIOR ELEVATIONS
INTERIOR BEARING WALL CONSTRUCTION

√ Dbl√

__ __ INTERIOR BEARING WALLS

 __ BRICK (04210)

 __ CONCRETE BLOCK (04220)

 __ CONCRETE, CAST-IN-PLACE (03316)

 __ CONCRETE, PRECAST PANELS (03411)

 __ STONE (04400)

 __ WOOD FRAMING AND SHEATHING (06110)

 __ _____

 __ _____

 __ materials __ dimensions __ detail keys __ notes/refs
 coord check: __ struct footings/frame __ int elev __ ref clg
 __ roof drain __ fin sched

__ __ FIREPROOFING (07250)
 __ materials __ dimensions __ detail keys __ notes/refs
 coord check: __ code __ int elev __ fin sched

__ __ CORNER GUARDS (10260)
 __ materials __ locations __ detail keys __ notes/refs
 coord check: __ wall anchor __ int elev

NOTES Date/Initials

FLOOR PLANS & INTERIOR ELEVATIONS
INTERIOR PARTITION CONSTRUCTION

√ Dbl√

__ __ INTERIOR PARTITIONS
 __ BRICK VENEER (04215)
 __ CONCRETE BLOCK (04220)
 __ GLASS UNIT MASONRY (04270)
 __ STONE (04400)
 __ CUT STONE (04420)
 __ MARBLE VENEER (04451)
 __ NATURAL STONE VENEER (04450)
 __ WOOD FRAMING AND SHEATHING (06110)
 __ WIRE MESH PARTITIONS (10601)
 __ WOOD PANELING (06420)
 __ GYPSUM LATH AND PLASTER (09202)
 __ METAL LATH AND PLASTER (09203)
 __ GYPSUM WALLBOARD (09250)
 __ _____

 __ materials __ dimensions __ detail keys __ notes/refs
 coord check: __ floor anch __ ref clg __ int elev
 __ fin sched __ elec

__ __ GLAZED WALLS
 (Fixed glass provided with removable stops on one side.
 For other components and assemblies, see Windows.)
 __ OBSCURE GLASS/ROUGH AND FIGURED (08815)
 __ WIRE GLASS (08814)
 __ PLASTIC (08840)
 __ LAMINATED SAFETY GLASS (08822)
 __ INSULATED GLASS (08823)
 __ STAINED GLASS (12170)
 __ TEMPERED GLASS (08813)
 __ MIRROR GLASS (08830)
 __ TWO WAY SURVEILLANCE MIRRORS (08835)
 __ _____

 __ materials __ dimensions __ detail keys __ notes/refs
 coord check: __ int elev __ ref clg __ frame sched
 __ fin sched

__ __ MOVABLE WALLS (10600)
 __ materials __ dimensions __ detail keys __ notes/refs
 coord check: __ struct frame __ int elev __ ref clg
 __ fin sched

__ __ DEMOUNTABLE PARTITIONS (10610)
 __ materials __ dimensions __ detail keys __ notes/refs
 coord check: __ struct frame __ int elev __ ref clg
 __ fin sched

__ __ FOLDING PARTITIONS (10620)
 __ materials __ dimensions __ detail keys __ notes/refs
 coord check: __ struct frame __ int elev __ ref clg
 __ fin sched

NOTES

FLOOR PLANS & INTERIOR ELEVATIONS
SPECIAL WALL CONSTRUCTION -- FURRING, CHASES, ETC.

√ Dbl√

__ __ FURRED WALLS
 __ materials __ dimensions __ detail keys __ notes/refs
 coord check: __ struct __ int/ext elev __ ref clg __ plumb
 __ hvac __ elec

__ __ ELECTRIC CLOSETS AND PANELBOARDS (16160)
 __ dimensions __ detail keys __ notes/refs
 coord check: __ elec __ plumb/mech chases __ int elev

__ __ ELECTRICAL CHASES
 __ dimensions __ detail keys __ notes/refs
 coord check: __ elec __ struct frame __ plumb __ hvac

__ __ TELEPHONE SWITCHING CLOSETS AND PANELBOARDS
(16740)
 __ dimensions __ detail keys __ notes/refs
 coord check: __ elec __ elec/mech chases __ int elev

__ __ TELEPHONE WIRING CHASES
 __ dimensions __ detail keys __ notes/refs
 coord check: __ struct frame __ plumb __ hvac __ elec

__ __ VERTICAL CHUTES IN WALLS
 __ materials __ dimensions __ detail keys __ notes/refs
 coord check: __ struct frame __ hvac __ elec chases
 __ int elev __ cross sect __ roof

__ __ PNEUMATIC TUBES (14581)
 __ locations __ detail keys __ notes/refs
 coord check: __ struct frame __ plumb chases __ hvac
 __ elec

__ __ THRU-WALL SLEEVES
 __ materials __ dimensions __ detail keys __ notes/refs
 coord check: __ struct frame __ int/ext elev __ plumb
 __ hvac __ elec

__ __ VENT CHASES
 __ dimensions __ detail keys __ notes/refs
 coord check: __ struct frame __ ref clg __ roof
 __ cross sect __ plumb __ hvac __ elec chases

__ __ PLUMBING CHASES
 __ dimensions __ detail keys __ notes/refs
 coord check: __ plumb __ struct frame __ ref clg __ roof
 __ cross sect __ hvac __ elec chases

__ __ PLUMBING CLEANOUT ACCESS COVERS (15423)
 __ locations __ detail keys __ notes/refs
 coord check: __ plumb __ wall anch __ int elev

FLOOR PLANS & INTERIOR ELEVATIONS
SPECIAL WALL CONSTRUCTION -- FURRING, CHASES, ETC.
continued

√ Dbl√

__ __ PLUMBING CHASE ACCESS DOORS (08305/10222)
 __ materials __ dimensions __ detail keys __ notes/refs
 coord check: __ plumb __ int elev __ door sched

__ __ ACCESS PANELS (08305/10222)
 __ materials __ dimensions __ detail keys __ notes/refs
 coord check: __ wall anch __ int/ext elev

__ __ GRILLES (10240)
 __ materials __ dimensions __ detail keys __ notes/refs
 coord check: __ wall anch __ int/ext elev

__ __ IN-WALL ROOF DRAINS (15406)
 __ materials __ dimensions __ detail keys __ notes/refs
 coord check: __ plumb __ struct frame __ roof __ cross sect

__ __ HEAVY FLOOR OR WALL-MOUNTED EQUIPMENT THAT
MAY REQUIRE SPECIAL STRUCTURAL SUPPORT
 __ materials __ dimensions __ detail keys __ notes/refs
 coord check: __ struct frame __ slab floor __ wall anch
 __ int elev

__ __ WALL SAFES (11028)
 __ materials __ dimensions __ detail keys __ notes/refs
 coord check: __ wall frame __ elec/alarm __ int elev

__ __ VAULTS (13140)
 __ materials __ dimensions __ detail keys __ notes/refs
 coord check: __ wall/floor frame __ elec/alarm __ int elev

NOTES

FLOOR PLANS & INTERIOR ELEVATIONS
ACOUSTICAL TREATMENT & NOISE CONTROL

√ Dbl√

__ __ NOISE BARRIER CONSTRUCTION WHERE CONVECTORS
PASS THROUGH PARTITIONS (13080)
__ materials __ dimensions __ detail keys __ notes/refs
coord check: __ hvac

__ __ VIBRATION AND NOISE CONTROL AT WALL-MOUNTED
TVS, INTERCOMS, FANS, AND OTHER MOVING OR NOISE
MAKING EQUIPMENT (13080)
__ materials __ dimensions __ detail keys __ notes/refs
coord check: __ wall anch __ elec __ hvac

__ __ VIBRATION AND NOISE CONTROL AT MECHANICAL
EQUIPMENT (15200)
__ materials __ dimensions __ detail keys __ notes/refs
coord check: __ hvac

__ __ SOUND ISOLATION WALLS (13080/09530)
__ materials __ dimensions __ detail keys __ notes/refs
coord check: __ ref clg

__ __ ACOUSTICAL PLASTER (09520)
__ dimensions __ detail keys __ notes/refs
coord check: __ int elev __ fin sched

__ __ ACOUSTICAL WALL PANELS (09511)
__ materials __ dimensions __ detail keys __ notes/refs
coord check: __ wall anch __ int elev __ fin sched

__ __ ACOUSTICAL WALL TILES (09512)
__ materials __ dimensions __ detail keys __ notes/refs
coord check: __ int elev __ fin sched

__ __ ACOUSTICAL INSULATION (09530)
__ materials __ dimensions __ detail keys __ notes/refs
coord check: __ int elev __ ref clg __ wall sect __ fin sched

NOTES

Date/Initials

FLOOR PLANS & INTERIOR ELEVATIONS
WATERPROOFING, SHIELDING, & INSULATION

√ Dbl√

__ __ WALLS WITH MEMBRANE WATERPROOFING (07110)
 __ waterproof barriers behind drinking fountains and sinks
 __ materials __ dimensions __ detail keys __ notes/refs
 coord check: __ floor __ wall sect __ plumb

__ __ ELECTROMAGNETIC SHIELDING (16650)
 __ materials __ dimensions __ detail keys __ notes/refs
 coord check: __ floor/clg __ wall sect __ elec

__ __ RADIATION SHIELDING (13090)
 __ materials __ dimensions __ detail keys __ notes/refs
 coord check: __ struct/frame __ floor/clg __ wall sect
 __ elec

__ __ BATT THERMAL INSULATION (07213)
 __ dimensions __ detail keys __ notes/refs
 coord check: __ wall sect __ clg/roof __ hvac

__ __ RIGID INSULATION (07212)
 __ dimensions __ detail keys __ notes/refs
 coord check: __ wall sect __ clg/roof __ hvac

__ __ GRANULAR INSULATION (07216)
 __ dimensions __ detail keys __ notes/refs
 coord check: __ wall sect __ hvac

NOTES

FLOOR PLANS & INTERIOR ELEVATIONS
WALL-MOUNTED ITEMS

√ Dbl√

__ __ WALL-MOUNTED ACCESSORIES AND FIXTURES

 __ MIRRORS (08830/10810)

 __ PEGBOARDS (06423)

 __ CHALKBOARDS (10110)

 __ TACKBOARDS (10120)

 __ PICTURE RAILS (05509/06445)

 __ MAP RAILS (05509/06646)

 __ PROJECTION SCREENS (11131)

 __ HOOKS/HANGERS (05507/05508)

 __ SIGNS (10440)

 __ _____

 __ _____

 __ locations/heights __ detail keys __ notes/refs
 coord check: __ int elev __ wall frame/anch

__ __ FIRE EXTINGUISHER CABINETS (15532)
 __ locations/heights __ detail keys __ notes/refs
 coord check: __ code __ plumb __ wall anch __ int elev

__ __ FIRE HOSE CABINETS (15532)
 __ locations/heights __ detail keys __ notes/refs
 coord check: __ code __ plumb __ wall anch __ int elev

__ __ DRINKING FOUNTAINS (15461)
 __ water protection at wall behind drinking fountain
 __ locations/heights __ detail keys __ notes/refs
 coord check: __ plumb __ wall anch __ int elev

FLOOR PLANS & INTERIOR ELEVATIONS
WALL-MOUNTED ITEMS continued

MISC EQUIP SCHED

1. TACKBOARD (NIC) - PROVIDE BACKING PER UNL STANDARD.

2. CHALKBOARD (NIC) - PROVIDE BACKING PER UNL STANDARD.

3. PROVIDE PLAM WITH METAL TRIM 3'-0" H x 3'-0" W (2) WALLS..
 PROVIDE BACKING FOR FUTURE MOP STRIP AT 4'-6" AFF.

4. FEMININE NAPKIN VENDOR
 BOBRICK NO. B-282.

5. FEMININE NAPKIN DISPOSAL
 BOBRICK NO. B-270

6. TOILET PAPER DISPENSER
 FORT HOWARD NO. 571-98

7. TOILET STALL GRAB BAR (HC)
 BOBRICK NO. B-62061X48
 MOUNT 33" AFF.

8. 16"x30" MIRROR (HC)
 BOBRICK NO. B-294-1630
 MOUNT 40" AFF. TO BOT.

9. 18"x24" MIRROR
 BOBRICK NO. B-290-1824
 MOUNT 44" AFF. TO BOT.

10. PAPER TOWEL DISPENSER
 FORT HOWARD NO. 514-10
 MOUNT 48" AFF. TO BOT.

11. SOAP DISPENSER
 AMERICAN DISPENSER CO.
 NO. 82 "LATHURSHELF"
 MOUNT 40" AFF.

12. 18" TOWEL BAR
 BOBRICK NO. B-6737X18

13. SHOWER GRAB BAR (HC)
 BOBRICK NO. B-6265
 MOUNT 36" AFF.

14. SHOWER SEAT (HC)
 BOBRICK NO. B-506 OR B-507
 MOUNT 19" AFF.

15. SHOWER CURTAIN ROD
 BOBRICK NO. B-204
 CURTAIN: 8 GA VINYL WITH RUSTPROOF GROMMETS
 AT 6" O/C AND HEMMED EDGES.
 MOUNT ROD 7'-0" AFF.

16. SOAP HOLDER
 CERAMIC TILE THIN SET HOLDER
 MOUNT 3'-6" AFF.

17. 30" x 24" MIRROR
 BOBRICK NO. B-290-3024
 MOUNT 44" AFF. TO BOT.

18. TOILET PARTITIONS

19. MOUNT EXG. BRONZE PLAQUE WITH (4) - EXP. BOLTS.
 USE BRONZE BOLTS TO MATCH EXG. OBTAIN PLAQUE
 FROM U.N.L. INVENTORY DEPT.

FLOOR PLANS & INTERIOR ELEVATIONS
WALL-MOUNTED ITEMS -- ELECTRICAL

√ Dbl√

__ __ WALL-MOUNTED ELECTRICAL AND COMMUNICATIONS
 FIXTURES

 __ CLOCKS (16730)

 __ LAMPS (16501)

 __ BURGLAR DETECTORS (16720)

 __ BURGLAR ALARMS (16727)

 __ SPEAKERS (16770)

 __ ANNUNCIATORS (16770)

 __ THERMOSTATS (15931)

 __ CLOSED CIRCUIT TV MONITORS (16780)

 __ SURVEILLANCE TV CAMERAS (16780)

 __ _____

 __ _____

 __ locations/heights __ detail keys __ notes/refs
 coord check: __ elec __ int elev __ wall anch

__ __ WALL-MOUNTED FIRE ALARMS

 __ SMOKE DETECTORS (16725)

 __ FIRE DETECTORS (16721)

 __ FIRE ALARMS (16721)

 __ _____

 __ _____

 __ locations/heights __ detail keys __ notes/refs
 coord check: __ code __ elec __ int elev __ wall anch

__ __ FIRE EXIT SIGNS (10455)
 __ locations/heights __ detail keys __ notes/refs
 coord check: __ code __ elec __ int elev __ wall anch

FLOOR PLANS & INTERIOR ELEVATIONS
HVAC EQUIPMENT & FIXTURES AT WALLS

√ Dbl√

__ __ METAL HEATING-COOLING UNIT ENCLOSURES (05551)
__ dimensions __ detail keys __ notes/refs
coord check: __ hvac __ plumb __ elec __ int elev

__ __ UNIT VENTILATORS (15762/16850)
__ locations __ detail keys __ notes/refs
coord check: __ hvac __ elec __ ref clg __ int elev

__ __ UNIT HEATERS (15700/16850)
__ locations __ detail keys __ notes/refs
coord check: __ hvac __ elec __ int elev

__ __ CONVECTORS AND ENCLOSURES (15700/16850)
__ locations __ detail keys __ notes/refs
coord check: __ hvac __ plumb __ elec __ int elev

__ __ REGISTERS (15800)
__ locations __ detail keys __ notes/refs
coord check: __ hvac __ wall anch __ int elev

__ __ DIFFUSERS (15871)
__ locations __ detail keys __ notes/refs
coord check: __ hvac __ wall anch __ int elev

NOTES Date/Initials

FLOOR PLANS & INTERIOR ELEVATIONS
SHELVING, CABINETS, & COUNTERTOPS

√ Dbl√

__ __ WALL-MOUNTED SHELVES
 __ WOOD SHELVING (06412)
 __ METAL STORAGE SHELVING (10671)
 __ WIRE SHELVING (10673)
 __ materials __ dimensions __ detail keys __ notes/refs
 coord check: __ wall anch __ furn __ int elev

__ __ WALL-MOUNTED CABINETS
 __ WOOD CABINETS (06410)
 __ WOOD CASEWORK (12302)
 __ METAL CASEWORK (12301)
 __ materials __ dimensions __ detail keys __ notes/refs
 coord check: __ wall anch __ furn .__ int elev
 __ ref clg/soffit __ elec

__ __ WALL-MOUNTED WOOD SHELF COUNTERTOPS (06412)
 __ materials __ dimensions __ detail keys __ notes/refs
 coord check: __ wall anch __ furn __ int elev __ elec

__ __ WOOD BASE CABINET COUNTERTOPS (16414)
 __ materials __ dimensions __ detail keys __ notes/refs
 coord check: __ wall anch __ furn __ int elev __ elec

__ __ TILE COUNTERTOPS (09318)
 __ materials __ dimensions __ detail keys __ notes/refs
 coord check: __ wall anch __ furn __ int elev __ elec

__ __ METAL COUNTERTOPS (11400/12300)
 __ materials __ dimensions __ detail keys __ notes/refs
 coord check: __ wall anch __ furn __ int elev __ elec

__ __ STONE COUNTERTOPS (04400)
 __ materials __ dimensions __ detail keys __ notes/refs
 coord check: __ wall anch __ furn __ int elev __ elec

__ __ PLASTIC FINISH COUNTERTOPS (06240)
 __ materials __ dimensions __ detail keys __ notes/refs
 coord check: __ wall anch __ furn __ int elev __ elec

__ __ UNIT KITCHEN CABINETS (11460)
 __ materials __ dimensions __ detail keys __ notes/refs
 coord check: __ wall anch __ furn __ int elev __ plumb
 __ vent __ elec

__ __ WORKBENCHES
 __ WOOD (06453)
 __ INDUSTRIAL (11511)
 __ materials __ dimensions __ detail keys __ notes/refs
 coord check: __ wall anch __ furn __ int elev __ plumb
 __ vent __ elec

FLOOR PLANS & INTERIOR ELEVATIONS
SHELVING, CABINETS, & COUNTERTOPS continued

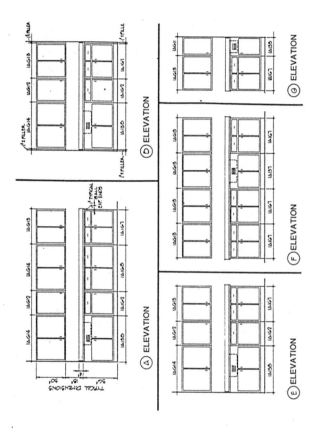

NOTES

FLOOR PLANS & INTERIOR ELEVATIONS
SHELVING, CABINETS, & COUNTERTOPS continued

√ Dbl√

__ __ LOCKERS (10500)
 __ soffit
 __ locker base or pedestal
 __ materials __ dimensions __ detail keys __ notes/refs
 coord check: __ wall anch __ slab/floor __ int elev
 __ ref clg/soffit

WALL-MOUNTED ART AND PLAQUES

√ Dbl√

__ __ WALL-MOUNTED MURALS (12110)
 __ materials __ dimensions __ detail keys __ notes/refs
 coord check: __ wall anch __ int/ext elev

__ __ BAS-RELIEF (12150)
 __ materials __ dimensions __ detail keys __ notes/refs
 coord check: __ wall anch __ int/ext elev

__ __ SCULPTURE/STATUARY (12140)
 __ materials __ dimensions __ detail keys __ notes/refs
 coord check: __ struct frame slab __ wall anch
 __ int/ext elev

__ __ CORNERSTONE PLAQUE (10420)
 __ location __ detail keys __ notes/refs
 coord check: __ wall anch __ ext elev

__ __ ARCHITECT'S PLAQUE (10420)
 __ location __ detail keys __ notes/refs
 coord check: __ wall anch __ ext elev

FLOOR PLANS & INTERIOR ELEVATIONS
DIMENSIONING

√ Dbl√

__ __ GENERAL NOTES ABOUT THE DIMENSIONING SYSTEM
 __ modular dimensioning practice and conventions
 __ whether dimensions are to finish surfaces, to rough
 surfaces, or to framing
 __ special arrowhead indications if using coded dimensioning

__ __ LEGEND OF DIMENSION NOTES
 __ n.t.s. __ "varies" __ + / - __ "eq" __"typ"

__ __ FINISH GRADE ELEVATION POINTS AT CORNERS AND
 PERIMETER OF BUILDING

__ __ OVERALL EXTERIOR WALL LENGTHS

__ __ OFFSETS

__ __ PROJECTIONS

__ __ RECESSES

__ __ SIZES OF REMOVABLE EXTERIOR WALL PANELS

__ __ EXTERIOR OPENINGS
 (Openings that clearly center on bays or are adjacent to columns
 often don't require dimensioning; door and window sizes may be
 covered in Schedules.)

__ __ INTERIOR WALL AND PARTITION LENGTHS

__ __ DISTANCES BETWEEN INTERIOR WALLS OR PARTITIONS
 IN DIMENSION STRINGS ACROSS THE LENGTH AND
 WIDTH OF BUILDING (Dimension strings are located so as not
 to conflict with other essential notes, such as room names or
 numbers. Parallel strings of dimensions on interior plans are not
 considered desirable.)

__ __ COLUMN, POST, AND MULLION CENTER-LINE DIMENSIONS

__ __ CUMULATIVE DIMENSION NOTES AT COLUMN LINES

__ __ DIMENSIONS OF OVERHANGS AND OVERHEAD
 PROJECTIONS

__ __ THICKNESSES OF EXTERIOR WALLS AND INTERIOR
 PARTITIONS
 (Interior partitions are often dimensioned to center lines.)

FLOOR PLANS & INTERIOR ELEVATIONS
DIMENSIONING continued

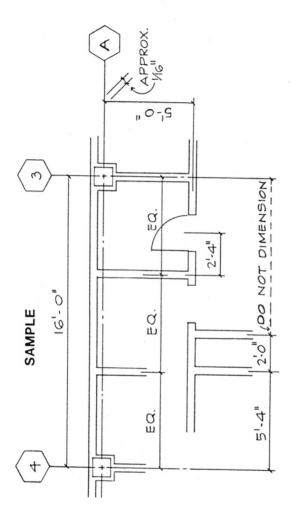

SAMPLE

FLOOR PLANS & INTERIOR ELEVATIONS
DIMENSIONING continued

√ Dbl√

__ __ DIMENSIONS OR DIMENSION NOTES
　　　　　__ chases
　　　　　__ furred walls
　　　　　__ shafts
　　　　　__ future shafts
　　　　　__ small thru-wall openings length and height
　　　　　__ built-ins, sizes and dimensions to finished surfaces

__ __ HEIGHT OR ELEVATION NOTES
　　　　　__ grades
　　　　　__ rough flooring
　　　　　__ rails
　　　　　__ height of sills of openings above floor
　　　　　__ countertops
　　　　　__ built-ins
　　　　　__ fixtures
　　　　　__ low partitions

__ __ SPACINGS OF PLUMBING FIXTURES

__ __ RADII OF ARCS WITH REFERENCE DIMENSIONS TO
　　　　LOCATE CENTERS OF ARCS OR CIRCLES

__ __ ANGLES IN DEGREES OF NON-RIGHT ANGLE WALLS AND
　　　　BUILT-INS (In lieu of degree measurements, ends of angled unit
　　　　or wall may be dimensioned from reference line or wall.)

__ __ CENTER LINES OF SYMMETRICAL PLANS WITH NOTE
　　　　THAT DIMENSIONS ARE TYPICAL FOR AREAS ON BOTH
　　　　SIDES OF THE CENTER LINE

NOTES

Date/Initials

FLOOR PLANS & INTERIOR ELEVATIONS
WINDOWS -- DESIGN CONSIDERATIONS AND DRAWING
COMPONENTS

√ Dbl√

__ __ WINDOW OPENINGS DESIGNED AND LOCATED TO
 AVOID CONFLICT OF TRIM, MOLDING, SILLS, OR STOOLS
 WITH ADJACENT WALLS, WINDOWS, OR DOORS

__ __ SPANDREL GLASS INTEGRATED WITH FENESTRATION

__ __ GLASS LINES

__ __ SILL AND STOOL LINES

__ __ METAL FRAME SCHEDULE

__ __ OPERABLE DIRECTIONS
 __ horizontal sliding windows
 __ swings for vertical casements
 __ pivot windows
 __ awning windows

__ __ WINDOW SYMBOLS KEYED TO WINDOW SCHEDULE

__ __ GLAZING TYPES
 __ PLATE/FLOAT (08811)
 __ DOUBLE GLAZING (08802)
 __ SPANDREL GLASS (08817)
 __ OBSCURE GLASS/ROUGH AND FIGURED (08815)
 __ WIRE GLASS (08814)
 __ PLASTIC (08620)
 __ PLASTIC INSULATION (08845)
 __ LAMINATED SAFETY GLASS (08822)
 __ INSULATED GLASS (08802/08823)
 __ STAINED GLASS (12170)
 __ TEMPERED GLASS (08813)

NOTES Date/Initials

FLOOR PLANS & INTERIOR ELEVATIONS
WINDOWS -- DESIGN CONSIDERATIONS AND DRAWING
COMPONENTS continued

√ Dbl√

__ __ WINDOW TYPES
 __ GLAZED CURTAIN WALLS (08900)
 __ STEEL WINDOWS (08510)
 __ AWNING (08511)
 __ CASEMENT (08512)
 __ JALOUSIE (08514)
 __ PIVOTED (08515)

 __ ALUMINUM WINDOWS (08520)
 __ AWNING (08521)
 __ CASEMENT (08522)
 __ DOUBLE HUNG (08523)
 __ PIVOTED (08525)
 __ SLIDING (08527)

 __ WOOD WINDOWS (08610)
 __ AWNING (08611)
 __ CASEMENT (08612)
 __ DOUBLE HUNG (08613)
 __ PIVOTED (08615)
 __ SLIDING (08617)

 __ locations/sizes __ detail keys __ notes/refs
 coord check: __ ext elev __ window sched __ wall anch
 __ struct frame/lintels

__ __ INTEGRATED STOREFRONT SYSTEM (08400)
 __ materials __ dimensions __ detail keys __ notes/refs
 coord check: __ frame sched __ wall anch __ ext elev
 __ wall sect __ struct frame/lintels

__ __ WINDOW, STOREFRONT AND CURTAIN WALL MULLIONS
 __ materials __ dimensions __ detail keys __ notes/refs
 coord check: __ frame sched __ wall anch
 __ window sched __ ext elev __ wall sect
 __ struct frame/lintels

__ __ EXTERIOR SHUTTERS
 __ METAL (10240)
 __ WOOD (06235)
 __ materials __ dimensions __ detail keys __ notes/refs
 coord check: __ code __ wall anch __ ext elev

__ __ PROTECTIVE GRILLES AT WINDOWS ACCESSIBLE TO
PUBLIC WALKWAYS, EXTERIOR STAIRS, OR FIRE
ESCAPES (10240)
 __ fixed
 __ operable
 __ materials __ dimensions __ detail keys __ notes/refs
 coord check: __ code __ wall anch __ ext elev

FLOOR PLANS & INTERIOR ELEVATIONS
WINDOWS -- DESIGN CONSIDERATIONS AND DRAWING
COMPONENTS continued

√ Dbl√

__ __ WIRE MESH WINDOW GUARDS (10240)
 __ fixed __ operable
 __ materials __ dimensions __ detail keys __ notes/refs
 coord check: __ code __ wall anch __ ext elev

__ __ SECURITY WINDOWS (08651)
 __ materials __ dimensions __ detail keys __ notes/refs
 coord check: __ code __ wall anch __ ext elev

__ __ WINDOW BURGLAR ALARMS (16727)
 __ locations __ detail keys __ notes/refs
 coord check: __ wall anch __ elec

__ __ WINDOW CLEANER'S HOOKS (05507)
 __ locations __ detail keys __ notes/refs
 coord check: __ code __ wall anch __ roof

__ __ INTERIOR DRAPE, BLIND, OR WINDOW SHADE TRACKS
 (12500)
 __ materials __ dimensions __ detail keys __ notes/refs
 coord check: __ furn __ solar __ hardwr sched __ int elev
 __ hvac

__ __ INTERIOR SHUTTERS (12527)
 __ materials __ dimensions __ detail keys __ notes/refs
 coord check: __ code __ wall anch __ hardwr sched
 __ int elev

NOTES Date/Initials

FLOOR PLANS & INTERIOR ELEVATIONS
WINDOWS -- DESIGN CONSIDERATIONS AND DRAWING
COMPONENTS continued

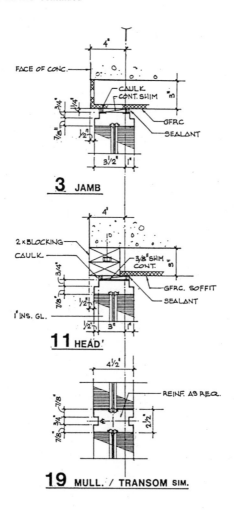

3 JAMB

11 HEAD

19 MULL. / TRANSOM SIM.

NOTES Date/Initials

FLOOR PLANS & INTERIOR ELEVATIONS
DOORS -- DESIGN CONSIDERATIONS

√ Dbl√

__ __ VARIETY OF DOOR SIZES KEPT TO MINIMUM TO
SIMPLIFY DOOR SCHEDULES AND CONSTRUCTION

__ __ DOORS AVOIDED AT HEAVY TRAFFIC AREAS UNLESS
ABSOLUTELY NECESSARY

__ __ REMOVABLE WINTER AIR LOCK STORM DOORS AT
ENTRY VESTIBULES

__ __ REMOVABLE AND LOCKABLE STILES FOR EXTERIOR
DOUBLE DOORS

__ __ STRIKE SIDE OF DOORS LOCATED GENEROUS DISTANCE
FROM POSTS, WING WALLS, WINDOW MULLIONS, OR
OTHER VULNERABLE CONSTRUCTION

__ __ DOOR JAMBS DESIGNED AND LOCATED TO AVOID
CONFLICT OF MOLDINGS OR TRIM THAT INTERSECT
ADJACENT WALLS, DOORS, OR WINDOWS

__ __ PROTECTIVE METAL JACKETS FOR DOOR OPENINGS
SUBJECT TO DAMAGE

__ __ DOOR OPENINGS LOCATED SO THAT DOORS AVOID
TANGLING WITH NEIGHBORING DOORS IN ADJACENT
WALLS

__ __ DOORS OPENING ON OPPOSITE SIDES OF COMMON
CORRIDOR STAGGERED WHERE VISUAL AND SOUND
PRIVACY IS IMPORTANT

__ __ DOORS OPENING TO TOILET ROOMS, DRESSING ROOMS,
OTHER PRIVATE AREAS, LOCATED AND HINGED TO
BLOCK DIRECT VIEW INTO ROOMS (Avoid doors and use
visual and acoustic screening instead of doors in heavily trafficked
areas.)

__ __ SOUNDPROOFING AND STRIPPING AT THRESHOLDS OF
NOISY ROOMS

__ __ WEATHER STRIPPING AT PLENUM SPACE ACCESS DOORS

FLOOR PLANS & INTERIOR ELEVATIONS
DOORS -- DRAWING COMPONENTS

√ Dbl√

__ __ DOOR OPENINGS
> __ door swing or sliding direction
> __ symbol key references to door schedule
> __ thresholds
> __ veneer notes

__ __ DIRECTION OF MOVEMENT
> __ side sliding
> __ split action/dutch door
> __ folding
> __ bi-fold
> __ pivoted
> __ double-acting
> __ vertical coil
> __ vertical slide
> __ center parting
>
> coord check: __ elec/switch __ hvac

__ __ DOOR MATERIALS/CONSTRUCTION
> __ STEEL (08110)
> __ CUSTOM STEEL (08112)
> __ PACKAGED STEEL (08115)
> __ ALUMINUM (08120)
> __ STAINLESS STEEL (08130)
> __ BRONZE (08140)
> __ FLUSH WOOD (08210)
> __ WOOD PANEL (08212)
> __ KALAMEIN (metal clad) (08320)
> __ PLASTIC FACED WOOD (08213)
> __ STEEL FACED WOOD (08214)
> __ PLASTIC (08220)
> __ WIRE MESH (10601)
>
> __ materials __ dimensions __ detail keys __ notes/refs
> coord check: __ ext elev __ int elev __ door sched
> __ frame sched __ hardwr sched

FLOOR PLANS & INTERIOR ELEVATIONS
DOORS

√ Dbl√

__ __ DOOR TYPES
 __ ACCORDION (08300)
 __ AIR DOORS (15800)
 __ AUTOMATIC (08425)
 __ BLAST RESISTANT (08315)
 __ COILING DOORS (08330/08332)
 __ COILING GRILLS (08340/08342)
 __ ELEVATOR (14200)
 __ FLEXIBLE (08355)
 __ FOLDING DOORS (08350)
 __ PANEL FOLDING (08351)
 __ METAL-CLAD (08320)
 __ OVERHEAD (08360)
 __ REVOLVING (08450)
 __ SECTIONAL OVERHEAD (08361/08363)
 __ SCREEN (08390)
 __ SECURITY (08316)
 __ SLIDING GLASS (08370)
 __ SOUND RETARDANT (08380)
 __ STOREFRONT ENTRY (08420)
 __ STORM (08391)
 __ opening sizes __ detail keys __ notes/refs
 coord check: __ ext elev __ int elev __ door sched
 __ frame sched __ hardwr sched __ elec/switch

__ __ FIRE-RATED DOORS (08100)
 __ automatic closing fire doors
 __ opening sizes __ detail keys __ notes/refs
 coord check: __ code __ int elev __ door sched
 __ frame sched __ hardwr sched __ elec/switch

NOTES

 Date/Initials

FLOOR PLANS & INTERIOR ELEVATIONS
DOORS continued

√ Dbl√

___ ___ SLIDING FIRE DOORS (08310)
 ___ opening sizes ___ detail keys ___ notes/refs
 coord check: ___ code ___ int elev ___ door sched
 ___ frame sched ___ hardwr sched ___ elec

___ ___ DOOR HEADERS OR LINTELS
 ___ materials sizes ___ sizes ___ detail keys ___ notes/refs
 coord check: ___ struct frame/lintel

___ ___ JAMBS, FRAMES, AND DOOR BUCKS
 (Usually referenced and detailed keyed in the door schedule
 or door frame schedule. May be referenced and keyed on
 floor plans for smaller buildings.)
 ___ STANDARD STEEL FRAMES (08111)
 ___ CUSTOM STEEL FRAMES (08113)
 ___ PACKAGED STEEL DOORS AND FRAMES (08115)
 ___ WOOD (06400)
 ___ ALUMINUM STORE FRONT ENTRANCES (08410)
 ___ _____

 ___ materials ___ sizes ___ detail keys ___ notes/refs
 coord check: ___ ext elev ___ int elev ___ door sched
 ___ frame sched ___ hardwr sched

___ ___ DOOR SADDLES OR SILLS (08740)
 ___ materials ___ detail keys ___ notes/refs
 coord check: ___ slab/floor anch ___ hardwr sched

___ ___ THRESHOLDS @ EXTERIOR DOORS (08740)
 ___ materials ___ dimensions ___ detail keys ___ notes/refs
 coord check: ___ slab/floor anch ___ hardwr sched

___ ___ ALARMS AT RESTRICTED EXIT DOORS (16728)
 ___ locations ___ notes/refs
 coord check: ___ code ___ door sched ___ elec

___ ___ WARNING SIGNS AT RESTRICTED EXIT DOORS (10440)
 ___ locations ___ notes/refs
 coord check: ___ code ___ int elev ___ door sched

___ ___ DOOR SIDE LIGHTS (08800)
 ___ detail keys ___ notes/refs
 coord check: ___ code ___ int elev ___ door sched

___ ___ FIXED MATCHING PANELS ABOVE WOOD FLUSH DOOR
 (06420)
 ___ materials ___ sizes ___ detail keys ___ notes/refs
 coord check: ___ int elev ___ ref clg ___ door sched
 ___ fin sched

FLOOR PLANS & INTERIOR ELEVATIONS
DOORS continued

√ Dbl√

__ __ INVISIBLE DOORS IN PANELING (06420)
 __ materials __ sizes __ detail keys __ notes/refs
 coord check: __ int elev __ door sched __ fin sched

__ __ FLOOR-MOUNTED TRACKS FOR FOLDING DOORS
(08745)
 __ materials __ sizes __ detail keys __ notes/refs
 coord check: __ slab/floor anch __ wall anch
 __ door sched __ hardwr sched

__ __ FLOOR-MOUNTED TRACKS SLIDING DOORS (08746)
 __ materials __ dimensions __ detail keys __ notes/refs
 coord check: __ slab/floor anch __ wall anch
 __ door sched __ hardwr sched

__ __ OVERHEAD TRACKS FOR FOLDING DOORS (08747)
 __ materials __ dimensions __ detail keys __ notes/refs
 coord check: __ struct __ ref clg __ door sched ΄
 __ hardwr sched

__ __ OVERHEAD TRACKS FOR SLIDING DOORS (08748)
 __ materials __ dimensions __ detail keys __ notes/refs
 coord check: __ struct __ ref clg __ door sched
 __ hardwr sched

__ __ SLIDING METAL FIRE DOORS (08310)
 (Type of door operation, single slide or center-parting,
inclined track or level track, manual or power-operated.)
 __ single slide __ center-parting __ inclined track/level
 __ manual operated __ power operated
 __ materials __ dimensions __ detail keys __ notes/refs
 coord check: __ code __ struct __ ref clg __ door sched
 __ elec

__ __ AUTOMATIC DOOR ACTIVATING EQUIPMENT (08425)
 __ location __ detail keys __ notes/refs
 coord check: __ slab/floor __ ref clg __ door sched
 __ elec

__ __ FLOOR CUTS FOR PIVOT HINGE DOORS
 __ detail keys __ notes/refs
 coord check: __ slab/floor __ door sched __ hardwr sched

__ __ SLIDING DOOR POCKETS
 __ dimensions __ detail keys __ notes/refs
 coord check: __ wall frame __ elec __ hvac
 __ door sched

FLOOR PLANS & INTERIOR ELEVATIONS
DOORS continued

√ Dbl√

__ __ DOOR HARDWARE AND ATTACHMENTS (08700)
(These are normally covered in Schedules and Specifications but
some of these items may be noted on floor plans of smaller
buildings.)

> __ panic bars
> __ locksets
> __ ventilation undercuts
> __ louvers
> __ kickplates
> __ "push-pull" plates
> __ view panels
> __ closers
> __ mirrors
> __ door-mounted signs
> __ operators
> __ name and number plates
> __ floor-mounted doorstops
> __ door roller bumpers where adjacent doors may clash
> __ weatherstripping
> __ light tight seals
>
> __ _____
> __ _____
> __ _____
>
> __ sizes __ detail keys __ notes/refs
> coord check: __ code __ int elev __ door sched
> __ fin sched __ hardwr sched __ vent

NOTES Date/Initials

FLOOR PLANS & INTERIOR ELEVATIONS
DOORS continued

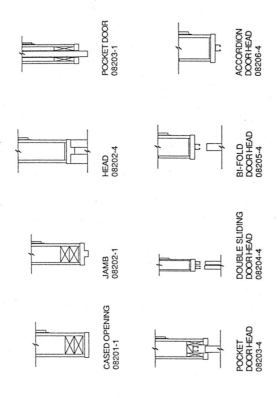

POCKET DOOR
08203-1

ACCORDION
DOOR HEAD
08206-4

HEAD
08202-4

BI-FOLD
DOOR HEAD
08205-4

JAMB
08202-1

DOUBLE SLIDING
DOOR HEAD
08204-4

CASED OPENING
08201-1

POCKET
DOOR HEAD
08203-4

FLOOR PLANS & INTERIOR ELEVATIONS
DOORS continued

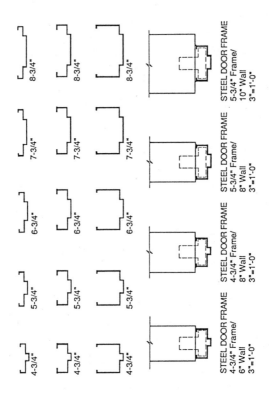

8-3/4" 8-3/4" 8-3/4"

7-3/4" 7-3/4" 7-3/4"

6-3/4" 6-3/4" 6-3/4"

5-3/4" 5-3/4" 5-3/4"

4-3/4" 4-3/4" 4-3/4"

STEEL DOOR FRAME
5-3/4" Frame/
10" Wall
3"=1'-0"

STEEL DOOR FRAME
5-3/4" Frame/
8" Wall
3"=1'-0"

STEEL DOOR FRAME
4-3/4" Frame/
8" Wall
3"=1'-0"

STEEL DOOR FRAME
4-3/4" Frame/
6" Wall
3"=1'-0"

NOTES Date/Initials

FLOOR PLANS & INTERIOR ELEVATIONS
FLOOR CONSTRUCTION

√ Dbl√

__ __ ROUGH/NONSKID FLOOR SURFACES AT ENTRY
LANDINGS, EXTERIOR STEPS AND ALL OTHER AREAS
EXPOSED TO MOISTURE

__ __ FINISH FLOOR MATERIAL INDICATION AND/OR NAME
(Sometimes noted by type under each room name or number and
described in detail in Finish Schedule and/or Specifications.)

__ __ DIVIDED LINES AND FLOOR HEIGHT NOTES AT
CHANGES IN FLOOR LEVEL (Note whether floor elevations
apply to slab, subfloor, or finish floor.)

__ __ FLOORING PATTERNS, OR PARTIAL PLAN OF FLOORING
PATTERNS

__ __ DIRECTION OF FLOORING SEAMS OR BREAKS

__ __ JOINT PATTERNS OF MASONRY, TILE, MARBLE, OR
TERRAZZO FLOORS

__ __ DATUM REFERENCES AT INTERIOR BALCONIES,
LANDINGS, AND MEZZANINES

__ __ RAILINGS AT FLOOR OPENINGS OR MAJOR CHANGES
IN LEVEL
__ METAL RAILINGS (05520)
__ ORNAMENTAL METAL RAILINGS (05720)
__ WOOD RAILINGS (06440)
__ materials __ dimensions __ detail keys __ notes/refs
coord check: __ code __ floor anch __ wall anch
__ struct slab __ int elev __ cross sect

__ __ STEPS
__ direction arrow
__ number or risers
__ handrail
__ materials __ dimensions __ detail keys __ notes/refs
coord check: __ code __ slab floor __ ext elev
__ int elev __ cross sect

__ __ RECESSED SUB FLOOR OR SLAB FOR TILE, MASONRY,
OR TERRAZZO (Slab heights set for alignment of different finish
floor materials.)
__ materials __ dimensions __ detail keys __ notes/refs
coord check: __ struct frame/slab __ cross sect __ fin sched

FLOOR PLANS & INTERIOR ELEVATIONS
FLOOR CONSTRUCTION continued

√ Dbl√

__ __ FLOOR TYPES
　　　　　__ BRICK (09620)
　　　　　__ CONCRETE SLAB (03308)
　　　　　__ FLAGSTONE (09614)
　　　　　__ GRANITE (09614)
　　　　　__ MARBLE (09613)
　　　　　__ RESILIENT (09650)
　　　　　__ SLATE (09612)

　　　　　__ TERRAZZO (09400)
　　　　　__ TERRAZZO, CONDUCTIVE (09430)
　　　　　__ TERRAZZO, PRECAST (09420)
　　　　　__ TERRAZZO TILE (09421)

　　　　　__ TILE (09300)
　　　　　__ TILE, CERAMIC (09310)
　　　　　__ TILE, CONDUCTIVE (09380)
　　　　　__ TILE, MARBLE (09340)
　　　　　__ TILE, QUARRY (09330)
　　　　　__ TILE, SLATE (09332)

　　　　　__ WOOD (09550)
　　　　　__ WOOD STRIP (09560)
　　　　　__ WOOD, GYMNASIUM (09561/09562)
　　　　　__ WOOD PARQUET (09570)
　　　　　__ WOOD, PLYWOOD BLOCK (09580)
　　　　　__ WOOD, RESILIENT (09590)
　　　　　__ WOOD BLOCK (09595)

　　　　　__ floor elevs __ detail keys __ notes/refs
　　　　　coord check: __ struct frame/slab __ fin sched

__ __ EXPANSION JOINTS, TOOLED JOINTS, CONSTRUCTION
　　　JOINTS, AND PERIMETER JOINTS IN CONCRETE SLABS
　　　(03251)
　　　　　__ materials __ dimensions __ detail keys __ notes/refs
　　　　　coord check: __ struct frame/slab

__ __ EXPANSION SPACE AT PERIMETER OF WOOD STRIP OR
　　　WOOD BLOCK FINISH FLOORING (09550)
　　　　　__ materials __ dimensions __ detail keys __ notes/refs
　　　　　coord check: __ fin sched/base

__ __ WOOD FLOOR PATTERN OR PATTERN DIRECTION (09550)
　　　　　(Note species if more than one is involved in pattern.)
　　　　　coord check: __ specs __ fin sched

__ __ SADDLES, THRESHOLDS, METAL STRIPS SEPARATING
　　　ONE FLOOR MATERIAL FROM ANOTHER
　　　　　__ materials __ locations __ detail keys __ notes/refs
　　　　　coord check: __ specs __ fin sched

FLOOR PLANS & INTERIOR ELEVATIONS
FLOOR CONSTRUCTION continued

√ Dbl√

__ __ UNDERLAYMENT FOR RESILIENT FLOORS (09650)
 __ materials __ notes/refs
 coord check: __ specs __ fin sched

__ __ WATER AND MILDEW RESISTIVE UNDERLAYMENT
 BENEATH CARPET EXPOSED TO WATER (09680)
 __ materials __ dimensions __ detail keys __ notes/refs
 coord check: __ specs __ fin sched __ plumb

__ __ FLOOR ANCHORS FOR BUILT-INS AND EQUIPMENT
 __ anchors for N.I.C. equipment
 __ future equipment
 __ materials __ locations __ detail keys __ notes/refs
 coord check: __ struct/slab floor __ furn/equip
 __ plumb __ vent __ elec

__ __ VIBRATION PADS (10380)
 __ curbs
 __ pedestals
 __ materials __ dimensions __ detail keys __ notes/refs
 coord check: __ struct/slab floor __ hvac

__ __ ISOLATION SLABS (13080)
 __ materials __ dimensions __ detail keys __ notes/refs
 coord check: __ struct slab/floor __ hvac

__ __ FLOOR OPENINGS FOR ACCESS PANELS
 __ materials __ dimensions __ detail keys __ notes/refs
 coord check: __ struct frame/floor __ plumb __ hvac

__ __ BALCONIES, EXTERIOR LANDINGS, AND DECKS
 __ floor elevation points
 __ slopes
 __ floor drains
 __ hose bibbs and drains for planters
 __ exterior surface elevation 3" below door thresholds
 __ materials __ dimensions __ detail keys __ notes/refs
 coord check: __ struct frame/slab __ ext elev __ ref clg
 __ fin sched __ plumb/drain __ elec

__ __ WATERPROOF MEMBRANE CONSTRUCTION AT
 SHOWERS AND OTHER WET ROOMS (07110)
 __ materials __ dimensions __ detail keys __ notes/refs
 coord check: __ specs __ fin sched __ plumb

FLOOR PLANS & INTERIOR ELEVATIONS
FLOOR CONSTRUCTION continued

√ Dbl√

__ __ RAISED COMPUTER ROOM FLOOR/ACCESS FLOORING
(10270)
 __ floor grid (24" x 24" is standard)
 __ substrate elevations finish floor elevations
 __ stairs, ramps, and railings
 __ plenum seal, plenum dividers
 __ materials __ dimensions __ detail keys __ notes/refs
 coord check: __ wall anch __ floor anch __ int elev
 __ cross sect __ fin sched __ hvac __ elec

__ __ CABLE, PIPE, AND DRAIN TRENCH COVER PLATES (05531)
 __ materials __ dimensions __ detail keys __ notes/refs
 coord check: __ struct/slab __ plumb __ hvac __ elec

__ __ THRU-FLOOR SHAFTS
 __ chases
 __ chutes
 __ future shafts or chases
 __ shaft numbers
 __ materials __ dimensions __ detail keys __ notes/refs
 coord check: __ struct frame/slab __ ref clg __ cross sect
 __ plumb __ hvac __ elec

__ __ CAPPED SLEEVES FOR MOVABLE STANCHIONS, OTHER
PORTABLE FLOOR-MOUNTED FIXTURES OR EQUIPMENT
(05520/08700)
 __ materials __ dimensions __ detail keys __ notes/refs
 coord check: __ slab/floor __ furn __ elec

__ __ FLOOR DRAINS AT MECHANICAL ROOMS, GARAGES,
TRASH ROOMS, TOILET ROOMS, COMMERCIAL
KITCHENS (15421)
 __ slope to drain
 __ locations __ detail keys __ notes/refs
 coord check: __ struct slab/floor __ plumb __ hvac

__ __ RECESSED FRAMES FOR DOOR MATS (12673)
 __ depth of frame and mat sinkage
 __ materials __ dimensions __ detail keys __ notes/refs
 coord check: __ slab/floor

__ __ RECESSED DOOR MAT (12675)
 __ depth of mat sinkage
 __ materials __ dimensions __ detail keys __ notes/refs
 coord check: __ slab/floor __ fin sched

__ __ FLOOR GRILLES (12672)
 __ depth of grille sinkage
 __ materials __ dimensions __ detail keys __ notes/refs
 coord check: __ slab/floor __ fin sched

FLOOR PLANS & INTERIOR ELEVATIONS
FLOOR CONSTRUCTION continued

√ Dbl√

__ __ CONDUCTIVE FLOORS
 __ CONDUCTIVE TERRAZZO (09430)
 __ CONDUCTIVE RESILIENT (09675)
 __ CONDUCTIVE ELASTOMERIC (09731)
 __ materials __ dimensions __ detail keys __ notes/refs
 coord check: __ specs __ struct slab/floor __ fin sched
 __ elec

__ __ ARMORED FLOORS (09741)
 __ materials __ dimensions __ detail keys __ notes/refs
 coord check: __ specs __ struct slab/floor __ fin sched

__ __ GRATINGS (05530)
 __ materials __ dimensions __ detail keys __ notes/refs
 coord check: __ struct slab/floor __ hvac __ elec

__ __ FLOOR PITS
 __ materials __ dimensions __ detail keys __ notes/refs
 coord check: __ struct slab/floor __ cross sect __ plumb
 __ hvac __ elec

__ __ FLOOR PLATE PIT COVERS (05531)
 __ materials __ dimensions __ detail keys __ notes/refs
 coord check: __ struct slab/floor

__ __ CATWALKS (05530)
 __ materials __ dimensions __ detail keys __ notes/refs
 coord check: __ floor anch __ wall anch __ ref clg
 __ int elev __ cross sect __ hvac __ elec

__ __ SHIPS LADDERS (05516)
 __ materials __ dimensions __ detail keys __ notes/refs
 coord check: __ floor anch __ wall anch __ int elev

__ __ PIT AND MANHOLE WALL LADDERS (05515)
 __ materials __ dimensions __ detail keys __ notes/refs
 coord check: __ floor anch __ wall anch __ struct
 __ int elev __ cross sect

__ __ METAL SPIRAL STAIRS (05715)
 __ materials __ dimensions __ detail keys __ notes/refs
 coord check: __ floor/wall anch __ struct frame/slab
 __ int elev __ cross sect

__ __ CAGED LADDERS (05515)
 __ materials __ dimensions __ detail keys __ notes/refs
 coord check: __ floor anch __ wall anch __ struct
 __ int elev __ cross sect

135

FLOOR PLANS & INTERIOR ELEVATIONS
FLOOR CONSTRUCTION continued

02507.02513 PAVING & PAVERS

ASPHALTIC CONCRETE PAVING
1 1/2"=1'-0" 02513-1

ASPHALT PAVING
1 1/2"=1'-0" 02513-2'

WOOD BLOCK PAVING On Concrete
1 1/2"=1'-0" 02507-1

WOOD PLANK WALKWAY
1 1/2"=1'-0" 02507-11

02514 (a) PAVING & PAVERS

BRICK PAVING On Concrete
1 1/2"=1'-0" 02514-1

BRICK PAVING On Sand & Concrete
1 1/2"=1'-0" 02514-6

NOTES Date/Initials

FLOOR PLANS & INTERIOR ELEVATIONS
TRANSPORTATION

√ Dbl√

__ __ MOVING WALKS (14720)
 __ dimensions __ detail keys __ notes/refs
 coord check: __ struct frame/slab __ int elev __ cross sect
 __ elec

__ __ PASSENGER ELEVATORS (14210)
 __ elevator shaft numbers
 __ dimensions __ detail keys __ notes/refs
 coord check: __ struct frame __ ref clg __ roof
 __ cross sect __ plumb __ hvac __ elec

__ __ FREIGHT ELEVATORS (14220)
 __ elevator shaft number
 __ dimensions __ detail keys __ notes/refs
 coord check: __ struct frame __ ref clg __ roof
 __ cross sect __ plumb __ hvac __ elec

__ __ ESCALATORS (14710)
 __ escalator number
 __ dimensions __ detail keys __ notes/refs
 coord check: __ struct frame __ floor sup __ ref clg
 __ cross sect __ elec

__ __ DUMBWAITERS (14101/141020)
 __ dumbwaiter shaft number
 __ manual or powered
 __ dimensions __ detail keys __ notes/refs
 coord check: __ struct frame __ floor sup __ ref clg
 __ cross sect __ elec

__ __ PEOPLE LIFTS (14410)
 __ dimensions __ detail keys __ notes/refs
 coord check: __ struct frame __ floor sup __ ref clg
 __ cross sect __ elec

__ __ SIDEWALK LIFTS (14411)
 __ dimensions __ detail keys __ notes/refs
 coord check: __ struct frame/slab __ site/paving
 __ floor sup __ cross sect __ elec

__ __ WHEELCHAIR LIFTS (14415)
 __ dimensions __ detail keys __ notes/refs
 coord check: __ struct frame __ floor support
 __ cross sect __ elec

__ __ VEHICLE LIFTS (14450)
 __ dimensions __ detail keys __ notes/refs
 coord check: __ struct frame __ floor support
 __ cross sect __ elec

__ __ PNEUMATIC TUBES (14581)
 __ dimensions __ detail keys __ notes/refs
 coord check: __ struct frame __ ref clg __ cross sect
 __ elec

FLOOR PLANS & INTERIOR ELEVATIONS
TRANSPORTATION continued

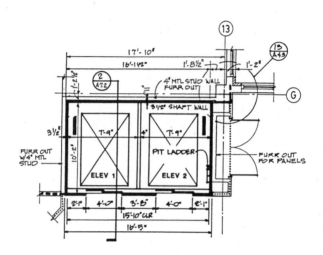

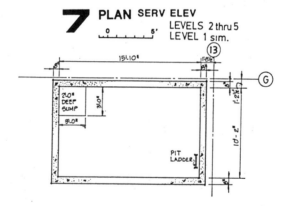

7 PLAN SERV ELEV

0 5'

LEVELS 2 thru 5
LEVEL 1 sim.

NOTES

FLOOR PLANS & INTERIOR ELEVATIONS
ROOM CONTENT -- TOILET ROOMS

√ Dbl√

__ __ SMOOTH, NONABSORBENT FLOOR SURFACE, UP WALL
TO 4' HEIGHT MINIMUM (Terrazzo is subject to deterioration
near urinals and water closets.)
 __ floors slope to drain
 __ materials __ dimensions __ detail keys __ notes/refs
 coord check: __ fin sched __ plumb

__ __ DRINKING FOUNTAIN OUTSIDE RESTROOM ENTRIES
(15461)
 __ auxiliary fountain for handicapped
 __ water protection at walls behind drinking fountains
 __ materials __ dimensions __ detail keys __ notes/refs
 coord check: __ wall anch __ int elev __ plumb

__ __ FLOOR DRAINS (15421)
 __ floors sloped to drains
 __ locations __ detail keys __ notes/refs
 coord check: __ struct slab __ plumb __ hvac

__ __ HOSE BIBB (15109)
 coord check: __ plumb __ foundation

__ __ JANITOR'S SERVICE SINK (15476)
 __ location __ notes/refs
 coord check: __ wall anch __ int elev __ plumb

__ __ LAVATORIES (15471)
(30" spacing typical.)
 __ low lav for children/disability
 __ handicap lav
 __ wash fountain
 __ locations/spacing __ notes/refs
 coord check: __ wall anch __ int elev __ plumb

__ __ BUILT-IN COUNTER LAVATORIES (06410)
 __ materials __ dimensions __ detail keys __ notes/refs
 coord check: __ wall anch __ int elev __ plumb

__ __ URINAL STALLS (10160)
(30" spacing typical.)
 __ low urinal for children
 __ wide handicap stall with grab bars
 __ ash trays
 __ chalkboard
 __ materials __ dimensions __ detail keys __ notes/refs
 coord check: __ wall anch __ int elev __ plumb

FLOOR PLANS & INTERIOR ELEVATIONS
ROOM CONTENT -- TOILET ROOMS continued

√ Dbl√

__ __ WATER CLOSET STALLS (10160)
 (32" spacing typical.)
 __ wide handicap stall with grab bars
 __ materials __ dimensions __ detail keys __ notes/refs
 coord check: __ wall anch __ floor support __ int elev
 __ ref clg __ plumb

__ __ WATER CLOSET STALL ACCESSORIES (10800)
 __ rigid or fold-down package and purse shelf
 __ toilet paper holders
 __ sanitary napkin dispenser
 __ napkin disposers
 __ seat cover tissue dispenser
 __ coat hook
 __ ash tray
 __ chalkboard
 __ locations __ detail keys __ notes/refs
 coord check: __ wall anch __ int elev

__ __ PAPER TOWEL DISPENSERS (10811)
 __ locations __ detail keys __ notes/refs
 coord check: __ wall anch __ int elev

__ __ WARM AIR HAND DRYERS (10819)
 __ locations __ detail keys __ notes/refs
 coord check: __ wall anch __ int elev __ elec

__ __ WASTE PAPER TOWEL RECEPTACLES
 __ BUILT-IN (10812)
 __ FREESTANDING (12654)
 __ locations __ detail keys __ notes/refs
 coord check: __ furn __ wall anch __ int elev

__ __ ROTARY CLOTH TOWEL DISPENSERS (10813)
 __ locations __ detail keys __ notes/refs
 coord check: __ wall anch __ int elev

__ __ ASH RECEPTACLES
 __ BUILT-IN (10800)
 __ FREESTANDING (12654)
 __ locations __ detail keys __ notes/refs
 coord check: __ furn __ wall anch __ int elev

__ __ LAV SHELVES (10805)
 __ electric razor outlet
 __ materials __ locations __ detail keys __ notes/refs
 coord check: __ wall anch __ int elev __ elec

FLOOR PLANS & INTERIOR ELEVATIONS
ROOM CONTENT -- TOILET ROOMS continued

√ Dbl√

__ __ METAL FRAMED LAVATORY MIRRORS (10810)
　　　　　 __ locations __ detail keys __ notes/refs
　　　　　 coord check: __ wall anch __ int elev __ elec

__ __ FULL-LENGTH MIRRORS (08830)
　　　　　 __ locations __ detail keys __ notes/refs
　　　　　 coord check: __ wall anch __ int elev

__ __ COAT AND UMBRELLA RACKS/HOOKS (12650)
　　　　　 __ locations __ detail keys __ notes/refs
　　　　　 coord check: __ wall anch __ int elev

__ __ VENDING MACHINE AND SCALE ALCOVE (11124)
　　　　　 __ materials __ dimensions __ detail keys __ notes/refs
　　　　　 coord check: __ wall anch __ int elev __ fin sched __ elec

__ __ PLUMBING CHASES
　　　　　 __ dimensions __ detail keys __ notes/refs
　　　　　 coord check: __ plumb __ struct __ cross sect

__ __ PLUMBING CLEANOUT ACCESS COVERS (15423)
　　　　　 __ locations __ detail keys __ notes/refs
　　　　　 coord check: __ plumb __ wall anch __ int elev

__ __ PLUMBING CHASE ACCESS PANELS OR DOORS (08305)
　　　　　 __ locations __ detail keys __ notes/refs
　　　　　 coord check: __ plumb __ int elev __ door sched

TOILET ACCESSORY SCHEDULE

TA 1	TOILET PAPER HOLDER
TA 2	GRAB BAR 36", CENTERED
TA 3	GRAB BAR 40", 12" FROM BACK WALL
TA 4	PAPER TOWER DISPENSER/TRASH RECEPTACLE
TA 5	SOAP DISPENSER
TA 6	MIRROR
TA 7	COAT HOOK
TA 8	DIAPER CHANGING TABLE

FLOOR PLANS & INTERIOR ELEVATIONS
ROOM CONTENT -- TOILET ROOMS continued

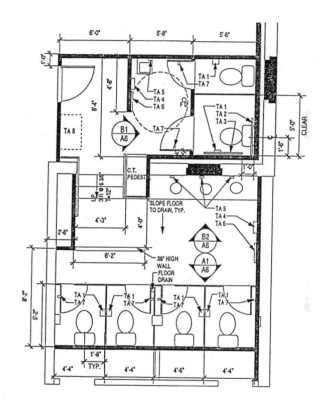

FLOOR PLANS & INTERIOR ELEVATIONS
ROOM CONTENT -- TOILET ROOMS

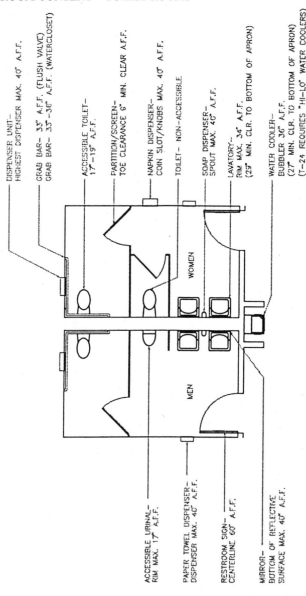

DISPENSER UNIT—
HIGHEST DISPENSER MAX. 40" A.F.F.

GRAB BAR— 33" A.F.F. (FLUSH VALVE)
GRAB BAR— 33"—36" A.F.F. (WATERCLOSET)

ACCESSIBLE TOILET—
17"—19" A.F.F.

PARTITION/SCREEN—
TOE CLEARANCE 9" MIN. CLEAR A.F.F.

NAPKIN DISPENSER—
COIN SLOT/KNOBS MAX. 40" A.F.F.

TOILET— NON—ACCESSIBLE

SOAP DISPENSER—
SPOUT MAX. 40" A.F.F.

LAVATORY—
RIM MAX. 34" A.F.F.
(29" MIN. CLR. TO BOTTOM OF APRON)

WATER COOLER—
BUBBLER 36" A.F.F.
(27" MIN. CLR. TO BOTTOM OF APRON)
(T—24 REQUIRES "HI—LO" WATER COOLERS)

WOMEN

MEN

ACCESSIBLE URINAL—
RIM MAX. 17" A.F.F.

PAPER TOWEL DISPENSER—
DISPENSER MAX. 40" A.F.F.

RESTROOM SIGN—
CENTERLINE 60" A.F.F.

MIRROR—
BOTTOM OF REFLECTIVE
SURFACE MAX. 40" A.F.F.

FLOOR PLANS & INTERIOR ELEVATIONS
ROOM CONTENT -- STAIRWAYS continued

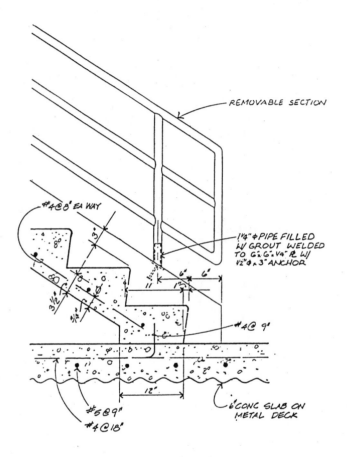

REMOVABLE SECTION

#4@8" EA WAY

1¼"Φ PIPE FILLED
W/ GROUT WELDED
TO 6"×6"×¼" ℞ W/
½"Φ×3" ANCHOR

#4@ 9"

#5@9"

#4@18"

6"CONC SLAB ON
METAL DECK

12"

3½"

(1E) _____ **DETAIL**
SCALE: ¾" = 1'-0"

FLOOR PLANS & INTERIOR ELEVATIONS
ROOM CONTENT -- STAIRWAYS continued

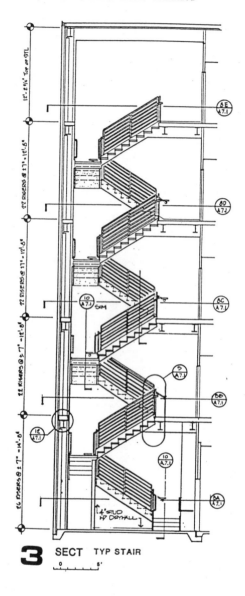

3 SECT TYP STAIR

FLOOR PLANS & INTERIOR ELEVATIONS
ROOM CONTENT -- BOILER ROOM

√ Dbl√

__ __ VENTILATED PLENUM ABOVE BOILER ROOMS AS
REQUIRED TO INSULATE ROOMS ABOVE
__ dimensions __ detail keys __ notes/refs
coord check: __ hvac __ ref clg __ cross sect

__ __ BOILER FLOOR DROP OR PIT
__ floor sloped to drain
__ dimensions __ detail keys __ notes/refs
coord check: __ hvac __ struct/slab __ cross sect
__ plumb

__ __ REMOVABLE WALL PANELS FOR CHANGE OF BOILER
UNITS
__ CONCRETE PANELS (03411)
__ MASONRY (04235)
__ materials __ dimensions __ detail keys __ notes/refs
coord check: __ struct/frame __ ref clg __ int/ext elev
__ cross sect __ wall sect

__ __ BOILER PLANT INSULATION (15262)
__ materials __ detail keys __ notes/refs
coord check: __ hvac

__ __ CRANE HOIST (14300)
__ materials __ dimensions __ detail keys __ notes/refs
coord check: __ struct __ ref clg __ elec __ cross sect

__ __ FLOOR PLATES (05530)
__ materials __ dimensions __ detail keys __ notes/refs
coord check: __ struct/slab __ plumb __ hvac __ elec

__ __ FLOOR GRATINGS (05530)
__ materials __ dimensions __ detail keys __ notes/refs
coord check: __ struct/slab __ plumb __ hvac __ elec

__ __ FLOOR DRAINS (15421)
__ floor sloped to drain
__ water sources to be drained
__ locations __ detail keys __ notes/refs
coord check: __ struct/slab __ equip __ plumb __ hvac

__ __ RAILINGS AT PITS (15520)
__ materials __ dimensions __ detail keys __ notes/refs
coord check: __ floor anch __ struct/slab __ cross sect

__ __ SHIPS LADDERS (05516)
__ materials __ dimensions __ detail keys __ notes/refs
coord check: __ wall anch __ floor anch __ int elev

FLOOR PLANS & INTERIOR ELEVATIONS
ROOM CONTENT -- BOILER ROOM continued

√ Dbl√

__ __ RAISED WALKWAYS
 __ CAST IN PLACE CONCRETE (03335)
 __ METAL GRATING (05530)
 __ WOOD PLANK (06125)
 __ materials __ dimensions __ detail keys __ notes/refs
 coord check: __ wall anch __ floor anch __ int elev
 __ fin sched __ hvac

__ __ CATWALKS (05530)
 __ materials __ dimensions __ detail keys __ notes/refs
 coord check: __ wall anch __ floor anch __ int elev
 __ ref clg __ hvac

NOTES Date/Initials

FLOOR PLANS & INTERIOR ELEVATIONS
ROOM CONTENT -- ELEVATOR AND DUMBWAITER PITS

√ Dbl√

__ __ PIT CONSTRUCTION
__ materials __ dimensions __ detail keys __ notes/refs
coord check: __ struct __ cross sect

__ __ GUARD RAIL (05520)
__ materials __ dimensions __ detail keys __ notes/refs
coord check: __ floor anch __ wall anch

__ __ PIT LADDER (05515)
__ materials __ dimensions __ detail keys __ notes/refs
coord check: __ floor anch __ wall anch

__ __ FLOOR DRAINS (15421)
__ floor sloped to drain
__ locations __ detail keys __ notes/refs
coord check: __ struct/slab __ plumb

__ __ LIGHT SWITCH AND CONVENIENCE OUTLETS (16050)
(Maintenance outlets also provided in elevator shaft.)
__ locations __ notes/refs
coord check: __ elec

NOTES Date/Initials

FLOOR PLANS & INTERIOR ELEVATIONS
ROOM CONTENT -- JANITOR'S CLOSET/MAINTENANCE SHOP

√ Dbl√

__ __ SMOOTH, NONABSORBENT FLOOR SURFACE
 __ floors sloped to drains
 __ materials __ dimensions __ detail keys __ notes/refs
 coord check: __ plumb __ fin sched

__ __ FLOOR DRAINS (15421)
 __ floor slopes
 __ water sources to be drained
 __ locations __ notes/refs
 coord check: __ struct slab __ plumb __ hvac

__ __ FLOOR SINK (15475)
 __ materials __ dimensions __ detail keys __ notes/refs
 coord check: __ struct/slab __ plumb

__ __ SHELVING
 __ METAL (10671)
 __ WIRE (10673)
 __ WOOD (06412)
 __ materials __ dimensions __ detail keys __ notes/refs
 coord check: __ wall anch __ floor anch __ int elev

__ __ MAINTENANCE SUPPLY STORAGE RACKS OR CAGES
 __ METAL (10671)
 __ WIRE (10673)
 __ WOOD (06453)
 __ materials __ dimensions __ detail keys __ notes/refs
 coord check: __ wall anch __ floor anch __ int elev

__ __ TOOL RACKS (11515)
 __ materials __ dimensions __ detail keys __ notes/refs
 coord check: __ wall anch __ int elev

__ __ PEGBOARD (06423)
 __ materials __ dimensions __ detail keys __ notes/refs
 coord check: __ wall anch __ int elev

__ __ STORAGE RACKS FOR PIPE
 __ METAL (10675)
 __ WOOD (06453)
 __ materials __ dimensions __ detail keys __ notes/refs
 coord check: __ struct __ wall anch __ floor anch

__ __ STORAGE RACKS FOR LUMBER
 __ METAL (10676)
 __ WOOD (06453)
 __ materials __ dimensions __ detail keys __ notes/refs
 coord check: __ struct __ wall anch __ floor anch

FLOOR PLANS & INTERIOR ELEVATIONS
ROOM CONTENT -- JANITOR'S CLOSET/MAINTENANCE SHOP
continued

√ Dbl√

__ __ WORKBENCHES
 __ WOOD (06453)
 __ INDUSTRIAL (11511)
 __ materials __ dimensions __ detail keys __ notes/refs
 coord check: __ wall anch __ floor anch __ int elev
 __ furn __ elec

__ __ WORKBENCH ACCESSORIES
 __ GAS OUTLETS (15309)
 __ COMPRESSED AIR (15311)
 __ STRIP ELECTRICAL OUTLETS (16135)
 __ EXHAUST FANS (15829)
 __ WORK SINKS (15481)
 __ _____
 __ locations __ detail keys __ notes/refs
 coord check: __ elec __ plumb/piping __ vent __ int elev
 __ ref clg

__ __ CABINETS
 __ WOOD (06410)
 __ WOOD CASEWORK (12302)
 __ METAL CASEWORK (12301)
 __ materials __ dimensions __ detail keys __ notes/refs
 coord check: __ wall anch __ int elev __ furn

__ __ CORNER GUARDS (10260)
 __ materials __ dimensions __ detail keys __ notes/refs
 coord check: __ wall anch __ int elev

__ __ CLOTHES HOOKS (05506)
 __ locations __ notes/refs

__ __ CLOTHES LOCKERS (10501)
 __ soffit
 __ pedestal
 __ materials __ dimensions __ detail keys __ notes/refs
 coord check: __ wall anch __ floor anch __ int elev
 __ ref clg/soffit

__ __ SHOWER STALLS (10170/15459)
 __ FLOOR DRAIN (15421)
 __ ROBE HOOKS (10809)
 __ GRAB BARS (10807)
 __ SOAP DISH (10906)
 __ _____
 __ floor sloped to drain __ water/moisture proofing
 __ materials __ dimensions __ detail keys __ notes/refs
 coord check: __ wall anch __ floor anch __ int elev
 __ fin sched __ plumb __ vent

FLOOR PLANS & INTERIOR ELEVATIONS
ROOM CONTENT -- JANITOR'S CLOSET/MAINTENANCE SHOP
continued

√ Dbl√

__ __ LOCKER ROOM BENCHES (10510)
 __ materials __ dimensions __ detail keys __ notes/refs
 coord check: __ furn __ floor anch

__ __ MESH PARTITIONS (10601)
 __ materials __ dimensions __ detail keys __ notes/refs
 coord check: __ wall anch __ floor anch __ ref clg
 __ int elev

NOTES Date/Initials

NOTES

FLOOR PLANS & INTERIOR ELEVATIONS
ROOM CONTENT -- RESIDENTIAL

ENTRIES

√ Dbl√

__ __ EXTERIOR LANDING, STOOP, OR PORCH
 __ MATERIAL
 __ ELEVATION POINTS
 __ SLOPE
(Nonskid finish surface if exposed to weather. Surface is 3" below door threshold if exposed to weather.)

__ __ RECESSED DOORMAT

__ __ WEATHER- AND SKID-RESISTIVE VESTIBULE FLOOR
 SURFACE

__ __ ARROW ON DRAWING TO INDICATE MAIN ENTRY

__ __ SMALLER ARROW FOR SECONDARY ENTRY

__ __ MAIN ENTRY AND SERVICE ENTRY ROOF OVERHANG OR
 CANOPY WEATHER PROTECTION

__ __ MAIL SLOT IN WALL OR DOOR, OR EXTERIOR-MOUNTED
 MAILBOX.

__ __ GLAZING AT SIDE OF DOOR
 __ VIEWING LENS IN DOOR

__ __ GUEST COAT CLOSET:
 __ HOOKS
 __ SHELF
 __ POLE

__ __ WEATHER-RESISTIVE FLOORING

__ __ ENTRY VESTIBULE POWDER ROOM WITH LAVATORY
 AND TOILET.
 (Sound-insulation wall construction and door stripping.)

__ __ SNOW COUNTRY:
 __ STORM VESTIBULE WITH WEATHERPROOF
 FLOOR
 __ SNOW GRATING AND DRAIN
 __ BENCH
 __ WET CLOTHING AND SKI EQUIPMENT STORAGE

__ __ BEACH HOUSE:
 __ DRESSING ROOM AND LAUNDRY NEAR BEACH
 ENTRY
 __ BATHROOM WITH EXTERIOR ACCESS
 __ EXTERIOR DRINKING FOUNTAIN

FLOOR PLANS & INTERIOR ELEVATIONS
ROOM CONTENT -- RESIDENTIAL

LIVING AREAS:
LIVING ROOM, FAMILY ROOM, DINING ROOM

√ Dbl√

__ __ MASONRY OR PREFAB FIREPLACE
 __ FLUE SIZE
 __ FIREWOOD STORAGE
 __ EXTERIOR ASH DUMP CLEANOUT
 __ HEARTH SIZE AND MATERIAL
 __ HEIGHT OF RAISED HEARTH
 __ GAS FIRE STARTER PIPE WITH KEY VALVE AT
 HEARTH
 __ FIREPLACE DETAIL REFERENCE

__ __ BUILT-IN SEATING

__ __ WET BAR:
 __ SMALL UNIT REFRIGERATOR
 __ GLASSWARE CABINET
 __ BAR TOP MATERIAL
 __ CABINET WITH LOCK

__ __ DINING BAR WITH PASS-THROUGH TO KITCHEN
 __ BAR TOP MATERIAL
 __ BUILT-IN WARMING PLATE

__ __ STEREO EQUIPMENT
__ __ TELEVISION
__ __ GAMES EQUIPMENT
__ __ CHAIR RAIL (usually at formal dining room)
__ __ PICTURE MOLDING OR RAIL
__ __ WAINSCOT
__ __ PANELING
__ __ WALL-MOUNTED DISPLAY CABINETS
__ __ SHELVING
__ __ BUILT-IN TROPHY CASE
__ __ HOBBY CASE
__ __ GUN CASE
__ __ INTERIOR PLANTERS;
 __ LINER MATERIAL
 __ DRAINS
 __ WATER SUPPLY
 __ DETAIL KEYS

__ __ GUARDRAILS AT FULL-HEIGHT GLASS WALLS

FLOOR PLANS & INTERIOR ELEVATIONS
ROOM CONTENT -- RESIDENTIAL continued

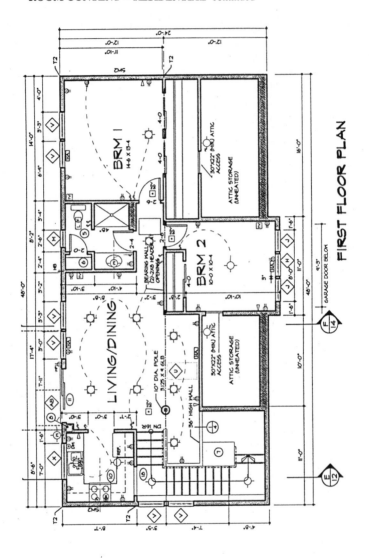

FIRST FLOOR PLAN

FLOOR PLANS & INTERIOR ELEVATIONS
ROOM CONTENT -- RESIDENTIAL

KITCHEN AND DINETTE

√ Dbl√

__ __ BASE CABINETS AND COUNTER TOP
 __ COUNTER TOP AND SPLASH MATERIALS

__ __ BROKEN-LINE INDICATION OF OVERHEAD CABINETS
__ __ CENTRAL WORK ISLAND
__ __ CUTTING BOARD
__ __ PANTRY CLOSET
__ __ SPICE CABINET OR SHELF
__ __ TRAY STORAGE BINS
__ __ DRAWERS
__ __ POT AND PAN RACK
__ __ BROOM OR CLEANING CLOSET WITH SHELF

__ __ PLANNING CENTER:
 __ COOKBOOK SHELVING
 __ RECIPE FILE

__ __ SERVING AND CLEANUP CART RECESS

__ __ EQUIPMENT:
 __ SINK AND VEGETABLE SINK
 __ BOILING WATER OUTLET
 __ HAND LOTION DISPENSER
 __ DISHWASHER WITH COUNTER TOP AIR GAP
 DEVICE
 __ GARBAGE DISPOSAL
 __ TRASH COMPACTOR
 __ RANGE OR COOKTOP
 __ AUXILIARY COOKTOP
 __ BUILT-IN FOOD WARMER
 __ INDOOR BBQ WITH EXHAUST
 __ BUILT-IN OVEN
 __ RANGE OR COOKTOP EXHAUST HOOD WITH
 LIGHT AND FAN
 __ SPACE FOR REFRIGERATOR/FREEZER WITH
 CABINET OR SOFFIT OVER
 __ BUILT-IN MICROWAVE

__ __ GAS OUTLETS AND ACCESSIBLE SHUTOFFS FOR
 APPLIANCES:

 __ REFRIGERATOR
 __ OVEN
 __ RANGE
 __ BROILER OR INDOOR BBQ

FLOOR PLANS & INTERIOR ELEVATIONS
ROOM CONTENT -- RESIDENTIAL

KITCHEN AND DINETTE continued

√ Dbl√

__ __ COLD WATER STUB AND VALVE (3/8") FOR
REFRIGERATOR AUTOMATIC ICE MAKER

__ __ VENTS AND DUCT TO OUTSIDE AIR FOR RANGE HOOD
AND OVEN (Concealed duct shown in broken line.)

__ __ BULLETIN BOARD
__ __ WHITEBOARD
__ __ RECESS FOR KITCHEN CLOCK

__ __ PASS-THROUGH AND/OR DINING BAR AT KITCHEN
WALL ADJACENT TO TERRACE OR PATIO
__ __ DOUBLE-ACTING GATE ("RESTAURANT DOOR") AT
KITCHEN-DINING DOORWAY

__ __ INTERIOR ELEVATIONS:
__ CABINET DOOR SWINGS
__ SHELVING
__ DRAWERS
__ RACKS
__ PULL-OUT EQUIPMENT
__ CABINETS TO CEILING OR TO SOFFIT
__ BASE, COVE, AND TOE SPACE HEIGHT AND
MATERIAL
__ SPLASH MATERIAL AND HEIGHT
__ DOOR AND WINDOW SURROUNDS AND TRIM
__ COUNTER TOP MATERIAL AND HEIGHT
__ HEIGHT OF CABINETS ABOVE COUNTER
__ HEIGHT OF VENT HOOD
__ ELECTRIC OUTLETS AND SWITCHES

__ __ DINETTE CHAIR RAIL

__ __ WAINSCOT

FLOOR PLANS & INTERIOR ELEVATIONS
ROOM CONTENT -- RESIDENTIAL continued

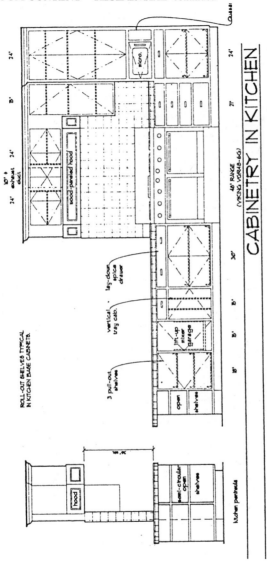

CABINETRY IN KITCHEN

FLOOR PLANS & INTERIOR ELEVATIONS
ROOM CONTENT -- RESIDENTIAL

UTILITY ROOM, MUD ROOM, LAUNDRY ROOM

√ Dbl√

__ __ WASHER AND DRYER WITH CABINET AND LIGHT OVER
__ __ DRYER VENT TO OUTSIDE AIR
__ __ WATER SOFTENER
__ __ LAUNDRY SINK AND DRAINBOARD
__ __ LAUNDRY STANDPIPE
__ __ WATER-RESISTIVE FLOOR SURFACE AT LAUNDRY
__ __ FLOOR DRAIN
__ __ WATER HEATER WITH CAPACITY IN GALLONS
__ __ RELIEF VALVE PIPE AND FLOOR DRAIN
__ __ EXHAUST FLUE, MATERIAL AND SIZE

__ __ GAS WATER HEATER CABINET COMBUSTION AIR VENTS
AT FLOOR AND CEILING
(Water heater should be located to avoid proximity to parked cars,
gasoline, or other sources of volatile fumes.)

__ __ GAS SUPPLY AND ACCESSIBLE SHUTOFF VALVES FOR
GAS WATER HEATER AND CLOTHES DRYER

__ __ FREEZER OR AUXILIARY REFRIGERATOR SPACE:
__ GAS STUB-OUT AND SHUTOFF

__ __ IRONING BOARD AND IRON STORAGE CABINET
__ __ CLOTHING SORTING BENCH
__ __ HANGING ROD, DRIP-DRY AREA, OR VENTILATED
DRYING CLOSET
__ __ LINEN CLOSET (Six shelves are typical.)
__ __ BUILT-IN CLOTHES HAMPER
(Ventilated, may be supplied with small warm-air branch duct.)
__ __ SEWING CENTER WORKBENCH AND CABINETS
__ __ PEG- AND TACKBOARD

__ __ COAT CLOSET OR CABINET NEAR SERVICE ENTRY DOOR

__ __ MOP AND SUPPLY STORAGE CABINET OR CLOSET

__ __ DOG OR CAT ENTRY DOOR IN EXTERIOR DOOR

FLOOR PLANS & INTERIOR ELEVATIONS
ROOM CONTENT -- RESIDENTIAL

HALLWAYS

√ Dbl√

_ _ HALL LINEN CLOSET
 (18" deep; 6 shelves are typical.)
_ _ SKYLIGHTS OVER INTERIOR HALLWAYS AND
 STAIRWAYS
_ _ SCUTTLE OR FOLDING STAIR TO ATTIC

NOTES Date/Initials

FLOOR PLANS & INTERIOR ELEVATIONS
ROOM CONTENT -- RESIDENTIAL

STAIRWAYS

√ Dbl√

___ ___ STAIR RULES: MINIMUM WIDTH 30" FOR BUILDING
OCCUPANT LOAD FEWER THAN 10; 36" FOR OCCUPANT
LOAD OF 50 OR FEWER; 44" FOR OCCUPANT LOAD OF
MORE THAN 50

___ ___ TREADS AND RISERS: RISERS 7-1/2" MAXIMUM; TREADS
10" WIDE MINIMUM

___ ___ LANDINGS:
___ MINIMUM ONE EACH 12' OF VERTICAL STAIR
RUN
___ MINIMUM LANDING WIDTH, IN DIRECTION OF
TRAVEL EQUAL TO STAIR WIDTH

___ ___ HANDRAILS:
___ NOT REQUIRED FOR STAIRS WITH THREE OR
FEWER RISERS
___ AT LEAST ONE HANDRAIL FOR RESIDENTIAL S
TAIRS 44" WIDE OR LESS

___ ___ HANDRAIL OR OTHER PROJECTION INTO STAIR AREA MAY
REDUCE REQUIRED CLEARANCE WIDTH BY 3-1/2" MAX.
___ ___ MAXIMUM ENDS TERMINATE ON NEWELS OR RETURN
TO WALL
___ ___ HANDRAIL HEIGHT 3-" MINIMUM AND 34" MAXIMUM
ABOVE TREAD NOSINGS
___ ___ HEAD ROOM: MINIMUM 6'6" CLEARANCE BETWEEN
NOSING AND SOFFIT
___ ___ UNDER-STAIR STORAGE CABINETS
___ ___ UNDER-STAIR SOFFIT MATERIAL
___ ___ TREAD AND RISER MATERIALS
___ ___ SIZE OF NOSING PROJECTION
___ ___ BREAK LINE FOR PARTIAL PLAN OF STAIR ABOVE OR
BELOW
___ ___ NUMBER OF RISERS
___ ___ DIRECTION ARROW POINTING DOWN FROM FLOOR
LEVEL
___ ___ STAIR AND LANDING DIMENSIONS
___ ___ FLOORING MATERIAL
___ ___ ELEVATION POINTS OF LANDING

FLOOR PLANS & INTERIOR ELEVATIONS
ROOM CONTENT -- RESIDENTIAL

BEDROOMS

√ Dbl√

__ __ BUILT-IN HEADBOARD SHELF
__ __ HEADBOARD CABINET
__ __ BUILT-IN BED
__ __ WATER BED
__ __ CANOPY
__ __ BED CEILING MIRROR
 (Ceiling mirror usually plastic tile or Mylar.)
__ __ FULL-LENGTH MIRROR
__ __ TWO- OR THREE-HINGE PANEL DRESSING MIRROR

__ __ MAKEUP COUNTER OR VANITY INCLUDING:
 __ DRAWERS
 __ CABINET
 __ LIGHTED MAKEUP MIRROR

__ __ BUILT-IN VENTILATED HAMPER
__ __ LINEN CLOSET
__ __ LUGGAGE AND BLANKET STORAGE
__ __ WARDROBE AND BLANKET STORAGE
__ __ WARDROBES WITH SHELVES AND RODS
 (Two shelves if door is floor to ceiling height; Minimum
 2'2" closet width is recommended; closet shelf 5'6" high.)
__ __ BUILT-IN VENTILATED DRESSER DRAWER OR BIN UNITS
__ __ FLOOR OR WALL SAFE
 (Closet safes are well known to burglars; out-of-the-way
 location is recommended.)
__ __ CEDAR PANELING AT WARDROBE
__ __ BOOK SHELVING
__ __ STEREO AND TV CENTER

NOTES Date/Initials

FLOOR PLANS & INTERIOR ELEVATIONS
ROOM CONTENT -- RESIDENTIAL

BATHROOMS

√ Dbl√

__ __ FIXTURES:
 __ WATER CLOSETS
 __ LAVATORIES
 __ BIDET
 __ SHOWER
 __ TUB
 __ HOT TUB
 __ JACUZI

__ __ TUB OR SHOWER ENCLOSURE:
 __ ROD AND DRAPE
 __ RIGID PLASTIC
 __ WIRE GLASS
 (Large, built-in combination "Japanese" bath/shower may
 not need enclosure.)

__ __ TILE OR OTHER WATERPROOF WALL SURFACE:
 __ MATERIAL
 __ HEIGHT

__ __ NOTE WATERPROOF CONSTRUCTION AT WATER-
EXPOSED WALLS AND FLOORS

__ __ SHOWER:
 __ SHOWER SEAT
 __ ACCESSORIES SHELF
 __ SOAP AND SHAMPOO HOLDER

__ __ TUB:
 __ FLEXIBLE "TELEPHONE" SHOWER AND HOOK
 AT TUB
 __ TUB SHELF FOR BATH OILS AND POWDERS

__ __ FORCED-AIR HEAT DUCT BRANCH TO UNDER-TUB
 SPACE
__ __ ACCESS PANEL FOR BATHTUB PLUMBING (14"x14" is
 typical.)
__ __ BUILT-IN VENTILATED CLOTHES HAMPER

__ __ LAVATORY COUNTER, COUNTER TOP, AND SPLASH:
__ __ MEDICINE CABINET AND LIGHT
__ __ VANITY COUNTER WITH DRAWER AND CABINET
__ __ VANITY MAKEUP MIRROR
__ __ FULL-LENGTH MIRROR
__ __ OVERHEAD CABINET ABOVE WATER CLOSET
__ __ BATH SCALE SPACE OR BUILT-IN FLOOR SCALE
__ __ SKYLIGHT AT INTERIOR BATH
__ __ EXHAUST FAN VENT DUCT AT INTERIOR BATH

FLOOR PLANS & INTERIOR ELEVATIONS
ROOM CONTENT -- RESIDENTIAL

BATHROOMS continued

√ Dbl√

__ __ ACCESSORIES:
 __ ROBE HOOKS
 __ TOWEL BARS
 __ SOAP HOLDERS AT LABS
 __ SOAP DISH AND GRAB BAR AT TUB AND
 SHOWER
 __ TOILET PAPER HOLDERS
 __ HAND LOTION DISPENSER
 __ TUMBLER HOLDER OR PAPER CUP DISPENSER
 __ TOOTHBRUSH HOLDER

__ __ BUILT-IN PLANTER BOXES

__ __ BASE
 __ FLOOR COVE
 __ COUNTER TOE SPACE

NOTES Date/Initials

FLOOR PLANS & INTERIOR ELEVATIONS
ROOM CONTENT -- RESIDENTIAL continued

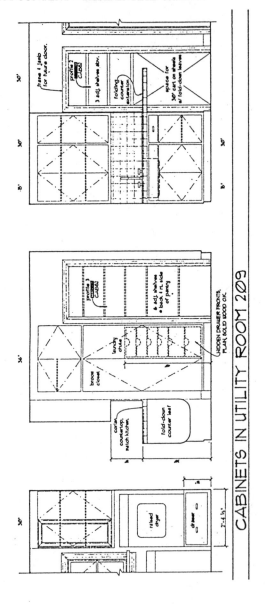

CABINETS IN UTILITY ROOM 209

**FLOOR PLANS & INTERIOR ELEVATIONS
ROOM CONTENT -- RESIDENTIAL**

MECHANICAL ROOM

√ Dbl√

__ __ FURNACE:
 __ SIZE DIMENSIONS
 __ CLEARANCES FROM WALLS
 __ BTU RATING
 __ FLUE MATERIAL AND SIZE

__ __ FURNACE CLOSET COMBUSTION AIR VENTS NEAR
 FLOOR AND CEILING
 (Usually 1 sq. ft. for each 2000 Btu input rating.)

__ __ RETURN AIR DUCT

__ __ GAS OR FUEL SUPPLY AND SHUTOFF VALVE

__ __ INCOMBUSTIBLE PLATFORM FOR FORCED-AIR FURNACE
 ON WOOD FRAME FLOOR

NOTES Date/Initials

FLOOR PLANS & INTERIOR ELEVATIONS
ROOM CONTENT -- RESIDENTIAL

GARAGE

√ Dbl√

__ · __ FLOOR SLAB:
 __ SLOPE TO APRON OR TO DRAIN (2" slope is
 typical.)
 __ APRON GUTTER OR DRAIN IF DRIVEWAY
 SLOPES TOWARD GARAGE ENTRY

__ __ POSTS:
 __ SIZE AND MATERIAL
 __ CONCRETE PEDESTAL FOR POSTS

__ __ CORNER GUARDS, PROTECTIVE JACKETS AT POSTS,
 DOOR JAMBS, OR OTHER OF STRUCTURE SUBJECT
 TO DAMAGE BY VEHICLES

__ __ OVERHEAD DOOR:
 __ DOOR TYPE AND SIZE
 __ SIZE AND MATERIAL OF DOOR HEADER
 __ AUTOMATIC DOOR OPENER/CLOSER

__ __ CEILING BRACES: DIAGONAL, FLAT TWO-BY-FOURS AT
 WOOD-FRAME OVERHEAD DOOR OPENING
__ __ GARAGE EXIT DOOR: EXTERIOR SWINGING, WITH
 OVERHANG AND SHELTERED ACCESS TO MAIN-
 BUILDING ENTRY
__ __ ATTACHED GARAGE: SOLID-CORE DOOR WITH
 AUTOMATIC CLOSER, BETWEEN GARAGE AND
 MAIN BUILDING

__ __ GARAGE WALLS: ONE-HOUR FIRE-RESISTIVE
 CONSTRUCTION AT WALLS COMMON TO MAIN
 BUILDING
__ __ SCREENED VENTS TO OUTSIDE AIR
 (Typical is 60 sq. in. of vent per car.
 Vents within 6" of floor.)

__ __ STORAGE CABINETS; WALL- AND CEILING-MOUNTED
 UNITS OVER CAR HOOD SPACE
__ __ SHOP WORKBENCH AND STORAGE CABINET
__ __ UTILITY SINK OR LAUNDRY SINK
__ __ FREEZER SPACE
__ __ HOSE BIBB FOR CAR WASHING
__ __ GAS OUTLET: CAPPED, WITH VALVE AT WORKBENCH

FLOOR PLANS & INTERIOR ELEVATIONS
ROOM CONTENT -- RESIDENTIAL

GREEN HOUSE/GARDEN SHED

√ Dbl√

___ ___ FLOWER SINK
___ ___ TOOL RACK
___ ___ POT SHELVES
___ ___ RACKS FOR FLATS
___ ___ WORKBENCH AND CABINET
___ ___ GAS OUTLET: CAPPED, WITH VALVE AT WORKBENCH
___ ___ HOSE BIBBS AND GARDEN HOSE STORAGE REELS

EXTERIOR SPACES

___ ___ AIR CONDITIONING UNIT
 ___ SLAB
 ___ ELECTRICAL SUPPLY
 ___ SHELTER

___ ___ COURTYARD

___ ___ ATRIUM

___ ___ PAVING, SLOPE, AND DRAINS

___ ___ STORAGE CABINETS:
 ___ RECREATIONAL EQUIPMENT
 ___ GARDEN FURNITURE
 ___ TOOLS

___ ___ GARDEN HOSE STORAGE REELS

___ ___ TRASH CANS:
 ___ BURIED RECEPTACLES
 ___ RACKS
 ___ STORAGE CABINET

___ ___ BBQ GAS OUTLET

___ ___ HOSE BIBBS/SILL COCKS

___ ___ FROSTPROOF BIBBS

FLOOR PLANS & INTERIOR ELEVATIONS
ROOM CONTENT -- RESIDENTIAL

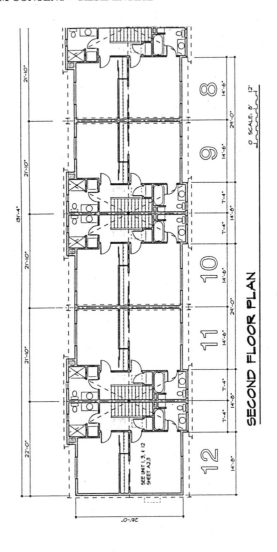

SECOND FLOOR PLAN

FLOOR PLANS & INTERIOR ELEVATIONS
ROOM CONTENT -- RESIDENTIAL

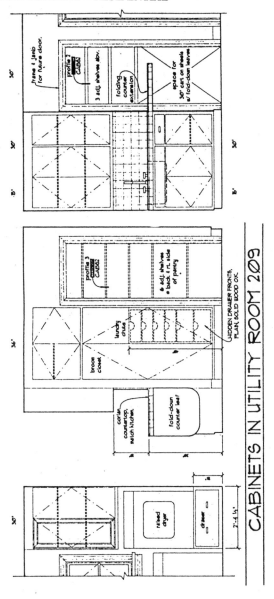

CABINETS IN UTILITY ROOM 209

FLOOR PLANS & INTERIOR ELEVATIONS
ROOM CONTENT -- RESIDENTIAL

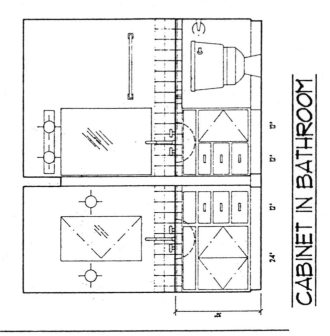

CABINET IN BATHROOM

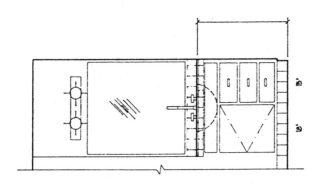

EXTERIOR ELEVATIONS

CHAPTER CONTENTS

EXTERIOR ELEVATIONS PROCEDURAL CHECKLIST

EXTERIOR ELEVATION LAYOUT AND DRAFTING, STEP BY STEP

PHASE 1 -- "OUTLINE" INFORMATION

Exterior elevation information is dependent on Floor Plans, Site Plans, Cross Sections, Roof Plans, and Door and Window Schedules.

Update and verify cross sections, plate heights, ceiling heights, floor to floor heights, and fenestration completed during design. Using the updated design development drawings and/or the latest working drawings as your guide, proceed with the following steps.

Layout & Linework

__ Decide on the desirable scale, size, and positioning of the Exterior Elevations on the working drawing sheet(s). Consider locations of Keynote legend, Door and/or Window Schedule, General Notes, Titles, Key Plan, and exterior construction details.

__ It's desirable to do Cross Sections during Design Development and use them as base sheets for Exterior Elevations.

__ If Exterior Elevations in Design Development were drawn on base sheet without extraneous entourage or rendering, then adapt them for direct reuse in working drawings. (If using CADD, this will be handled automatically by layering.)

__ If restarting Exterior Elevations from scratch, use Floor Plans and Cross Sections as guides for roughing in exterior walls, doors, windows, and floor, ceiling, and roof heights.

__ Confirm and rough in the outline of perimeter walls of building. Compare floor plan with design drawings of exterior elevations to confirm exterior wall lengths, setbacks, and door and window locations and sizes.

__ Draw the vertical modular grid, if any.

__ Confirm and redraw as necessary in "light line" the floor lines and plate lines. Later these will be hard-lined as long-to-short dash lines and extended for vertical dimension lines.

__ Confirm and lightly rough in other horizontal lines: Rough and finish grade, foundation or basement walls and footings, header, soffit, and roof lines.

__ Rough in lines of auxiliary construction such as raised ceilings, dropped floors, adjacent slabs, etc.

EXTERIOR ELEVATION PROCEDURAL CHECKLIST continued

PHASE 1 -- "OUTLINE" INFORMATION continued

__ Coordinate the Exterior Elevations with the Roof Plan.
If the Roof Plan and roof framing are still not finalized, rough in data
that is known in terms of roof height, slopes, parapets, etc.

__ Confirm and redraw as necessary in "light line" the vertical lines: End
walls, offsets, doors and windows.

__ Rough in connecting construction such as hand rails, decks, trellises, etc.

__ Rough in cantilever projections.

__ Rough in the roof profile, slopes, and overhangs.

__ Rough in roof projections such as skylights, chimneys, etc.

__ Size and rough in door and window openings. Compare door and
window locations with site conditions and requirements for fire
exit safety.

__ Show changes in floor level in dash line.

__ Rough in exterior stairs or steps and confirm tread/riser sizes relative
to stair height.

__ Add ramps -- direction and upper and lower sub-floor elevations.

Dimensioning

__ Draw overall exterior dimension lines from floor to roof framing, floor to
floor, floor to ceiling or soffit, floor to door and window headers (as
rough openings).

__ Show height dimension lines for auxiliary construction such as trellises
and sun shades.

__ Double check floor height and finish grade elevations with Floor Plan
and Site Plans.

Notation & Titles

__ Add identification notes or keynotes required for consultants who will
refer to Exterior Elevations at this stage.

__ Add Exterior Elevation drawing title and scale.

EXTERIOR ELEVATION PROCEDURAL CHECKLIST continued

PHASE 2 -- "HARDLINE" INFORMATION

AND DETAILED ARCHITECTURAL CONSTRUCTION DATA

__ Hold completion of Exterior Elevations until plans and overall design
have had final review and are signed off by the client

Layout & Dimensioning

__ Once plans and the exterior design are confirmed and signed off
by the client, proceed with hardlining perimeter and major
horizontal and vertical features of the building.

__ Show dash lines for construction below grade, behind overhangs, etc.

__ Show reference dimension or datum lines.

__ Firm up dimension lines and add dimension numbers in feet and inches.

__ Add small height dimensions such as for wing walls, furred walls, etc.
Avoid horizontal dimensions with the possible exception of
overhangs of cantilevers that aren't clearly shown and dimensioned
elsewhere.

Construction Elements

__ Show gutters roof drains, scuppers, downspouts, and drains or splash
blocks at grade.

__ Show grading slopes away from building.

__ Add door and window light or mullion patterns.
Avoid adding door and window schedule key symbols -- those
belong on the floor plan. Avoid adding door and window frame
detail keys except for special cases, those belong in the door/window
schedules.)

__ Show and note soffit and attic vents.

__ Complete flashing such as at chimneys.

__ Show skylights that would be visible in orthographic projection of roof
side views.

__ Show roof slope angles.

EXTERIOR ELEVATION PROCEDURAL CHECKLIST continued

PHASE 2 -- "HARDLINE" INFORMATION continued

Construction Elements
__ Confirm locations and "hardline" any wall construction that was tentative and still in "light line."

__ Profile the finish grade line and perimeter exterior linework for emphasis.

Notation

__ Write identification notes or keynote reference numbers.

__ Where elements or dimensions are highly repetitive, note or dimension one and add "Typical" or "Unless Noted Otherwise" notes:

__ Write construction assembly notation and note references to specifications and details.

__ Complete gutters, downspouts, chimney flashing, etc.

__ Complete partial wall materials patterns, textures, handrail members, etc. Avoid extraneous entourage such as triple line door/window frames, foliage, shadows, etc.

__ Add final clarification reference notes regarding exterior finishes, fixtures, and auxiliary connected or adjacent construction.

__ Edit and update the keynote legend.

__ Add, edit, and update any General Notes that pertain to exterior construction.

Referencing & Symbols

__ Add detail bubbles such as for overhangs, soffits, handrails, etc.

__ If using a modular grid, add coordination letters and numbers.

__ Add small-scale reference key plan.

__ Add wall and cross-section reference keys and coordinate with small scale reference key plan. Key plans with exterior elevation, cross section, and wall section keys will be added later to all architectural working drawing sheets to aid the user in finding and cross-coordinating all drawing construction data.

__ Add view reference number or letter and coordinate with small scale reference key plan. Identify Exterior Elevation views by letter or number. Calling them "North, "South" etc. may be confusing to the user.

EXTERIOR ELEVATION PROCEDURAL CHECKLIST continued

PHASE 3 -- CHECKING

__ Use transparency prints to layer and cross-check and coordinate
Exterior Elevations with Floor Plans, Foundation Plans, and
Structural Framing Plans.

__ Especially double-check and confirm exact locations of fireplace flues
and chimneys.

__ For check prints, attach a blank transparency on the Exterior Elevations
and mark changes and additions in red and mark data that's correct
in yellow.

__ In each later phase of checking, remove the transparency from the first
check print and attach to the next phase check print. Verify that
required changes and additions have been completed as required,
and mark with yellow over the red marks.

__ To minimize oversights, checking for errors and incompleteness
should be a separate process from checking for progress.

__ Checking for changes and additions is often more complete and accurate
if done by a third party who has not been working on the project.

NOTES Date/Initials

ABOUT EXTERIOR ELEVATIONS

The primary purpose of the exterior elevations is to show heights of exterior construction elements. Despite this, important heights are often excluded, particularly heights of sills, lintels, thru-wall sleeves and openings, etc. The other most common omissions are "partial elevation" views of walls within small recesses or extensions.

Exterior elevations are most important to the designer in terms of showing design intent: forms, proportions, composition of exterior patterns and textures, etc. Their primary value to the contractor is to show heights and to identify junctures, joints, and boundaries of materials. This divergence in design intent and construction need is the source of most elevation errors and omissions. Double check that final elevations are elaborated upon specifically with construction data foremost in mind.

ITEMS THAT SHOULD BE AVOIDED ON EXTERIOR ELEVATION DRAWINGS

__ The most common area of overdrawing is the inclusion of door and window symbols referenced to schedules and details. Except possibly in the smallest of building designs, doors and windows should be referenced strictly on the plans. Any further referencing in elevations will either be unnecessary duplicated labor, or will be a source of error and contradiction as changes accumulate on plans which are not picked up in elevations.

__ Another common kind of overdrawing is the inclusion of sill/jamb/ head detail keys for doors and windows. Those detail keys should be in the door and window schedule frame drawings, not on plans or elevations. (A plan or exterior elevation detail key at doors or windows is justified only to call attention to one-of-a-kind construction conditions.)

__ Exterior elevations are frequently drawn at much larger scale than required for the information shown. For best speed and accuracy, elevations should be derived in direct one-to-one overlay taken from the exterior walls shown on the plans. Thus both plans and elevations should be at the same scale and should be at the smallest practical size. (This assumes other graphic simplifications have been implemented to make sure the plans are not crowded and cluttered.)

__ Use only partial indications of materials and textures, and single-line (or double-line at most) outlines of doors, windows, etc. (Large-scale drawings tend to encourage over-elaboration since they otherwise tend to look empty and unfinished.)

EXTERIOR ELEVATION COORDINATION

__ The exterior elevations should be derived directly, by overlay comparison and of exterior wall elements from the plans. This is a natural function of CADD but non-CADD drafters sometimes attempt to measure and draw elevations without direct tracing from plans -- an error-prone process.

__ Minor side views of recesses in the perimeter of a building are often overlooked. Double-check for small partial views.

__ If the exterior elevations show broken-line indications of below-grade construction, they should also be directly overlaid with foundation and/or basement plans in drawing and checking.

__ Do overlay comparisons of exterior elevations with structural drawings to verify structurally framed opening locations and sizes and the locations of vertical expansion or construction joints.

__ Do overlay comparisons of exterior elevations with roof plans to coordinate roof overhangs, visible roof slopes, and visible roof-mounted components.

__ Use overlay comparisons of exterior elevations with mechanical drawings to verify locations of air intakes, exhausts, hydrants, standpipes, exterior-mounted mechanical equipment, roof mechanical room and cooling tower sizes, etc.

__ Use overlay comparisons of exterior elevations with electrical drawings to verify exterior lighting, illuminated signage, exterior-mounted powered equipment, etc.

__ Use overlay comparisons of exterior elevations with roof plans to verify location of visible rainwater leaders. Compare locations with building perimeter drainage shown on site plans.

__ Compare exterior elevations with site plans to identify any attached or nearby site improvements such as walls, fences, walkway canopies, etc. that should be shown with exterior views of the building.

__ Compare exterior elevations with site plans to identify any site construction such as walls, kiosks, gazebos, fences, etc. that may require separate exterior elevation views.

__ Design or drafting staff don't always know whether the building's "north" elevation is supposed to face north or if the viewer is facing north. The office should have a stated rule in the drafting manual, and this rule should also be included as a general note on the drawings. Otherwise, and preferably, include number or letter symbols for all exterior views and show them on miniature key plans on all plan, elevation and section sheets.

ITEMS SUITED TO SYSTEMATIC PRODUCTION METHODS

__ When exterior elevations or variations of exterior designs are completed for presentation drawings, do all rendering and studies of design options on separate layers or overlays. Allow no notation or rendering elements on the original elevation drawing or layer. After final design revisions, use the uncluttered plain-line drawings as base sheets for working drawing overlays or CADD layers.

__ By keeping base sheets or layers uncluttered with architectural notes, you can print out screened shadow print images of the elevations with solid-line cross section drawings.

__ If the drawings include additions or remodeling work, make screened shadow print images of the existing conditions as background, and print new work in solid line. Similarly, if drawings include alternate or phased construction, use the combination of screened lines and solid-line overlay combinations to clearly separate base contract work from alternates, or first phase work from later construction.

__ Notes for exterior elevations are highly repetitive from view to view, so you can readily use one keynote legend and bubble reference all notation in the field of the drawing by number. In lieu of keynoting, you can create one or more strips of notes and copy them as needed onto each elevation view.

EXTERIOR ELEVATIONS -- GENERAL REFERENCE DATA

√ Dbl√

__ __ DRAWING TITLE AND SCALE

__ __ SHEET NUMBER AT TITLE BLOCK

__ __ TITLES OR SYMBOL KEYS TO IDENTIFY EACH ELEVATION
VIEW

__ __ KEY PLAN SHOWING NORTH ARROW AND ELEVATION
VIEW LOCATIONS

__ __ MODULAR GRID OR STRUCTURAL COLUMN GRID WITH
NUMBER AND LETTER COORDINATES

__ __ PROPERTY LINES

__ __ SETBACK LINES

__ __ OUTLINE OF ADJACENT STRUCTURES

__ __ OUTLINE OF FUTURE BUILDING ADDITIONS

__ __ MATCH UP LINE, OVERLAP LINE, AND REFERENCE IF
DRAWING IS CONTINUED ON ANOTHER SHEET

__ __ ITEMS N.I.C., N.I.C. ITEMS INSTALLED OR CONNECTED
BY CONTRACTOR

__ __ REMODELING
__ work to be removed __ work to remain
__ work to be repaired __ work to be relocated

__ __ GENERAL NOTES

__ __ BUILDING CODE REFERENCES

__ __ DRAWING CROSS REFERENCES

__ __ SPECIFICATION REFERENCES

__ __ CROSS SECTION LINES AND KEYS

__ __ WALL SECTION LINES AND KEYS

__ __ MATERIALS HATCHING (Use only partial materials indications
on building area.)

__ __ DETAIL KEYS (Not for doors, windows or storefront details.
Those details are to be referenced from schedules, not elevations or
plans.)

NOTES

Date/Initials

EXTERIOR ELEVATIONS -- SUBGRADE TO FLOOR LINE

√ Dbl√

__ __ EXISTING AND NEW FINISH GRADE LINE AND
ELEVATIONS (Rough grade, finish grade, and topsoil depth
sometimes shown.)

__ __ FILL AND ENGINEERED FILL

__ __ CRUSHED ROCK FILL

__ __ EXISTING UNDERGROUND CONSTRUCTION
__ to remain
__ to be repaired
__ to be removed

__ __ HOLE, TRENCH, EXCAVATION TO BE FILLED (02221)

__ __ EXISTING ROCK OUTCROP TO BE REMOVED (02211)

__ __ FOUNDATION WALL AND BASEMENT WALL
(03306/03307) (Show wall below grade in dash line.)
__ elevation point

__ __ FOOTINGS AT FOUNDATION WALLS AND BASEMENT
WALLS (03305)
__ elevation point at bottoms of footing

__ __ BUILDING SLAB FOOTING LINES (03308/03309)
__ slab floor line
__ chimney footing in slab
__ slab footing at other concentrated load
__ elevation point at bottom of footing

NOTES Date/Initials

EXTERIOR ELEVATIONS -- SUBGRADE TO FLOOR LINE
continued

√ Dbl√

__ __ DRAINPIPE AND GRAVEL BED AT FOOTING (02411)
 __ elevation point
 __ slope

__ __ BASEMENT WALL OPENING

__ __ CONCRETE (03316/03306/03307)

__ __ CONCRETE BLOCK (04229/04230)

__ __ BASEMENT WALL AREAWAY

__ __ FOUNDATION CRAWL SPACE AREAWAY

__ __ GRATING COVER FOR AREAWAY (05530)

__ __ GUARDRAIL AT AREAWAY (02451/05520)

__ __ CRAWL SPACE VENT (10200)

__ __ CRAWL SPACE ACCESS PANEL (03305/08305)

__ __ DOWNSPOUT/LEADER BOOT (07632)

__ __ SPLASH BLOCK (02435)

__ __ EXTERIOR WALKS
 __ WOOD PLANK (02506)
 __ CRUSHED STONE (02511)
 __ ASPHALTIC CONCRETE (02513)
 __ BRICK (02514)
 __ CONCRETE ((02529)
 __ ASPHALT (02516)
 __ STONE (02517)
 __ CONCRETE BLOCK/PAVERS (02518)
 __ GRAVEL (02519)
 __ TILE FINISH (09300)
 __ materials __ dimensions __ detail keys __ notes/refs
 __ elevation points __ direction of slopes
 coord check: __ fl plan __ site __ site/drain

__ __ CURBS
 __ STONE (02524)
 __ PRECAST CONCRETE (02526)
 __ ASPHALT CONCRETE (02527)
 __ CONCRETE (02528)
 __ materials __ dimensions __ detail keys __ notes/refs
 coord check: __ fl plan

EXTERIOR ELEVATIONS -- SUBGRADE TO FLOOR LINE
continued

√ Dbl√

__ __ EXTERIOR STEPS AND LANDINGS
 __ BRICK (02514)
 __ CONCRETE (02529)
 __ STONE (02517)
 __ CONCRETE BLOCK/PAVERS (02518)
 __ WOOD (02523)
 __ materials __ dimensions __ detail keys __ notes/refs
 __ elevation points __ slopes __ riser number and heights
 coord check: __ fl plan __ site __ site/drain

__ __ HANDRAILS AT EXTERIOR WALKS, RAMPS AND STEPS
 (05520 -- 05521)
 __ materials __ dimensions __ detail keys __ notes/refs
 coord check: __ code __ fl plan __ site

__ __ FOOTINGS AND ROCK SUB-BASE FOR EXTERIOR SLABS
 (03308)
 __ materials __ dimensions __ detail keys __ notes/refs
 coord check: __ civil/soil __ struct __ site

__ __ PLANTERS
 __ BRICK (04203)
 __ CONCRETE (03303)
 __ CONCRETE BLOCK (04220)
 __ WOOD (02447)
 __ materials __ dimensions __ detail keys __ notes/refs
 coord check: __ landscape __ site/drain __ plumb

__ __ RETAINING WALLS
 (Low height wood or brick retaining walls are considered to
 be planter walls.)
 __ CONCRETE (03302)
 __ CONCRETE BLOCK (04228)
 __ WOOD (02447)
 __ materials __ heights __ detail keys __ notes/refs
 coord check: __ civil/soil __ struct __ site/drain

__ __ BICYCLE AND HANDICAP RAMPS ADJACENT TO
 WALKWAY STEPS AND AT CURBS
 __ materials __ heights __ detail keys __ notes/refs
 coord check: __ code __ site

__ __ SOIL AND CRUSHED ROCK MATERIAL INDICATIONS

EXTERIOR ELEVATIONS -- SUBGRADE TO FLOOR LINE
continued

√ Dbl√

__ __ DIMENSIONS OF HEIGHTS OF BUILDING ELEMENTS
 __ footing thickness
 __ foundation wall heights
 __ depths of areaways
 __ paving elevations
 __ floor elevations
 __ top of basement floor to top of ground floor
 __ top of wall heights

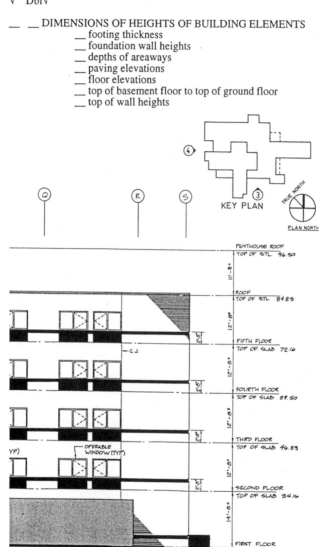

KEY PLAN

PENTHOUSE ROOF
TOP OF STL. 96.50

ROOF
TOP OF STL. 84.83

FIFTH FLOOR
TOP OF SLAB 72.16

FOURTH FLOOR
TOP OF SLAB 59.50

THIRD FLOOR
TOP OF SLAB 46.83

SECOND FLOOR
TOP OF SLAB 34.16

FIRST FLOOR
TOP OF SLAB 19.50

WING WALL BEYOND

OPERABLE WINDOW (TYP.)

190

EXTERIOR ELEVATIONS -- SUBGRADE TO FLOOR LINE
continued

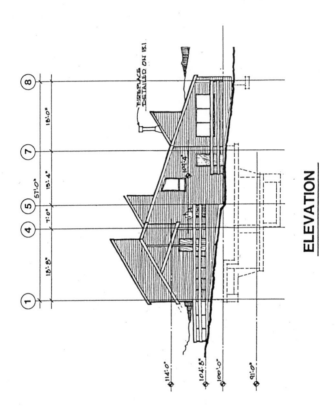

NOTES

Date/Initials

EXTERIOR ELEVATIONS -- FLOOR TO CEILING OR ROOF LINE

Most coordination checks should be made by comparing exterior elevations with floor plans and roof plans. Therefore, most "coord check" notes are omitted from the following portions of the exterior elevations checklist. Only those coordination checks which might not be found also on the floor plans or roof plan are included in this list.

√ Dbl√

__ __ ADJACENT OR ATTACHED FENCES AND GATES
 __ CHAIN LINK (02444)
 __ WIRE (02445)
 __ WOOD (02446)
 __ materials __ heights __ detail keys __ notes/refs
 coord check: __ site

__ __ ADJACENT OR ATTACHED YARD WALLS
 __ BRICK (04210)
 __ ADOBE (04212)
 __ CONCRETE BLOCK (04220)
 __ STONE (04400)
 __ materials __ heights __ detail keys __ notes/refs
 coord check: __ site

__ __ CONSTRUCTION JOINTS
 (Minor joints are normally not shown but are indicated in
 details and/or notation.)
 __ CONTROL JOINTS IN CONCRETE WALLS (03251)
 __ CONTROL JOINTS IN MASONRY SPANDRELS
 OVER OPENINGS (04180)
 __ PLYWOOD SIDING MOVEMENT JOINTS (1/4"
 BETWEEN PANELS) (06420)
 __ locations __ detail keys __ notes/refs
 coord check: __ specs __ struct

__ __ WEEP HOLES
 (Normally indicated in details and general notes rather than
 in the broadscope Exterior Elevations.)
 __ BRICK CAVITY WALLS (02414)
 __ CONCRETE BLOCK CAVITY WALLS (04220)
 __ MASONRY VENEER (04215)
 __ GLAZED METAL CURTAIN WALLS (08900)
 __ heights/spacings __ detail keys __ notes/refs

__ __ EXTERIOR-MOUNTED HVAC ENCLOSURES (05551)
 __ heights __ detail keys __ notes/refs
 coord check: __ code __ hvac __ wall anch __ elec

EXTERIOR ELEVATIONS -- FLOOR TO CEILING OR ROOF LINE
continued

√ Dbl√

__ __ EXTERIOR LANDING OR STOOP PAVING
 (Top of exterior landing 3" below door thresholds.)
 __ BRICK (02514)
 __ CONCRETE (02529)
 __ STONE (02517)
 __ CONCRETE BLOCK/PAVERS (02518)
 __ WOOD (02523)
 __ materials __ dimensions __ detail keys __ notes/ref
 __ elevation points __ slopes
 coord check: __ site

__ __ HANDRAILS AT EXTERIOR STAIR LANDINGS OR STOOPS
 (05520 -- 05521)
 __ materials __ dimensions __ detail keys __ notes/refs
 coord check: __ slab/wall anch

__ __ DECK, PORCH, AND BALCONY RAILINGS OR RAILING
 WALLS (Newels or horizontal members spaced at 9" maximum.)
 __ BRICK (04210)
 __ CONCRETE BLOCK (04220)
 __ METAL (05520)
 __ WOOD (06440)
 __ CHAIN LINK/WIRE (02444/02445)
 __ materials __ dimensions __ detail keys __ notes/refs
 coord check: __ slab/wall anch

__ __ METERS
 __ WATER (15181)
 __ GAS (15182)
 __ ELECTRIC (16430)
 __ heights __ notes/refs
 coord check: __ util __ site __ wall anch

__ __ PILASTERS
 __ CONCRETE (03317)
 __ REINFORCED BRICK (04216)
 __ REINFORCED CONCRETE BLOCK (04230)
 __ materials __ heights __ detail keys __ notes/refs
 coord check: __ struct

__ __ EXTERIOR POSTS AND COLUMNS
 __ REINFORCED BRICK (04216)
 __ CONCRETE (03317)
 __ REINFORCED CONCRETE BLOCK (04230)
 __ STEEL WF (05110)
 __ TIMBER, MILL FRAME (06132/06133)
 __ TUBULAR STEEL (05122)
 __ WOOD (06101 -- 06104)
 __ materials __ heights __ detail keys __ notes/refs
 coord check: __ struct __ site

EXTERIOR ELEVATIONS -- FLOOR TO CEILING OR ROOF LINE
continued

√ Dbl√

__ __ PARKING GUARDRAILS (02451)
 __ materials __ dimensions __ detail keys __ notes/refs
 coord check: __ site __ cross sect

__ __ PARKING BUMPERS (02456)
 __ materials __ dimensions __ detail keys __ notes/refs
 coord check: __ site __ slab/wall anch

__ __ CORNER GUARDS (10260)
 __ materials __ heights __ detail keys __ notes/refs
 coord check: __ wall anch

__ __ LOADING DOCK (11160)
 __ materials __ dimensions __ detail keys __ notes/refs
 coord check: __ site __ cross sect __ wall anch __ elec

__ __ DOCK BUMPERS (11165)
 __ materials __ detail keys __ notes/refs
 coord check: __ wall anch

__ __ LOADING DOCK SHELTER (11164)
 (Canopy height clearance for trucks.)
 __ materials __ heights __ detail keys __ notes/refs
 coord check: __ roof __ cross sect __ wall anch __ elec

__ __ EXTERIOR FINISH CARPENTRY (06200)
 __ dimensions/spacings __ detail keys __ notes/refs
 coord check: __ millwork schedule

__ __ DOWNSPOUTS (07632)
 __ gutters
 __ leaders
 __ leader connection to wall
 __ materials __ dimensions __ detail keys __ notes/refs
 coord check: __ roof __ site/drain __ wall anch

__ __ HOSE BIBBS/ WALL HYDRANTS (15109)
 (Shown only if important in relationship to other elements.)
 __ heights __ notes/refs
 coord check: __ plumb __ wall anch __ drain

__ __ STANDPIPES (15530)
 (Siamese fire department connections and identifying sign.)
 __ locations __ detail keys __ notes/refs
 coord check: __ code __ plumb __ wall anch

__ __ INTEGRATED STOREFRONT SYSTEM (08400)
 __ materials __ heights __ detail keys __ notes/refs
 coord check: __ sched

EXTERIOR ELEVATIONS -- FLOOR TO CEILING OR ROOF LINE
continued

√ Dbl√

__ __ CAULKING AT DOOR AND WINDOW FRAMES (07900)
(Caulking particularly required in masonry walls.)
 __ detail keys __ notes/refs
 coord check: __ specs

__ __ DOOR AND WINDOW FLASHING (07620 -- 07626)
 __ detail keys __ notes/refs
 coord check: __ specs

__ __ DOORS AND WINDOWS
(Door and window identification and schedule keys are
shown on plan. Detail keys are to be shown on the door
and window frame schedules. Door and window detail keys
are sometimes also added to the plan and elevation drawings
in special cases to call attention to exceptional conditions.)
 __ sills
 __ trim
 __ muntins
 __ mullions
 __ direction of swing, direction of slide, swing of hopper
 units may be shown in special cases
 __ heights __ detail keys __ notes/refs
 coord check: __ schedules

__ __ SHUTTERS
 __ METAL (08300/10240)
 __ WOOD (06235)
 __ materials __ heights __ detail keys __ notes/refs
 coord check: __ wall anch

__ __ GRILLES AT WINDOWS (10240)
(Used mainly where windows are accessible from exterior
walkways or stairs.)
 __ materials __ heights __ detail keys __ notes/refs
 coord check: __ wall anch __ window sched

__ __ WIRE MESH WINDOW GUARDS (10240)
 __ fixed __ operable
 __ materials __ dimensions __ detail keys __ notes/refs
 coord check: __ wall anch __ window sched

__ __ SECURITY WINDOWS (08651)
 __ materials __ heights __ detail keys __ notes/refs
 coord check: __ window sched

EXTERIOR ELEVATIONS -- FLOOR TO CEILING OR ROOF LINE
continued

√ Dbl√

__ __ FIXED GLASS (08800)
(Glass type should be identified in window schedule but
may be noted in plans or elevations in drawings for smaller
buildings.)
 __ DOUBLE GLAZING (08802)
 __ INSULATING GLASS (08823)
 __ LAMINATED SAFETY GLASS (08822)
 __ OBSCURE GLASS/ROUGH AND FIGURED (08815)
 __ PLATE/FLOAT (08811)
 __ PLASTIC (08620/08840)
 __ PLASTIC INSULATING (08845)
 __ SPANDREL GLASS (08817)
 __ STAINED GLASS (12170)
 __ TEMPERED GLASS (08813)
 __ materials __ heights __ detail keys __ notes/refs
 coord check: __ specs __ window sched

__ __ AIR INTAKE OR VENT LOUVERS (10200)
 __ materials __ heights __ detail keys __ notes/refs
 coord check: __ hvac

__ __ AIR INTAKE OR VENT GRILLES AND SCREENS (10240)
 __ materials __ heights __ detail keys __ notes/refs
 coord check: __ hvac

__ __ BUILDING NAME AND ADDRESS PLAQUES (10420)
 __ materials __ location __ detail keys __ notes/refs
 coord check: __ site __ elec

__ __ ARCHITECT'S PLAQUE (10420)
 __ materials __ location __ detail keys __ notes/refs
 coord check: __ site

__ __ EXTERIOR-MOUNTED FIRE ALARMS (16721)
 __ heights __ detail keys __ notes/refs
 coord check: __ code __ elec

__ __ EXTERIOR-MOUNTED BURGLAR ALARMS (16727)
 __ heights __ detail keys __ notes/refs
 coord check: __ elec

__ __ WALL-MOUNTED FLAGPOLES (10350)
 __ heights __ detail keys __ notes/refs
 coord check: __ wall anch

__ __ EXTERIOR BUILDING LIGHTING (16520)
 __ locations __ notes/refs
 coord check: __ site __ elec

EXTERIOR ELEVATIONS -- FLOOR TO CEILING OR ROOF LINE
continued

√ Dbl√

__ __ WALL-MOUNTED SIGNS (10440)
 __ materials __ dimensions __ detail keys __ notes/refs
 coord check: __ wall anch __ elec

__ __ NIGHT DEPOSITORY SLOTS AND BOX (11026)
 __ heights __ detail keys __ notes/refs
 coord check: __ site __ elec

__ __ WASTE HANDLING EQUIPMENT (11170)
 __ locations __ notes/refs
 coord check: __ site

__ __ TRASH/WASTE HANDLING EQUIPMENT ENCLOSURES
 __ BRICK (04210)
 __ CHAIN LINK FENCE (02444)
 __ CONCRETE BLOCK (04220)
 __ WIRE FENCE (02445)
 __ WOOD (02446)
 __ materials __ dimensions __ detail keys __ notes/refs
 coord check: __ site __ elec

__ __ FLASHING AT CHANGES IN BUILDING MATERIAL
 (07600 -- 07626)
 __ detail keys __ notes/refs
 coord check: __ specs

__ __ DRIPS AT UNDERSIDE EDGE OF CANTILEVERED
 BALCONIES AND WALL PROJECTIONS
 __ locations __ detail keys __ notes/refs
 coord check: __ struct

__ __ MARQUEES (10533)
 __ materials __ dimensions __ detail keys __ notes/refs
 coord check: __ struct __ roof __ cross sect __ wall anch

__ __ SUN SCREENS (10700)
 __ materials __ dimensions __ detail keys __ notes/refs
 coord check: __ struct __ wall anch

__ __ AWNINGS (10535)
 __ materials __ dimensions __ detail keys __ notes/refs
 coord check: __ wall anch

__ __ CANOPIES (10531)
 __ scuppers/rain water leaders
 __ materials __ dimensions __ detail keys __ notes/refs
 coord check: __ struct __ roof __ cross sect __ wall anch

EXTERIOR ELEVATIONS -- FLOOR TO CEILING OR ROOF LINE
continued

√ Dbl√

__ __ EXTERIOR WALLS/WALL FINISHES
 __ ADOBE (04212)
 __ BRICK (04210)
 __ BRICK CAVITY WALL (04214)
 __ BRICK VENEER (04215)
 __ CONCRETE BLOCK, REINFORCED (04230)
 __ CONCRETE, CAST-IN-PLACE (03316)
 __ CONCRETE, PRECAST (03450)
 __ CONCRETE, PRECAST PANELS (03411)
 __ CONCRETE, TILT-UP (03430)
 __ GLAZED CURTAIN WALLS (08900)
 __ STONE (04400)
 __ CUT STONE (04420)
 __ FLAGSTONE (04440)
 __ MARBLE VENEER (04451)
 __ NATURAL STONE VENEER (04450)
 __ ROUGH STONE (04410)
 __ PLYWOOD SIDING (07465)
 __ METAL SIDING (07411)
 __ WOOD FRAMING AND SHEATHING (06110)
 __ WOOD SIDING (07461)
 __ STUCCO (09230)
 __ wall material indications, textures, and patterns
 __ material __ heights __ detail keys __ notes/refs
 coord check: __ cross sect __ wall sect

NOTES Date/Initials

EXTERIOR ELEVATIONS -- FLOOR TO CEILING OR ROOF LINE

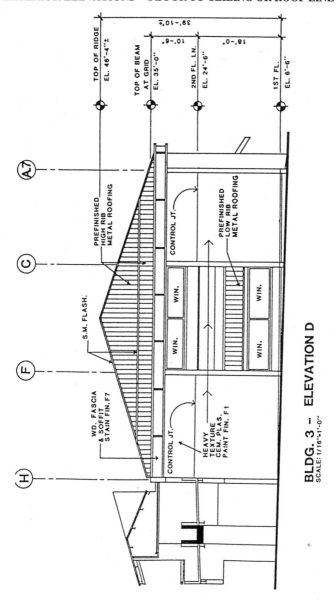

BLDG. 3 — ELEVATION D
SCALE: 1/16"=1'-0"

NOTES

Date/Initials

EXTERIOR ELEVATIONS -- CEILING LINE TO ROOF

√　Dbl√

__ __ FASCIAS
 __ CONCRETE　(03450)
 __ METAL　(05730)
 __ WOOD　(06160)
 __ TERRA COTTA　(04251)
 __ materials __ dimensions __ detail keys __ notes/refs
 coord check: __ ref clg __ cross sect

__ __ EXTERIOR SOFFITS
 __ METAL　(05730)
 __ STUCCO　(09200)
 __ WOOD　(06420)
 __ exterior soffit lines
 __ construction and control joints
 __ materials __ dimensions __ detail keys __ notes/refs
 coord check: __ ref clg __ cross sect

__ __ EAVE SOFFIT VENTS　(10200/10240)
 __ materials __ dimensions __ detail keys __ notes/refs
 coord check: __ ref clg __ hvac

__ __ RIDGE VENTS　(07630)
 __ materials __ dimensions __ detail keys __ notes/refs
 coord check: __ roof __ hvac

__ __ ATTIC VENTS　(10200/10240)
 __ materials __ dimensions __ detail keys __ notes/refs
 coord check: __ roof __ hvac

__ __ GRAVEL STOPS　(07660)
 __ materials __ dimensions __ detail keys __ notes/refs
 coord check: __ specs __ roof

__ __ CAP FLASHING　(07603)
 __ materials __ dimensions __ detail keys __ notes/refs
 coord check: __ specs __ roof

__ __ GUTTERS　(07631)
 __ materials __ dimensions __ detail keys __ notes/refs
 coord check: __ roof __ site/drain __ wall anch

__ __ RAIN DEFLECTORS　(07634)
 __ materials __ dimensions __ detail keys __ notes/refs
 coord check: __ roof __ site/drain

__ __ DOWNSPOUTS　(07632)
 __ materials __ dimensions __ detail keys __ notes/refs
 coord check: __ roof __ site/drain __ wall anch

__ __ RAIN DOWNSPOUTS/LEADERS AND LEADER STRAPS
(07632)
 __ materials __ dimensions __ detail keys __ notes/refs
 coord check: __ site/drain __ wall anch

EXTERIOR ELEVATIONS -- CEILING LINE TO ROOF
continued

√ Dbl√

__ __ SCUPPERS (07633)
 __ materials __ dimensions __ detail keys __ notes/refs
 coord check: __ roof __ site/drain __ wall anch

__ __ EAVE SNOW GUARDS (07635)
 __ materials __ dimensions __ detail keys __ notes/refs
 coord check: __ roof

__ __ PARAPETS
 __ CONCRETE (03300/03400)
 __ MASONRY (04200)
 __ METAL FRAME (05100/05400)
 __ WOOD FRAME (06168)
 __ materials __ dimensions __ detail keys __ notes/refs
 coord check: __ struct __ roof __ cross sect __ wall sect

__ __ PARAPET COPINGS
 (Parapet cap slope inward toward roof.)
 __ MASONRY (04200)
 __ METAL (07665)
 __ STONE (04400)
 __ materials __ dimensions __ detail keys __ notes/refs
 coord check: __ roof __ wall sect

__ __ PARAPET EXPANSION JOINTS (05802)
 __ locations __ detail keys __ notes/refs
 coord check: __ specs __ wall sect

__ __ RAILINGS (05520)
 __ materials __ dimensions __ detail keys __ notes/refs
 coord check: __ code __ struct __ roof/wall anch
 __ wall sect

__ __ ROOF LADDERS (05517)
 __ materials __ dimensions __ detail keys __ notes/refs
 coord check: __ struct __ roof/wall anch

__ __ FINISH ROOFING MATERIALS
 __ ASPHALT SHINGLES (07311)
 __ BUILT-UP ROOF (07510)
 __ CLAY TILES (07321)
 __ CONCRETE TILES (07322)
 __ MEMBRANE ROOF (07550/07560)
 __ METAL SHINGLES (07316)
 __ PREFORMED METAL (07412)
 __ SHEET METAL (07610)
 __ SLATE SHINGLES (07314)
 __ WOOD SHINGLES/SHAKES (07313)
 __ detail keys __ notes/refs
 coord check: __ specs __ roof __ cross sect

EXTERIOR ELEVATIONS -- CEILING LINE TO ROOF
continued

√ Dbl√

__ __ SKYLIGHTS (07810)
　　　　__ materials __ dimensions __ detail keys __ notes/refs
　　　　coord check: __ roof __ cross sect

__ __ MECHANICAL EQUIPMENT ENCLOSURE
　　　　__ materials __ dimensions __ detail keys __ notes/refs
　　　　coord check: __ roof __ hvac

__ __ COOLING TOWERS (15650)
　　　　__ materials __ dimensions __ detail keys __ notes/refs
　　　　coord check: __ roof __ hvac

__ __ COOLING TOWER PENTHOUSE
　　　　__ materials __ dimensions __ detail keys __ notes/refs
　　　　coord check: __ roof __ hvac

__ __ SOLAR HEAT COLLECTION PANELS (13980)
　　　　__ materials __ dimensions __ detail keys __ notes/refs
　　　　coord check: __ struct __ roof __ roof anch __ hvac
　　　　__ cross sect

__ __ SOLAR WATER HEATERS (13980/15431)
　　　　__ materials __ dimensions __ detail keys __ notes/refs
　　　　coord check: __ struct __ roof __ roof anch __ hvac
　　　　__ cross sect

__ __ WATER TANKS (13410/15400)
　　　　__ materials __ dimensions __ detail keys __ notes/refs
　　　　coord check: __ roof __ struct __ plumb

__ __ WATER TANK ENCLOSURE
　　　　__ materials __ dimensions __ detail keys __ notes/refs
　　　　coord check: __ roof

__ __ STAIR BULKHEADS
　　　　__ materials __ dimensions __ detail keys __ notes/refs
　　　　coord check: __ stair pl/sect __ roof __ cross sect

__ __ ELEVATOR PENTHOUSE/MACHINE ROOM (14200)
　　　　__ materials __ dimensions __ detail keys __ notes/refs
　　　　coord check: __ elev pl/sect __ roof __ cross sect

__ __ CHIMNEYS
　　　　__ MASONRY (04210)
　　　　__ PREFAB (10300)
　　　　__ flues
　　　　__ spark arrestors
　　　　__ coping caps
　　　　__ chimney coping block or cement wash slope toward flue
　　　　__ materials __ dimensions __ detail keys __ notes/refs
　　　　coord check: __ code __ struct __ hvac __ cross sect

EXTERIOR ELEVATIONS -- CEILING LINE TO ROOF
continued

√ Dbl√

__ __ CHIMNEY FLASHING (07608)
 __ saddle
 __ cricket
 __ materials __ dimensions __ detail keys __ notes/refs
 coord check: __ specs

__ __ ROOF ANTENNA
 __ TV TOWER MASTER ANTENNA (06781)
 __ SATELLITE DISH ANTENNA (11800/16700)
 __ BROADCAST ANTENNA (16781)
 __ locations __ detail keys __ notes/refs
 coord check: __ code __ struct __ roof anch __ elec

__ __ GUY WIRE ANCHORS FOR TV, FM, OR SHORTWAVE
ANTENNAS (07871)
 __ detail keys __ notes/refs
 coord check: __ roof anch

__ __ FLAGPOLES (10350)
 __ locations/heights __ detail keys __ notes/refs
 coord check: __ struct __ roof __ roof anch __ elec

__ __ LIGHTNING RODS (16601)
 __ detail keys __ notes/refs
 coord check: __ roof __ roof anch __ elec

__ __ WEATHER VANES (05700)
 __ detail keys __ notes/refs

__ __ OVERHEAD CABLE PERISCOPE ENTRY HEADS
(16401/16420)
 __ detail keys __ notes/refs
 coord check: __ util __ roof/wall anch

__ __ ROOF-MOUNTED SIGNS (10430-10440)
 __ materials __ dimensions __ detail keys __ notes/refs
 coord check: __ code __ struct __ roof anch __ elec

__ __ PREFABRICATED ROOF SPECIALTIES
 __ STEEPLES (10341)
 __ SPIRES (10342)
 __ CUPOLAS (10343)
 __ materials __ dimensions __ detail keys __ notes/refs
 coord check: __ struct __ roof __ roof anch __ cross sect

__ __ ROOFING MATERIALS INDICATIONS

EXTERIOR ELEVATIONS -- CEILING LINE TO ROOF
continued

√ Dbl√

__ __ DIMENSIONS
 __ roof slopes in inches per foot
 __ eave overhang
 __ depth of fascia
 __ height of parapet
 __ height of equipment enclosures
 __ floor to floor heights
 __ window, door, opening head heights from floor line
 __ floor to ceiling heights
 __ note whether vertical dimensions are to finish surfaces,
 subflooring, or framing
 __ note whether opening dimensions are rough or finish.

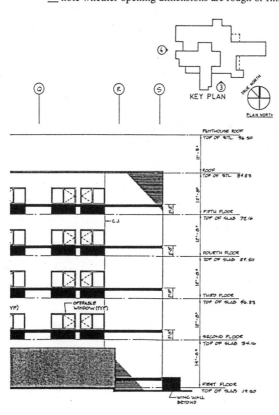

EXTERIOR ELEVATIONS -- FLOOR TO CEILING OR ROOF LINE
continued

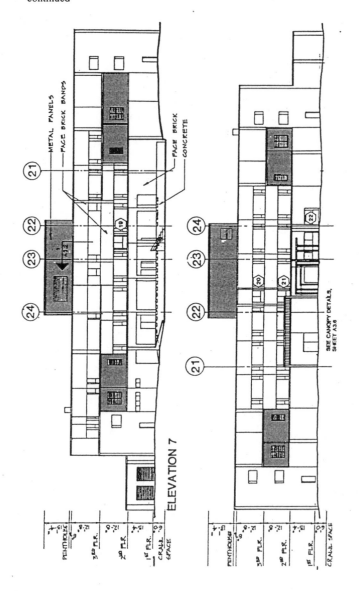

ELEVATION 7

NOTES

Date/Initials

ROOF PLANS

CHAPTER CONTENTS

ROOF PLAN PROCEDURAL CHECKLIST

ROOF PLAN LAYOUT AND DRAFTING, STEP BY STEP

PHASE 1 -- "OUTLINE" INFORMATION

AND INFORMATION REQUIRED BY CONSULTANTS

First, update and verify upper level room sizes in the ground floor plan.
Using the updated floor plan as your guide, proceed with the following steps.

__ Decide on the desirable scale, size, and positioning of the Roof
Plan on the working drawing sheet(s). Consider locations of
Keynote legend, General Notes, Symbols Legend (if any), Titles,
Key Plan, and roof-related details.

__ Small projects may include the roof plan at small scale as part of the
site plan. At that scale, only overhangs, materials, slopes, and
major features will be shown.

Layout & Linework

__ Use the uncompleted floor plan (upper-level if a multi-level building) --
at the stage showing walls, partitions etc. as the base sheet or base
layer for the roof plan.

__ Show roof overhangs with exterior wall line below shown in screened
or dash line.

__ Rough in roof openings for skylights, chimneys, plumbing chases, etc.

__ Show dash lines for relevant hidden construction below the roof.

__ Rough in gutter, scupper, and rain leader locations. Coordinate with
Site Plan, Plumbing Plan, and Foundation Plan.

ROOF PLAN PROCEDURAL CHECKLIST

PHASE 2 -- "HARDLINE" INFORMATION

AND DETAILED ARCHITECTURAL CONSTRUCTION DATA

__ The floor plan may be printed as a screened back ground image
with roof elements shown in solid line. If preferred, a wall
layer only may be shown in solid line in combination with
ceiling elements as doable with CADD layering.

Construction Elements

__ Show chimneys and flues.

__ Show thru-roof chases.

__ Show flashing, crickets, and valley flashing.

__ Show roof mounted antennas.

__ Show roof mounted lighting and overhead utility line connections.

__ Show final roof drains, gutters, scuppers, leaders, etc. Coordinate
with site drainage.

Dimensioning

__ Draw dimension lines as required for roof mounted equipment that
must be precisely located.

__ Add dimension numbers in feet and inches.

Titles, Labels, & Referencing

__ Add Roof Plan drawing title and scale.

__ Add roof materials and Keynote numbers or identification notes.

Plans should be ready at this point as base-layer references for drawings
by Mechanical Engineering and Electrical Engineering consultants.

Layout & Linework

__ Confirm upper floor level wall locations.

ROOF PLAN PROCEDURAL CHECKLIST continued

PHASE 2 -- "HARDLINE" INFORMATION continued

Construction Elements

__ Complete partial ceiling or soffit patterns, textures, and wall materials indications.

__ Show thru-roof plumbing.

Notation

__ Add reference notes to special areas shown elsewhere at larger scale.

__ Write materials identification notes or keynote reference numbers.

__ Where elements or dimensions are highly repetitive, note or dimension one and add "Typical" or "Unless Noted Otherwise" notes:

__ Write construction assembly notation and note references to specifications and details.

__ Add final clarification reference notes regarding roof-mounted fixtures and equipment.

__ Edit and update the Keynotes legend.

__ Add, edit, and update any General Notes that pertain to ceiling construction.

Referencing & Symbols

__ Show partial indications of roof framing and sheathing or refer to roof framing plans.

__ Show roof joist framing directions arrow with size and spacing notes or refer to roof framing plans. Don't include framing indications if complete separate framing plans are provided.

__ Add detail reference bubbles for ceiling construction details.

__ Key high roof-mounted equipment and fixtures to Equipment and Fixtures Schedules.

__ Show cross-section cut lines.

__ Show key plans with elevation references and cross section cut lines.

ROOF PLAN PROCEDURAL CHECKLIST continued

PHASE 3 -- CHECKING

___ Use transparency prints to cross check and coordinate Roof Plan
 with Floor Plans, Electrical Plans, Plumbing Plans, and
 HVAC plans.

___ For check prints, attach a blank transparency on the Roof Plan and
 mark changes and additions in red and data that's correct in yellow.

___ In each later phase of checking, remove the transparency from the first
 check print and attach to the next phase check print. Verify that
 required changes and additions have been completed as required,
 and mark with yellow over the red marks.

___ To minimize oversights, checking for errors and incompleteness
 should be separate from checking for progress.

___ Checking for errors and omissions is often more complete and accurate
 if done by a third party who has not been working on the project.

NOTES Date/Initials

NOTES

ABOUT ROOF PLANS

The roof plan is usually the simplest type of plan drawing, but its subject is the source of about 50% of all claims and lawsuits against design firms. The quality of a roofing installation is primarily established by specifications, flashing and roofing details, and stringent construction administration.

Roof plans are mainly for showing slopes, drainage, junctures of change in roof materials or construction, roof appurtenances such as bulkheads, and most importantly, to identify and reference all relevant construction detailing.

Besides inadequate detailing and improper roofing application, the most common source of roofing failure is in drainage. Roofing slopes are often minimal, and they flatten out more during construction. Later the nonslopes become undrainable ponds after the building settles. Even if the drain slopes are generous, often enough the drains themselves are inadequate in number and size.

The major sources of structural failure are inadequate allowances for extra heavy rain and ice loads and uneven loading in high winds and blizzards. Wind driven snow that piles up against parapets, bulkheads, and the like (aggravated by clogged drains) has caused hundreds of roofing failures these past few years.

ITEMS THAT SHOULD BE AVOIDED ON ROOF PLANS

__ Roofing notes tend to be overly specific and either duplicate or contradict the specifications. Use simple generic identification notes and leave exact materials, gauges, and application instructions for specifications.

__ Roof framing should usually be drawn on its own sheet and not combined with the roof plan. The roof plan is to show finish construction and it can be confusing when finish work is mixed in with structure or substructure. However, it can be useful to combine framing and finished roofing as base and overlay sheets. Then framing can be printed as a screened background shadow print to show its coordination with major features of the roof.

__ Drafters sometimes get overly decorative on special roof textures and materials indications. Use only partial indications or texturing.

ROOF PLAN COORDINATION

___ Roof plans should be directly derived from the uppermost building
floor plan by means of overlay drafting or by use of reproducible
background sheets. If using overlay drafting, you can print final
roof plans with a screened shadow print of the upper floor plan as
background reference for solid-line roof construction. That will
help assure 100% coordination between floor plan and roof.

___ The main coordination trouble spots are usually in the relationship of
the roof plan with structural drawings, with plumbing drawings
showing interior roof drains and rain water leaders, and with
building drainage at the sitework level.

___ The most crucial coordination trouble spot is the relationship of roof
plan and roof details to specifications. Details are frequently
drawn (copied) by unqualified junior or intermediate level drafting
staff members and often fail to fit the building situation they're
supposedly designed for. Specifications, even if correct, often fail
to agree with the drawings which creates another facet of the
problem. In checking the roof plan and roofing details,
specifications should be read side by side with the drawings.

ITEMS SUITED TO SYSTEMATIC PRODUCTION METHODS

___ As noted above, roof plans should be created as overlay sheets or
CADD layers in one-to-one reference to upper floor plans.
This not only maximizes coordination between roof, floor, and
consultants' plans, it allows the use of shadow prints to show the
upper floor plan as a screened background image in contrast to
solid-line roof data.

___ Roof construction details are highly standardized and should be a
large part of the office's master and reference detail library. As you
complete roofing details on a variety of projects, consider creating
an overall standard detail sheet with a variety of details reusable
from job to job.

___ If the roofing work includes repair or remodeling, use photo drafting.
Combine photographs of existing conditions with line drawing and
notation of new work.

___ Since the notation on roof plans tends to be sparse but highly repetitive,
it's especially convenient to use note numbers linked to a keynote
legend on the side of the drawing. Consider attaching detail keys to
the same legend to combine both types of data.

NOTES

ROOF PLANS -- REFERENCE INFORMATION

√ Dbl√

___ ___ BUILDING OUTLINE AND ROOF OUTLINE
(Broken-line building perimeter where shown below roof overhang.)

___ ___ OVERALL EXTERIOR WALL DIMENSIONS

___ ___ ROOF OVERHANG DIMENSIONS

___ ___ OUTLINE OF FUTURE ADDITIONS

___ ___ CONNECTION WITH EXISTING STRUCTURES

___ ___ BUILDING AND ROOF EAVE DIMENSIONS

___ ___ DIMENSIONS TO PROPERTY LINES

___ ___ BUILDING LOCATION REFERENCED TO BENCH MARK

___ ___ REQUIRED PROPERTY SETBACK LINES

___ ___ ALL PROJECTIONS LABELED AND DIMENSIONED
SHOWING COMPLIANCE WITH PROPERTY LINE AND
SETBACK REQUIREMENTS

___ ___ STAIR NUMBERS

___ ___ OUTLINE OF OPENINGS AND PROJECTIONS
___ bays
___ areaways
___ balconies
___ marquees
___ canopies
___ landings
___ decks
___ steps
___ sills

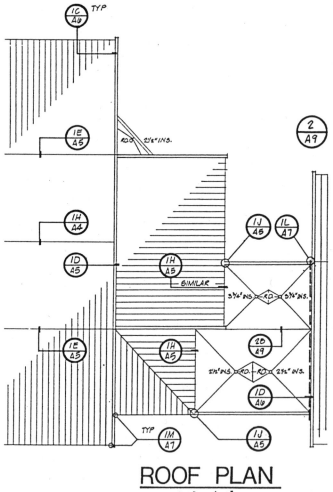

ROOF PLAN

SCALE: 1/32" = 1'-0"

NOTES

Date/Initials

ROOF PLANS -- CONSTRUCTION COMPONENTS

All items are assumed to require cross-checking with architectural floor plans, so those "coord checks" aren't listed. Most items are also assumed to require coordination checking with specifications, so that note is included only on the most critical items. Coordination checks with structural drawings are listed along with many other cross-checks that are most commonly overlooked.

√ Dbl√

__ __ LOWER STORY CANOPIES AND MARQUEES (10530)
 __ slopes
 __ drains and scuppers
 __ materials __ dimensions __ detail keys __ notes/refs
 coord check: __ code __ struct __ wall anch __ ext elev
 __ cross sect

__ __ UPPER FLOOR BALCONIES
 __ drain slopes
 __ drains and scuppers
 __ materials __ dimensions __ detail keys __ notes/refs
 coord check: __ code __ struct __ wall anch __ ext elev
 __ cross sect

__ __ ROOF DRAINS (15422)
 __ locations __ detail keys __ notes/refs
 coord check: __ plumb __ struct __ roof anch __ site drain

__ __ SCUPPERS (07633)
 __ locations __ detail keys __ notes/refs
 coord check: __ site drain __ roof anch

__ __ ROOF GUTTERS (07631)
 __ gutter screens
 __ expansion joints
 __ slopes and directions of slopes
 __ materials __ dimensions __ detail keys __ notes/refs
 coord check: __ site drain __ roof anch

__ __ DOWNSPOUTS AND RAIN WATER LEADERS (07632)
 __ strainers at tops of leaders
 __ overflows
 __ materials __ dimensions __ detail keys __ notes/refs
 coord check: __ site drain __ roof anch

__ __ ROOF SLOPES: DIRECTION OF SLOPES AND DEGREE IN INCHES PER FOOT
 __ valleys
 __ hips
 __ ridges
 coord check: __ struct __ ext elev __ cross sect

ROOF PLANS -- CONSTRUCTION COMPONENTS continued

√ Dbl√

__ __ GRAVEL STOPS (07660)
 __ expansion joints
 __ materials __ detail keys __ notes/refs

__ __ FASCIAS
 __ CONCRETE (03450)
 __ TERRA COTTA (04251)
 __ METAL (05730)
 __ WOOD (06160)
 __ materials __ dimensions __ detail keys __ notes/refs
 coord check: __ ext elev __ wall sect

__ __ EXPANSION JOINTS AND EXPANSION JOINT COVER
 (05802/05805)
 __ materials __ detail keys __ notes/refs
 coord check: __ specs __ struct __ cross sect

__ __ EAVE SNOW GUARDS (07635)
 __ materials __ dimensions __ detail keys __ notes/refs
 coord check: __ struct __ roof anch __ drain __ cross sect

__ __ PARAPETS
 __ CONCRETE (03300/03400)
 __ MASONRY (04200)
 __ METAL FRAME (05160/05400)
 __ WOOD FRAME (06100)
 __ expansion joints
 __ materials __ dimensions __ detail keys __ notes/refs
 coord check: __ struct __ ext elev __ cross sect
 __ wall sect

__ __ PARAPET FLASHING (07603/07604)
 __ materials __ detail keys __ notes/refs
 coord check: __ specs __ wall sect

__ __ PARAPET CAP FLASHING (07603)
 __ materials __ detail keys __ notes/refs
 coord check: __ specs __ ext elev __ cross sect
 __ wall sect

__ __ ROOF FRAMING (Sometimes shown in partial plan view.)
 __ CONCRETE (03300/03400)
 __ STEEL (05100)
 __ WOOD (06100)
 __ girders __ beams __ joists __ rafters __ trusses
 __ purlins __ joist bridging
 __ materials __ sizes/spacings __ detail keys __ notes/refs
 coord check: __ struct __ hvac __ plumb __ cross sect
 __ wall sect

ROOF PLAN LEGEND

BASE: ELEVATION = TOP OF 2" INSULATION AS SHOWN DETAIL 1/A-13

NUMBER INDICATES TOP OF INSULATION ABOVE (+) OR BELOW (-) BASE ELEVATION 'O'

NUMBER INDICATES TOP OF 2" INSULATION AROUND ROOF DRAIN IN RELATION TO BASE ELEVATION 'O'

INDICATES AREA WHERE INSULATION IS BUILT UP ON TOP OF 2" BASE INSULATION

LINE OF EXPANSION JOINT

DIRECTION OF SLOPE

ROOF PLANS -- CONSTRUCTION COMPONENTS continued

√ Dbl√

__ __ ROOF SHEATHING (06113)
 (Often shown in partial plan view.)
 __ detail keys __ notes/refs
 coord check: __ specs __ cross sect __ wall sect

__ __ FINISH ROOFING MATERIALS
 __ ASPHALT SHINGLES (07311)
 __ BUILT-UP ROOF (07510)
 __ CLAY TILES (07321)
 __ CONCRETE TILES (07322)
 __ MEMBRANE ROOF (07550/07560)
 __ METAL SHINGLES (07316)
 __ SHEET METAL (07610)
 __ SLATE SHINGLES (07314)
 __ WOOD SHINGLES/SHAKES (07313)
 __ PREFORMED METAL ROOFING (07412)
 __ detail keys __ notes/refs
 coord check: __ specs __ ext elev __ cross sect

__ __ WOOD DECK OR DUCKBOARD (06425)
 __ dimensions __ detail keys __ notes/refs
 coord check: __ roof anch

__ __ JOGGING TRACK/ATHLETIC SURFACES (02535/02540)
 __ materials __ dimensions __ detail keys __ notes/refs
 coord check: __ specs __ struct

__ __ ROOF INSULATION (07220)
 __ materials __ detail keys __ notes/refs
 coord check: __ specs __ hvac __ cross sect

__ __ SKYLIGHTS (07810)
 __ curb and cant strip lines at skylights
 __ wire mesh guards
 __ materials __ dimensions __ detail keys __ notes/refs
 coord check: __ struct __ hvac __ ext elev __ cross sect

__ __ MONITORS/ROOF WINDOWS (08655)
 __ materials __ dimensions __ detail keys __ notes/refs
 coord check: __ struct __ hvac __ ext elev __ cross sect

__ __ ROOF OPENINGS
 __ light wells
 __ atriums
 __ courts
 __ shafts
 __ shaft numbers
 __ shaft rooms
 __ railings at open shafts
 __ dimensions __ detail keys __ notes/refs
 coord check: __ struct __ roof anch __ hvac __ cross sect

ROOF PLANS -- CONSTRUCTION COMPONENTS continued

√ Dbl√

__ __ PLUMBING STACKS (15405)
__ locations __ detail keys __ notes/refs
coord check: __ plumb __ hvac

__ __ AIR HANDLING VENTS (15800)
(Air intakes located 10' minimum from soil stack vents.
Intakes and exhausts set at height to avoid clogging by snow.)
__ air intakes
__ exhaust vents
__ roof ventilators
__ ridge vents
__ dimensions __ detail keys __ notes/refs
coord check: __ hvac __ struct __ roof anch __ elec

__ __ SMOKE VENT HATCHES (07830)
__ materials __ dimensions __ detail keys __ notes/refs
coord check: __ code __ struct __ hvac __ elec

__ __ ROOF-MOUNTED HVAC EQUIPMENT (15650/15800)
__ dimensions __ detail keys __ notes/refs
coord check: __ hvac __ plumb __ struct __ roof anch

__ __ EXPOSED DUCTWORK (15840)
__ dimensions __ detail keys __ notes/refs
coord check: __ hvac __ struct __ roof anch

__ __ CHIMNEYS
__ MASONRY (04210)
__ PREFAB (10300)
__ flues
__ spark arrestors
__ coping caps
__ chimney coping block or cement wash, slope toward flue
__ materials __ dimensions __ detail keys __ notes/refs
coord check: __ code __ struct __ ext elev __ hvac
__ cross sect

__ __ CHIMNEY FLASHING (07608)
__ saddle
__ cricket
__ materials __ detail keys __ notes/refs
coord check: __ specs

__ __ ELEVATOR PENTHOUSE/MACHINE ROOM (14200)
__ elevator shaft vent
__ roof slope and drainage
__ materials __ dimensions __ detail keys __ notes/refs
coord check: __ elev sect __ struct __ ext elev
__ cross sect __ elec

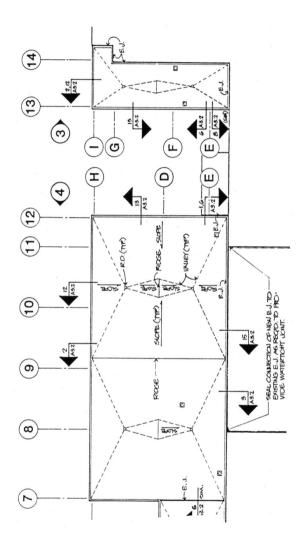

ROOF PLANS -- CONSTRUCTION COMPONENTS continued

√ Dbl√

__ __ SMOKE VENT PENTHOUSES
 __ smoke vent hatches
 __ drains
 __ materials __ dimensions __ detail keys __ notes/refs
 coord check: __ hvac __ struct __ ext elev __ cross sect

__ __ STAIR BULKHEADS
 __ materials __ dimensions __ detail keys __ notes/refs
 coord check: __ stair sect __ ext elev __ cross sect

__ __ OUTWARD OPENING DOORS ONTO ROOF
 __ curb
 __ overhead weather protection
 __ light
 coord check: __ stair sect __ door sched __ elec

__ __ FIRE ESCAPES (05514)
 __ materials __ dimensions __ detail keys __ notes/refs
 coord check: __ code __ struct __ roof anch

__ __ RAILINGS (05520)
 __ materials __ detail keys __ notes/refs
 coord check: __ code __ struct __ roof anch __ wall sect
 __ ext elev

__ __ ROOF LADDERS (05517)
 __ materials __ dimensions __ detail keys __ notes/refs
 coord check: __ struct __ roof anch __ ext elev
 __ wall sect

__ __ ROOF HATCHES (07830)
 __ materials __ dimensions __ detail keys __ notes/refs
 coord check: __ struct __ hvac __ cross sect __ wall sect

__ __ WINDOW WASHING EQUIPMENT PENTHOUSE (11012)
 __ materials __ dimensions __ detail keys __ notes/refs
 coord check: __ struct __ ext elev __ cross sect __ plumb
 __ elec

__ __ PIPE RAIL AND GATE FOR WINDOW WASHING
 EQUIPMENT (11012)
 __ materials __ dimensions __ detail keys __ notes/refs
 coord check: __ struct __ roof anch __ ext elev __ plumb
 __ cross sect __ elec

__ __ FLAGPOLES (10350)
 __ flood lights
 __ locations __ detail keys __ notes/refs
 coord check: __ struct __ roof anch __ ext elev __ elec

ROOF PLANS -- CONSTRUCTION COMPONENTS continued

√ Dbl√

__ __ LIGHTING RODS (16601)
 __ locations __ detail keys __ notes/refs
 coord check: __ ext elev __ elec

__ __ COOLING TOWERS (15650)
 __ materials __ dimensions __ detail keys __ notes/refs
 coord check: __ struct __ hvac __ plumb __ elec
 __ ext elev __ cross sect

__ __ COOLING TOWER PENTHOUSE
 __ cooling tower exhaust located 100' away from all air
 intakes
 __ materials __ dimensions __ detail keys __ notes/refs
 coord check: __ struct __ hvac __ plumb __ ext elev
 __ cross sect

__ __ SOUND AND VIBRATION ISOLATION BETWEEN ROOF-TOP
 EQUIPMENT AND ROOMS AT STORY BELOW ROOF (15200)
 __ materials __ dimensions __ detail keys __ notes/refs
 coord check: __ hvac __ struct __ acoust

__ __ BUILDING IDENTIFICATION MARKER FOR POLICE
 AIRCRAFT
 __ dimensions __ notes/refs
 coord check: __ code

__ __ DECORATIVE PAVING/COLORED GRAVEL PATTERNS
 __ dimensions __ notes/refs
 coord check: __ space

__ __ SOLAR HEAT PANELS (13980)
 __ materials __ dimensions __ detail keys __ notes/refs
 coord check: __ struct __ roof anch __ hvac __ plumb
 __ elec __ ext elev __ cross sect

__ __ SOLAR WATER HEATERS (13980/15431)
 __ materials __ dimensions __ detail keys __ notes/refs
 coord check: __ struct __ roof anch __ hvac __ plumb
 __ elec __ ext elev __ cross sect

__ __ WATER TANKS (13410/15400)
 __ materials __ dimensions __ detail keys __ notes/refs
 coord check: __ plumb __ struct __ roof anch
 __ ext elev __ cross sect

__ __ WATER TANK ENCLOSURE
 __ materials __ dimensions __ detail keys __ notes/refs
 coord check: __ struct __ roof anch __ ext elev
 __ cross sect

ROOF PLANS -- CONSTRUCTION COMPONENTS continued

√ Dbl√

__ __ ROOF PLUMBING (15400/15500)
 __ hose bibbs
 __ hydrants
 __ standpipes
 __ piping supports
 __ stub ups
 __ locations __ detail keys __ notes/refs
 coord check: __ plumb __ struct __ roof anch __ hvac

__ __ CABLE SERVICE ENTRIES
 (Overhead power, tv cable, and phone lines located to clear
 driveways or walkways at legally required heights.)
 __ ELECTRICAL SERVICE ENTRY (16401)
 __ TELEPHONE CABLE ENTRY (16740)
 __ TV CABLE ENTRY (16780)
 __ locations __ detail keys __ notes/refs
 coord check: __ code __ util __ site

__ __ SUPPORTS AND GUYS FOR OVERHEAD CABLE (07871)
 __ locations __ detail keys __ notes/refs
 coord check: __ elec __ roof anch

__ __ OVERHEAD CABLE PERISCOPE ENTRY HEADS
 (16401/16420)
 __ mounting pockets for entry heads
 __ locations __ detail keys __ notes/refs
 coord check: __ site __ util __ roof anch

__ __ WEATHERPROOF ELECTRIC OUTLETS (16134)
 __ locations __ notes/refs
 coord check: __ elec

__ __ EXTERIOR BUILDING LIGHTING (16520)
 __ locations __ detail keys __ notes/refs
 coord check: __ roof anch __ elec

__ __ AIRCRAFT WARNING LIGHTS (16560)
 __ locations __ detail keys __ notes/refs
 coord check: __ code __ struct __ roof anch __ elec

__ __ ROOF ANTENNA
 __ TV TOWER MASTER ANTENNA (16781)
 __ SATELLITE DISH ANTENNA (11800/16781)
 __ BROADCAST ANTENNA (16700)
 __ locations __ detail keys __ notes/refs
 coord check: __ code __ struct __ roof anch __ elec

__ __ ROOF-MOUNTED SIGNS (10430-10440)
 __ materials __ dimensions __ detail keys __ notes/refs
 coord check: __ code __ struct __ roof anch __ elec

ROOF PLANS -- CONSTRUCTION COMPONENTS continued

√ Dbl√

__ __ GUY WIRE ANCHORS FOR ANTENNA, SIGNS, AND OTHER
FIXTURES (07871)
__ locations __ detail keys __ notes/refs
coord check: __ struct __ roof anch

__ __ WEATHER VANES (05700)
__ locations __ detail keys __ notes/refs
coord check: __ roof anch

__ __ PREFABRICATED ROOF SPECIALTIES
__ STEEPLES (10341)
__ SPIRES (10342)
__ CUPOLAS (10343)
__ materials __ dimensions __ detail keys __ notes/refs
coord check: __ struct __ roof anch __ ext elev
__ cross sect

ROOF CONSTRUCTION SCHEDULE

A.
- 200 RIGID INSUL (RSI 7.0) w/
INTEGRAL CONCRETE BALLAST
- 4 PLY BUILT-UP ROOFING
- 16 T & G PLYWOOD SHEATHING
- TRUSSES - SEE STRUCTURAL
- 2 LAYERS 13 TYPE 'X' G.W.B. ON METAL
SUSPENSION SYSTEM

- 50 MIN. FIRERATED BASED ON MEMBRANE
PROTECTION FROM 1980 N.B.C.

B.
- As 'A' EXCEPT REPLACE 2 LAYERS OF
13 TYPE 'X' G.W.B. WITH 1 LAYER 13 G.W.B.

C.
- AS 'A' EXCEPT DELETE SUSPENDED DRYWALL
CEILING

D.
- CORRUGATED STEEL ROOFING PANELS
- 13 PLYWOOD SHEATHING
- 150 RIGID INSUL (RSI 5.25) WITH
Z GIRTS AS DETAILED
- V.B.
- 13 G.W.B.
- 38 METAL DECK - SEE STRUCTURAL
- H.S.S. PURLINS - SEE STRUCTURAL
- H.S.S. RIGID FRAMES - SEE STRUCTURAL

E.
- 150 RIGID INSUL (RSI 5.25) w/
INTEGRAL CONCRETE BALLAST
- 4 PLY BUILT-UP ROOFING
- CONCRETE TOPPING (MAX. 70 THICK TO
MIN. 20 @ ROOF DRAINS)
- 6 MIL POLY
- 38 METAL DECK
- H.S.S. FRAMING

F.
- 150 RIGID INSUL (RSI 5.25) w/
INTEGRAL CONCRETE BALLAST
- 4 PLY BUILT-UP ROOFING
- 16 T & G PLYWOOD SHEATHING
- WD JOISTS - SEE STRUCTURAL
- 38 x 38 WD FURRING @ 400 o/c
- 16 TYPE 'X' G.W.B.

- 50 MIN. FIRERATED FROM
SUPPLEMENT #2 TO 1980 N.B.C.

F1.
- As 'F' EXCEPT REVISE ROOF INSUL.
TO 200 RIGID INSUL.

G.
- CORRUGATED STEEL ROOFING PANELS
- BUILDING PAPER
- 13 PLYWOOD SHEATHING
- WOOD TRUSSES

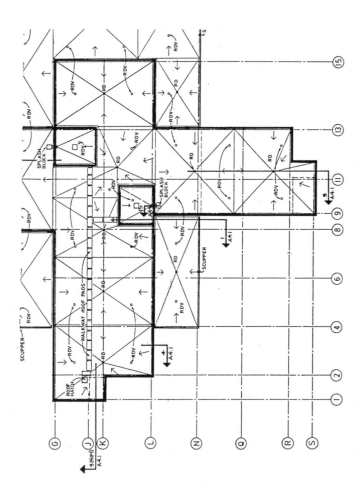

NOTES

Date/Initials

BUILDING CROSS SECTIONS

CHAPTER CONTENTS

CROSS SECTIONS PROCEDURAL CHECKLIST

CROSS SECTION LAYOUT AND DRAFTING, STEP BY STEP

PHASE 1 -- "OUTLINE" INFORMATION

Cross Section information is dependent on Floor Plans, Site Plans, Roof Plans, and may be affected through comparisons with final Exterior Elevations.

Update and verify Design Development data such as plate heights, ceiling heights, floor to floor heights. Using updated design development drawings and/or the latest Floor Plans and other working drawings as your guide, proceed with the following steps.

Layout & Linework

__ It's most desirable if the Cross Sections are completed and intricacies of construction are worked out during Design Development. Cross section drawings may be used as reference underlays for laying out Exterior Elevations and confirming floor, sill, and plate heights shown on the Elevations.

__ Decide on the desirable scale, size, and positioning of the Cross Sections on the working drawing sheet(s). Consider locations of Keynote legend, Door and/or Window Schedule, General Notes, Titles, Key Plan, and cross-section related details.

__ Decide the best portions of floor plan to cut for Longitudinal, Lateral and Partial Cross Sections.

__ If Cross Sections in Design Development were drawn on a base sheet without extraneous entourage or rendering, then adapt them for direct reuse in working drawings. (If using CADD, this will be handled automatically by layering.)

__ If restarting Cross Sections from scratch, use Floor Plans and Exterior Elevations as guides for roughing in exterior walls, doors, windows, and floor, ceiling, and roof heights. (If Cross Sections are worked out first, they'll determine key elements in Exterior Elevations; if Elevations are drawn first, they'll guide the Sections.)

__ Confirm and rough in the vertical outline of perimeter walls of building. Compare floor plan with design drawings of Cross Sections and Elevations to confirm exterior wall lengths, setbacks, and door and window locations and sizes.

__ Draw the vertical modular grid, if any.

__ Confirm and redraw as necessary in "light line" the floor lines and plate lines.

CROSS SECTIONS PROCEDURAL CHECKLIST continued

PHASE 1 -- "OUTLINE" INFORMATION continued

___ Confirm and lightly rough in other horizontal lines: Rough and
 finish grade, foundation or basement walls and footings, header,
 soffit, and roof lines.

___ Rough in lines of auxiliary construction such as raised ceilings,
 dropped floors, adjacent slabs, etc.

___ Coordinate the Cross Sections with the Roof Plan. If the Roof Plan and
 roof framing are still not finalized, rough in data that is known in
 terms of roof height, slopes, parapets, etc.

___ Confirm and redraw as necessary in "light line" the vertical lines:
 End walls, offsets, doors and windows.

___ Rough in connecting construction such as hand rails, decks, trellises, etc.

___ Rough in cantilever projections.

___ Rough in the roof profile, slopes, and overhangs.

___ Rough in roof projections such as skylights, chimneys, etc.

___ Show door and window opening in side view wall sections.
 Avoid showing doors or windows or other elements on the
 "back walls" of the section. Such items are redundant to
 start with and often end up contradicting the plans and elevations.

___ Show changes in floor level.

___ Rough in stair wells or steps and confirm tread/riser sizes relative
 to stair height.

___ Add ramps -- direction and upper and lower sub-floor elevations.

Dimensioning

___ Draw overall dimension lines from floor to roof framing, floor to floor,
 floor to ceiling or soffit, floor to door and window headers (as rough
 openings).

___ Show height dimension lines for auxiliary construction such as attached
 trellises and sun shades.

___ Double check floor height and finish grade elevations with Floor Plan
 and Site Plans.

Notation & Titles

___ Add identification notes or keynotes required for consultants who will
 refer to Cross Sections at this stage.

___ Add Cross Section drawing title and scale.

CROSS SECTIONS PROCEDURAL CHECKLIST

PHASE 2 -- "HARDLINE" INFORMATION

AND DETAILED ARCHITECTURAL CONSTRUCTION DATA

__ Hold hardline completion of Cross Sections until plans and overall design have had final review and are signed off by the client.

Layout & Dimensioning

__ Once plans and the exterior design are confirmed and signed off by the client, proceed with hardlining perimeter walls and major horizontal and vertical features of the building.

__ Show construction below grade, use dash lines for hidden relevant construction.

__ Show reference dimension or datum lines.

__ Firm up dimension lines and add dimension numbers in feet and inches.

__ Add small height dimensions such as for wing walls, furred walls, etc. Avoid horizontal dimensions with the possible exception of overhangs of cantilevers that aren't clearly shown and dimensioned elsewhere.

Construction Elements

__ Show drains at grade.

__ Show grading slopes away from building.

__ Indicate end wall soffit and attic vents.

__ Indicate flashing such as at chimneys, headers, and sills.

__ Show skylights and other roof openings occurring along cross section cut lines.

__ Show roof slope angles.

__ Confirm locations and "hardline" any wall construction that was tentative and still in "light line."

__ Profile the finish grade line and perimeter exterior linework for emphasis.

CROSS SECTIONS PROCEDURAL CHECKLIST continued

PHASE 2 -- "HARDLINE" INFORMATION continued

Notation

__ Write identification notes or keynote reference numbers.

__ Where elements or dimensions are highly repetitive, note or
dimension one and add "Typical" or "Unless Noted
Otherwise" notes:

__ Write construction assembly notation and note references to
specifications and details.

__ Complete indications of end wall elements such as scuppers,
flashing, etc.

__ Complete partial wall materials patterns, textures, stair handrail
members, etc.

__ Add final clarification reference notes regarding fixtures,
equipment supports and auxiliary connected or adjacent
construction.

__ Edit and update the keynote legend.

__ Add, edit, and update any General Notes that pertain to Cross Sections.

Referencing & Symbols

__ Add detail bubbles such as for overhangs, soffits, handrails, stairs, etc.

__ Add overall wall section reference bubbles and preferably draw the large-
scale wall sections on the same sheet for direct reference and com-
parison. Avoid duplicating the same information on small and large
scale wall sections, keep small-scale drawings generic and add detail
only to the larger drawings.

__ Add stair section bubbles and preferably draw large-scale walls stair
sections and related details on the same sheet.

__ Reference foundation, floor, and roof framing elements to Structural
Framing and Detail drawings.

__ If using a modular grid, add coordination letters and numbers.

__ Add small-scale reference key plan.

CROSS SECTIONS PROCEDURAL CHECKLIST continued

PHASE 2 -- "HARDLINE" INFORMATION continued

__ Add wall and cross-section reference keys and coordinate with small scale reference key plan. Key plans with exterior elevation, cross section, and wall section keys will be added later to all architectural working drawing sheets to aid the user in finding and cross-coordinating all drawing construction data.

__ Add view reference number or letter and coordinate with small scale reference key plan Identify Cross-Section views by letter or number.

NOTES Date/Initials

CROSS SECTIONS PROCEDURAL CHECKLIST

PHASE 3 -- CHECKING

___ Use transparency prints to cross-check and coordinate Cross Sections with Floor Plans, Foundation Plans, and Structural Framing Plans.

___ Especially double-check and confirm exact locations of stair openings, chimneys and flues, and floor and roof openings.

___ For check prints, attach a blank transparency on the Cross Sections and mark changes and additions in red and mark data that's correct in yellow.

___ In each later phase of checking, remove the transparency from the first check print and attach to the next phase check print. Verify that required changes and additions have been completed as required, and mark with yellow over the red marks.

___ To minimize oversights, checking for errors and incompleteness should be a separate process from checking for progress.

___ Checking for changes and additions is often more complete and accurate if done by a third party who has not been working on the project.

NOTES Date/Initials

ABOUT CROSS SECTIONS

Building cross sections are usually the most overdrawn of any drawings in a working drawing set. Their primary purpose is to show level to level heights, to show the overall structural/construction system, and to identify tricky areas such as junctures and changes in floor, ceiling, and roof construction.

Floor, wall, ceiling and roof construction need only be drawn schematically. Add detail bubbles and numbers to reference the more specific, larger scale sections and details.

ITEMS THAT SHOULD BE AVOIDED ON CROSS SECTION DRAWINGS

__ Don't show interior elevation drawings of the "back walls" of a cross section drawing. That will only duplicate or contradict other drawings such as the floor plans, interior elevations and exterior elevations. Although "back walls" make the drawing look more complete, they usually will serve no real useful purpose for the contractor. The exception is when you have only one space or a single line of rooms in a building and the cross section does double duty as the interior elevation sheet.

__ If doors or windows are shown, don't show door or window symbols. That will also either duplicate or contradict the floor plans.

__ Don't indicate interior finishes. That's the province of floor plans, interior elevations, and the finish schedule.

__ Don't show interior furnishings and fixtures. That's another common source of duplication or error. Show only those special fixtures or equipment, if any, that affect the overall structure.

COORDINATION

__ The cross section should be derived directly from the exterior elevation drawings which themselves have been derived directly from the floor plans. Then double check the accuracy of the elevations by overlaying the cross sections on the floor plans.

__ The necessity to check coordination of the cross sections with the floor plans is assumed in this list and not cited in the "coord check" notes. The necessity to check coordination of sections with specifications is also assumed as it is in other chapters of the checklist, but some special cases are added to the "coord check" lists as extra reminders. Ongoing checks with structural drawings could also be assumed but they are overlooked so often that these checks are noted throughout this list.

ITEMS SUITED TO SYSTEMATIC PRODUCTION METHODS

__ If presentation drawings include cross sections, have the sections show linework only. Show rendering entourage, titles, design options, phased construction, etc. only on overlays or CADD layers. Make prints of those base sheet/overlay combinations for presentation purposes. This process saves the uncluttered cross section drawing for easy revision and possible direct reuse as a working drawing sheet.

__ Use appropriate exterior elevation drawings as base layers or background sheets for your cross sections instead of measuring and drawing wall and floor sections from scratch. Overlay cross section drawings directly on floor plans to identify any special interior features that should be included in the sections.

__ In some cases the exterior elevations can be reversed, screen printed, and used as a subdued background for the solid line section drawings. In this instance it's OK to show "back walls" since they're not being drawn as a separate process.

__ Notes for cross sections are highly repetitive, so you can readily use one keynote strip and bubble reference all notation in the drawing to a notation legend.

NOTES Date/Initials

CROSS SECTIONS -- REFERENCE INFORMATION

√ Dbl√

__ __ KEY PLAN IDENTIFICATION OF CROSS SECTION CUT
POINTS
coord check: __ ext elev

__ __ EXISTING AND NEW FINISH GRADE LINES WITH
ELEVATIONS
coord check: __ ext elev __ civil __ site

__ __ HEIGHTS AND ELEVATION POINTS
__ finish floor to finish floor or subfloor to subfloor
__ floor or subfloor to finish ceiling
__ floor or subfloor to underside of beams, headers and
lintels
__ upper floor to roof substructure
coord check: __ struct __ ext elev __ wall sect

__ __ NOTE WHETHER DIMENSIONS ARE TO FINISH SURFACES,
ROUGH SURFACES, OR STRUCTURE

NOTES Date/Initials

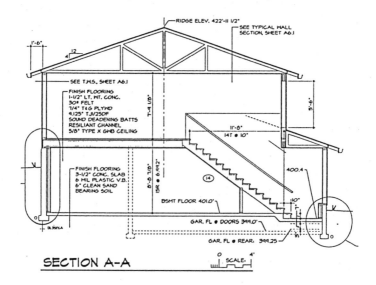

SECTION A-A

NOTES

Date/Initials

CROSS SECTIONS CONSTRUCTION COMPONENTS --
SUBGRADE THROUGH GROUND FLOOR

Most items are assumed to require cross checking with floor plans and
exterior elevations and so are not cited for "coord check" with those drawings
on every listing.

CSI coordination numbers are not included in this list. Those numbers can be
found linked to their building components in other chapters and aren't helpful
in checklisting this generalized type of drawing.

√ Dbl√

__ __ FOOTINGS AND FOUNDATION WALLS
 __ materials __ dimensions __ detail keys __ notes/refs
 coord check: __ struct __ civil

__ __ FOUNDATION DRAINS
 __ drain tiles
 __ crushed rock drain tile bed
 __ roof drain connections to storm sewer
 __ materials __ dimensions __ detail keys __ notes/refs
 coord check: __ struct __ site/drain

__ __ BASEMENT AREAWAYS
 __ areaway wall and footing
 __ drain
 __ window or hatch section
 __ materials __ dimensions __ detail keys __ notes/refs
 coord check: __ struct __ site/drain

__ __ PIPES AND SLEEVES THAT PENETRATE BASEMENT WALL
 __ heights/sizes __ detail keys __ notes/refs
 coord check: __ struct __ util __ plumb __ hvac __ elec

__ __ ADJACENT PAVING AND WALKWAYS
 __ slope away from building
 __ slope to drains
 __ materials __ dimensions __ detail keys __ notes/refs
 coord check: __ site/drain __ ext elev

__ __ ADJACENT STOOPS, PLATFORMS, AND LANDINGS
 __ materials __ dimensions __ detail keys __ notes/refs
 coord check: __ site/drain __ ext elev

__ __ EXTERIOR SLAB FOOTINGS OR FROST CURBS
 __ tamped fill
 __ sand and gravel fill
 __ vapor barrier
 __ reinforcing
 __ materials __ dimensions __ detail keys __ notes/refs
 coord check: __ struct __ site

CROSS SECTIONS CONSTRUCTION COMPONENTS --
SUBGRADE THROUGH GROUND FLOOR continued

√ Dbl√

__ __ FLOOR CONSTRUCTION
 __ framing
 __ floor slabs and deck
 __ subflooring and floor topping
 __ floor waterproofing at wet rooms
 __ depressed slabs for varied finish flooring and thicknesses
 __ curbs
 __ pedestals
 __ trenches
 __ pits and guard rails
 __ cantilevered slabs
 __ materials __ dimensions __ detail keys __ notes/refs
 coord check: __ struct __ fin sched

__ __ EXTERIOR WALLS
 __ types (See Floor Plans)
 __ ledgers
 __ spandrel beams
 __ spandrel angles
 __ materials __ dimensions __ detail keys __ notes/refs
 coord check: __ struct __ ext elev

__ __ DOOR AND WINDOW OPENINGS
 __ sills and saddles
 __ head framing
 __ stools and aprons
 __ materials __ dimensions __ detail keys __ notes/refs
 coord check: __ struct __ ext elev

__ __ GIRDERS, BEAMS, AND JOISTS
 __ hangers
 __ anchors
 __ stirrups
 __ pockets
 __ ledgers
 __ bearing plates
 __ bridging and blocking
 __ materials __ dimensions __ detail keys __ notes/refs
 coord check: __ struct __ hvac

__ __ SUSPENDED MECHANICAL WORK
 __ materials __ dimensions __ detail keys __ notes/refs
 coord check: __ struct __ clg/roof anch __ hvac __ ref clg

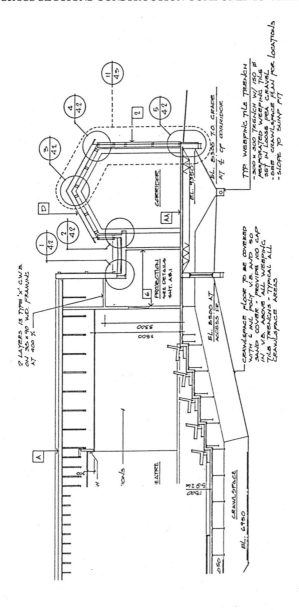

NOTES

Date/Initials

CROSS SECTIONS CONSTRUCTION COMPONENTS --
GROUND FLOOR THROUGH ROOF

√ Dbl√

__ __ INTERIOR WALLS AND CEILINGS
 __ light coves
 __ coffers
 __ valances
 __ vapor barriers
 __ rigid or batt terminal insulation
 __ fireproof construction
 __ soundproofing
 __ acoustical treatments
 __ wainscots
 __ finishes
 __ materials __ dimensions __ detail keys __ notes/refs
 coord check: __ struct __ hvac __ plumb __ elec __ ref clg
 __ int elev __ fin sched

__ __ SUSPENDED CEILINGS
 __ main tees, cross tees, and hangers
 __ celing-mounted equipment
 __ ceiling or attic barriers
 __ coffers
 __ materials __ dimensions __ detail keys __ notes/refs
 coord check: __ struct __ hvac __ plumb __ elec __ ref clg
 __ fin sched

__ __ COLUMNS AND POSTS
 __ base plates
 __ piers
 __ pedestals
 __ fireproofing
 __ column caps
 __ drop panels
 __ column splices
 __ stiffeners
 __ wind bracing
 __ cross ties
 __ materials __ dimensions __ detail keys __ notes/refs
 coord check: __ struct __ int elev __ mech

__ __ SUSPENDED HEAVY EQUIPMENT
 __ hoists/cranes
 __ fixtures/hvac equipment
 __ materials __ dimensions __ detail keys __ notes/refs
 coord check: __ struct __ mech __ elec

CROSS SECTIONS CONSTRUCTION COMPONENTS -- ROOF

For other more specialized components that might be included in cross sections, see Chapter Four, Roof Plan.

√ Dbl√

__ __ PARAPETS
 __ caps
 __ overflows
 __ materials __ dimensions __ detail keys __ notes/refs
 coord check: __ wall sect __ roof __ ext elev

__ __ TRUSSES
 __ truss splices
 __ sway bracing
 __ sag rods
 __ purlins
 __ materials __ dimensions __ detail keys __ notes/refs
 coord check: __ struct __ roof

__ __ OVERHANGS
 __ fascia
 __ soffit
 __ soffit vents
 __ trim
 __ expansion joints
 __ materials __ dimensions __ detail keys __ notes/refs
 coord check: __ struct __ roof __ ext elev

__ __ ROOF DECKING OR SHEATHING
 __ finish roofing materials
 __ roof expansion joints
 __ slopes
 __ materials __ dimensions __ detail keys __ notes/refs
 coord check: __ specs __ roof

__ __ ROOF APPURTENANCES
 __ penthouse
 __ stair bulkhead
 __ elevator bulkhead
 __ mechanical equipment
 __ water tower
 __ thru-roof vent pipes and flues
 __ curbs
 __ anchors
 __ pitch pockets
 __ snow melting equipment
 __ railings
 __ solar panels
 __ materials __ dimensions __ detail keys __ notes/refs
 coord check: __ struct __ roof __ mech __ ext elev

CROSS SECTIONS CONSTRUCTION COMPONENTS -- ROOF
continued

√ Dbl√

__ __ THRU-BUILDING SHAFTS
 __ elevator shaft, hoist, and pit
 __ escalator
 __ stairs/smoke towers
 __ trash chute
 __ conveyors
 __ plumbing chases
 __ hvac chases
 __ electrical chases
 __ interior rain water leaders
 __ materials __ dimensions __ detail keys __ notes/refs
 coord check: __ struct __ elevator pl/sect __ stair pl/sect
 __ hvac __ plumb __ elec

__ __ SKYLIGHTS
 __ light shafts
 __ condensation collectors
 __ mesh guards
 __ materials __ dimensions __ detail keys __ notes/refs
 coord check: __ struct __ roof

NOTES Date/Initials

CROSS SECTIONS CONSTRUCTION COMPONENTS continued

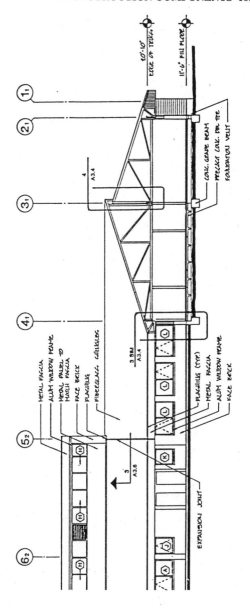

NOTES

Date/Initials

WALL SECTIONS

CONTENTS

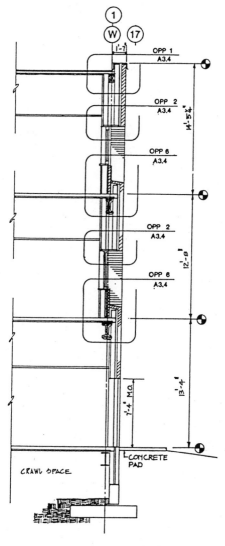

SECTION

ABOUT WALL SECTIONS

Wall sections are primarily to show the detail bubble key references of major junctures in construction: floor slab and foundation wall, sills, spandrels, upper floor slab at the exterior wall, ceiling at the exterior wall, roof construction at the exterior wall, and roof parapets and/or overhangs.

As a key map to more specific detail construction drawings, wall sections serve much the same function as building cross sections. They are a guide to other drawings and not necessarily definitive construction drawings in themselves.

Wall section information is often adequately covered by building cross section drawings. Thus even though wall sections may have been created as part of the design process, it may be redundant to include them as a part of working drawings. If they are included, then the detail reference key bubbles should not be repeated on both overall cross section and the larger scale wall sections.

Because of the schematic and referral nature of this type of drawing, this list does not include "coord check" notes or the CSI coordinated reference numbers. Consider this list to be just a reminder of basic components of wall section key drawings. You will cover all coordination checks and CSI number coordinations through the other chapters in this checklist.

√ Dbl√

__ __ EXISTING AND NEW FINISH GRADE LINES WITH HEIGHTS

__ __ FOOTINGS AND FOUNDATION WALLS
 __ materials __ dimensions __ detail keys __ notes/refs

__ __ DRAINS
 __ drain tiles
 __ crushed rock drain tile bed
 __ roof drain connections to storm sewer
 __ materials __ dimensions __ detail keys __ notes/refs

__ __ BASEMENT AREAWAY
 __ areaway wall and footing
 __ drain
 __ window or hatch section
 __ materials __ dimensions __ detail keys __ notes/refs

__ __ BASEMENT WALL MEMBRANE WATERPROOFING
 __ materials __ height __ detail keys __ notes/refs

__ __ PIPE AND SLEEVES THAT PENETRATE WATERPROOFING
 __ heights/sizes __ detail keys __ notes/refs

__ __ BASEMENT OR FOUNDATION WALL GIRDER RECESS
 __ heights/sizes __ detail keys __ notes/refs

WALL SECTIONS continued

√ Dbl√

__ __ ADJACENT PAVING AND WALKWAYS
> __ slope away from building
> __ slopes to drains
> __ materials __ dimensions __ detail keys __ notes/refs

__ __ ADJACENT STOOPS
> __ landings
> __ paving
> __ materials __ dimensions __ detail keys __ notes/refs

__ __ EXTERIOR SLAB FOOTINGS OR FROST CURBS
> __ tamped fill
> __ sand and gravel fill
> __ vapor barrier
> __ reinforcing
> __ materials __ dimensions __ detail keys __ notes/refs

__ __ DOWELS CONNECTING SLABS TO FOOTINGS OR
FOUNDATION WALLS
> __ locations __ detail keys __ notes/refs

__ __ MASONRY WALLS
> __ types (See Floor Plans)
> __ air space and weep holes
> __ courses and header courses
> __ sill flashing
> __ head flashing
> __ anchors and reinforcing
> __ grouting
> __ parging
> __ caulking
> __ materials __ dimensions __ detail keys __ notes/refs

__ __ CURTAIN WALLS
> __ types (See Floor Plans)
> __ support angles
> __ anchors
> __ weep holes
> __ movement joints
> __ caulking
> __ sealants
> __ materials __ dimensions __ detail keys __ notes/refs

WALL SECTIONS continued

√ Dbl√

__ __ WOOD FRAME WALLS
 __ mudsill
 __ blocking
 __ floor joists
 __ subfloor
 __ plates
 __ studs
 __ sills
 __ headers
 __ double top plates
 __ blocking
 __ ceiling/roof joists
 __ rafters
 __ purlins
 __ girts
 __ dimensions __ detail keys __ notes/refs

__ __ GIRDERS, BEAMS, AND JOISTS
 __ hangers
 __ anchors
 __ sills
 __ stirrups
 __ pockets
 __ ledgers
 __ bearing plates
 __ bridging and blocking
 __ materials __ dimensions __ detail keys __ notes/refs

__ __ FLOOR CONSTRUCTION
 __ connection at wall
 __ subflooring
 __ floor slabs and metal deck
 __ topping
 __ finish topping
 __ materials __ dimensions __ detail keys __ notes/refs

__ __ WATERPROOFING AT WET ROOMS
 __ materials __ height __ detail keys __ notes/refs

__ __ LINTELS
 __ headers
 __ masonry ledges
 __ steel wall angles
 __ spandrel beams
 __ spandrel angles
 __ materials __ height/sizes __ detail keys __ notes/refs

WALL SECTIONS continued

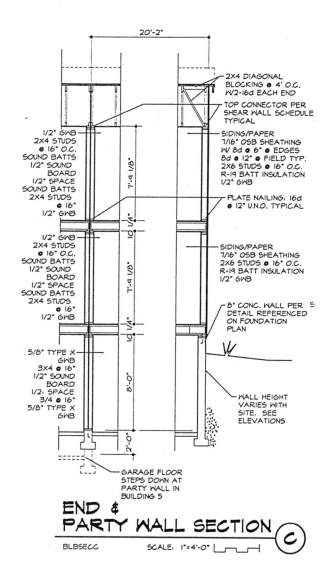

20'-2"

2X4 DIAGONAL
BLOCKING @ 4' O.C.
W/2-16d EACH END

TOP CONNECTOR PER
SHEAR WALL SCHEDULE
TYPICAL

1/2" GWB
2X4 STUDS
@ 16" O.C.
SOUND BATTS
1/2" SOUND
BOARD
1/2" SPACE
SOUND BATTS
2X4 STUDS
@ 16"
1/2" GWB

SIDING/PAPER
7/16" OSB SHEATHING
W/ 8d @ 6" @ EDGES
8d @ 12" @ FIELD TYP.
2X6 STUDS @ 16" O.C.
R-19 BATT INSULATION
1/2" GWB

7'-9 1/8"

PLATE NAILING: 16d
@ 12" U.N.O. TYPICAL

10 1/4"

1/2" GWB
2X4 STUDS
@ 16" O.C.
SOUND BATTS
1/2" SOUND
BOARD
1/2" SPACE
SOUND BATTS
2X4 STUDS
@ 16"
1/2" GWB

SIDING/PAPER
7/16" OSB SHEATHING
2X6 STUDS @ 16" O.C.
R-19 BATT INSULATION
1/2" GWB

7'-9 1/8"

8" CONC. WALL PER S
DETAIL REFERENCED
ON FOUNDATION
PLAN

10 1/4"

5/8" TYPE X
GWB
3X4 @ 16"
1/2" SOUND
BOARD
1/2: SPACE
3/4 @ 16"
5/8" TYPE X
GWB

8'-0"

WALL HEIGHT
VARIES WITH
SITE. SEE
ELEVATIONS

2'-0"

GARAGE FLOOR
STEPS DOWN AT
PARTY WALL IN
BUILDING 5

END &
PARTY WALL SECTION C

BLBSECC SCALE: 1"=4'-0"

WALL SECTIONS continued

√ Dbl√

__ __ DOORS AND WINDOWS
 __ sills and saddles
 __ head framing
 __ caulking
 __ flashing
 __ trim
 __ stools and aprons
 __ anchors to wall
 __ materials __ dimensions __ detail keys __ notes/refs

__ __ LIGHT COVES
 __ coffers
 __ valances
 __ materials __ dimensions __ detail keys __ notes/refs

__ __ WALL AND CEILING COMPONENTS
 __ rigid or batt terminal insulation
 __ fireproof construction
 __ soundproofing
 __ acoustical treatments
 __ wainscots
 __ finishes
 __ materials __ dimensions __ detail keys __ notes/refs

__ __ SUSPENDED CEILING
 __ connection at wall
 __ particle view of tees and hangers
 __ materials __ dimensions __ detail keys __ notes/refs

__ __ MASONRY WALL TOP PLATE OR LEDGERS
 __ plate anchors
 __ beam pockets
 __ materials __ dimensions __ detail keys __ notes/refs

__ __ PARAPET WATERPROOFING
 __ flashing reglet
 __ flashing and counterflashing
 __ overflows
 __ materials __ dimensions __ detail keys __ notes/refs

__ __ PARAPET CAP
 __ wash toward roof
 __ parapet expansion and construction joints
 __ materials __ dimension __ detail keys __ notes/refs

WALL SECTIONS continued

√ Dbl√

__ __EDGE FLASHING
 __ gutter and gutter connectors
 __ gravel stop
 __ cap flashing
 __ cant strips
 __ eave snow guards
 __ materials __ dimensions __ detail keys __ notes/refs

__ __TRUSSES
 __ connection at wall
 __ materials __ dimensions __ detail keys __ notes/refs

__ __OVERHANG
 __ fascia
 __ soffit
 __ soffit vents
 __ trim
 __ expansion joints
 __ materials __ dimensions __ detail keys __ notes/refs

__ __ROOF DECKING OR SHEATHING
 __ cant and flashing at roof edge or parapet
 __ railings
 __ materials __ dimensions __ detail keys __ notes/refs

NOTES Date/Initials

WALL SECTIONS continued

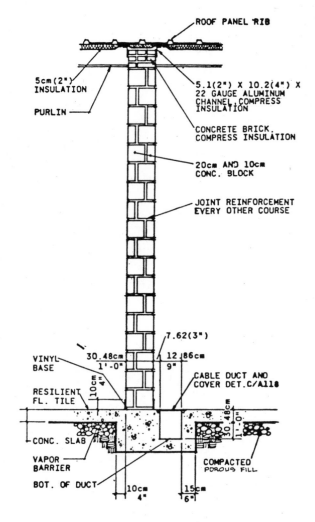

ROOF PANEL RIB

5cm(2")
INSULATION

PURLIN

5.1(2") X 10.2(4") X
22 GAUGE ALUMINUM
CHANNEL, COMPRESS
INSULATION

CONCRETE BRICK,
COMPRESS INSULATION

20cm AND 10cm
CONC. BLOCK

JOINT REINFORCEMENT
EVERY OTHER COURSE

7.62(3")

30.48cm
1'-0"

12.86cm
9"

VINYL
BASE

10cm
4"

CABLE DUCT AND
COVER DET. C/A118

RESILIENT
FL. TILE

30.48cm
1'-0"

CONC. SLAB

VAPOR
BARRIER

BOT. OF DUCT

10cm
4"

15cm
6"

COMPACTED
POROUS FILL

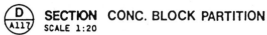

SECTION CONC. BLOCK PARTITION
SCALE 1:20

D
A117

NOTES

REFLECTED CEILING PLANS

CHAPTER CONTENTS

CEILING PLAN PROCEDURAL CHECKLIST

CEILING PLAN LAYOUT AND DRAFTING, STEP BY STEP

PHASE 1 -- "OUTLINE" INFORMATION

AND INFORMATION REQUIRED BY CONSULTANTS

First, update and verify room sizes in the floor plan. Using the updated design floor plan as your guide, proceed with the following steps.

__ Decide on the desirable scale, size, and positioning of the Reflected Ceiling Plan on the working drawing sheet(s). Consider locations of Keynote legend, Finish Schedule, General Notes, Symbols Legend (if any), Titles, Key Plan, and Reflected Ceiling Plan related details.

Layout & Linework

__ Use the uncompleted floor plan -- at the stage showing walls, partitions, door swings, soffits, etc. as the base sheet or base layer.

__ Show changes in ceiling level.

__ Rough in openings in ceiling, ceiling or attic scuttle.

__ Indicate "light-line" locations and sizes of electrically powered equipment.

__ Check door swings for conflicts with desired light switch locations.

__ Soffit lines.

__ Show dash lines for relevant hidden construction below or above the ceiling.

REFLECTED CEILING PLAN PROCEDURAL CHECKLIST
continued

PHASE 2 -- "HARDLINE" INFORMATION

AND DETAILED ARCHITECTURAL CONSTRUCTION DATA

__ The floor plan may be printed as a screened back ground image with ceiling elements shown in solid line. If preferred, a wall layer only may be shown solid line in combination with ceiling elements. This is doable with CADD layering, otherwise the drafter may "draw over" to profile walls on a screened background sheet.

Construction Elements

__ Complete partial ceiling or soffit patterns, textures, and wall materials indications.

__ Show all thru-ceiling plumbing or electrical chases and furred walls.

__ Show ceiling tracks and headers.

__ Add ceiling diffusers. Coordinate with HVAC plan.

__ Finalize and show sizes and locations of fans and other ceiling or high-wall mounted electrical equipment.

__ Show ceiling lighting; coordinate with suspended ceilings or module lines, if any.

__ Show switching and power connections.

Dimensioning

__ Draw interior dimension lines as required for ceiling fixtures that must be precisely located.

__ Add dimension numbers in feet and inches.
Avoid unrealistic small fractions of an inch; 1/2" is usually minimum.

Titles, Labels, & Referencing

__ Add Reflected Ceiling Plan drawing title and scale.

__ Add ceiling materials and fixture Keynote numbers or identification notes.

Plans should be ready at this point for base-layer references for drawings by Mechanical Engineering and Electrical Engineering consultants.

REFLECTED CEILING PLAN PROCEDURAL CHECKLIST
continued

PHASE 2 -- "HARDLINE" INFORMATION continued

Layout & Linework

__ Confirm wall locations and "hardline" any previously undecided walls
that are still in "light line."

Notation

__ Add reference notes to special areas shown elsewhere at larger scale.
Use enlarged portions of plans sparingly and don't repeat all details
of the space at both large and small scales; keep small scale area
diagrammatic to avoid redundancy and possible contradiction.

__ Write identification notes or keynote reference numbers.

__ Where elements or dimensions are highly repetitive, note or dimension
one and add "Typical" or "Unless Noted Otherwise" notes:

__ Write construction assembly notation and note references to
specifications and details.

__ Add final clarification reference notes regarding ceiling-mounted or high
wall-mounted fixtures and equipment.

__ Edit and update the Keynotes legend.

__ Add, edit, and update any General Notes that pertain to ceiling
construction.

Referencing & Symbols

__ If relevant to ceiling fixture locations, show ceiling or roof joist direction
arrow with size and spacing notes.
(Don't include framing indications if complete separate framing
plans are provided.)

__ Add detail reference bubbles for ceiling construction details.

__ Key high wall-mounted or ceiling-mounted equipment and fixtures to
Equipment and Fixtures Schedules.

__ Show cross-section cut lines.

__ Show key plans with elevation references and cross section cut lines.

REFLECTED CEILING PLAN PROCEDURAL CHECKLIST
continued

PHASE 3 -- CHECKING

__ Use transparency prints to cross check and coordinate Reflected Ceiling
Plan with Floor Plans, Electrical Plans, Plumbing Plans, and HVAC
plans.

__ For check prints, attach a blank transparency on the Reflected Ceiling
Plan and mark changes and additions in red and data that's correct in
yellow.

__ In each later phase of checking, remove the transparency from the first
check print and attach to the next phase check print. Verify that
required changes and additions have been completed as required,
and mark with yellow over the red marks.

__ To minimize oversights, checking for errors and incompleteness should
be separate from checking for progress.

__ Checking for changes and additions is often more complete and accurate
if done by a third party who has not been working on the project.

NOTES Date/Initials

ABOUT REFLECTED CEILING PLANS

Reflected ceiling plans serve two main purposes:

1) They show the designer's intent regarding the appearance of ceiling patterns and the placement of fixtures and equipment.

2) They provide base sheet or background sheet information for the electrical, communications, and mechanical consultants to work from and coordinate with one another.

Other drawings that may be derived from the architectural reflected ceiling plans include lighting and electrical power; communications: HVAC ceiling vents, diffusers, heaters, etc.; fire sprinklers; and special acoustical, fire barrier and thermal insulation treatments.

COORDINATION

__ The reflected ceiling plans should be derived directly from the floor plans by means of CADD layering or overlay drafting. This assures an exact, one-to-one correlation between ceiling plans and floor plans. Layering is one of the most natural and convenient uses of CADD but some drafters haven't yet caught on.

__ Periodically check prints of reflected ceiling plans against updated floor plans by direct overlay comparison on a light table. That's the only way to guarantee perfect accuracy in floor plan/ceiling coordination.

__ All related consultants' drawings will be derived from the architect's ceiling plans, so they in turn must be periodically checked by overlay comparison with the latest reflected ceiling plans.

__ In addition to overlaying and comparing architectural, electrical, plumbing, and HVAC, be sure to do overlay checks with structural drawings. Although framing plans aren't necessarily produced by the base sheet/ overlay method nor with the same CADD system, they should still be at the same scale and position on drawing sheets as all other consultants' work. It's the only way to facilitate this kind of checking and coordination.

REFLECTED CEILING PLANS
ITEMS SUITED TO SYSTEMATIC PRODUCTION METHODS

__ Combine screened image output of the floor plans with solid-line images
of the overlaid reflected ceiling plans when making progress prints
and when making base sheets for the consulting engineers. That
makes the architectural plan/ceiling plan clearer and more readable
for the consultants drafters. Just be careful that the screen used is
coarse enough (at least 50%) so that the screened lines remain
readable when overlay sheets are laid on them.

__ When printing the consultants' work, screen both the architectural floor
plans and reflected ceiling plans so that only consultants' work
appears in solid line. This further clarifies the drawings by visually
distinctly separating the different kinds of construction information.
Again, the screen should be coarse enough to guarantee readability.

__ Ceiling construction details are quite standard and should be a significant
part of the office's reference and standard detail library.

__ Reflected ceiling plans tend to require only a small number of notes
which are repeated widely around the field of the drawing. That
makes these drawings especially suitable for keynoting.

NOTES Date/Initials

CEILING PLANS -- CONSTRUCTION COMPONENTS

All items are assumed to require coordination checking with floor plans, therefore those "coord checks" are not noted here. Also, all electrical, communications, HVAC, plumbing, and vertical transportation are assumed to require cross-checking with the architectural ceiling plan as well as with one another. Especially important cases are marked "mech" in the coordination check notes as an extra reminder.

Although structural coordination checking might also be taken for granted and not listed, that is the most common area of oversight and interference. Therefore, structural coordination checks are noted where most important. Also included are reminders of another common omission: provision for anchoring attached fixtures, furnishings, and equipment with the ceiling structure. These are identified as "clg anch."

√ Dbl√

__ __ COLUMNS, POSTS, WALLS, AND CEILING-HIGH
PARTITIONS
__ broken line or screened indication
coord check: __ struct __ mech

__ __ WALLS OR PARTITIONS EXTENDING THROUGH CEILING
TO UNDERSIDE OF ROOF
__ solid-line indications __ heights/elevation points
__ materials
__ dimensions/spacing __ detail keys __ notes/refs
coord check: __ struct __ cross sect __ mech

__ __ EXPOSED CEILING BEAMS, GIRDERS, AND JOISTS
__ solid-line indications __ heights/elevation points
__ materials __ dimensions/spacing __ detail keys
__ notes/refs
coord check: __ struct __ cross sect __ int elev __ fin sched
__ mech

__ __ SLOPE OF EXPOSED BEAMS
__ direction of slopes __ low/high elevation points
coord check: __ struct __ cross sect __ int elev __ mech

__ __ CONCEALED BEAMS, GIRDERS, AND HEADERS
__ broken-line indications __ materials
__ dimensions/spacing
__ detail keys __ notes/refs
coord check: __ struct __ cross sect __ mech

__ __ SUSPENDED CEILING GRIDS (09120)
__ egg crates
__ light diffusers
__ dimensions/spacing __ detail keys __ notes/refs
coord check: __ struct __ fin sched __ mech __ elec

CEILING PLANS -- CONSTRUCTION COMPONENTS continued

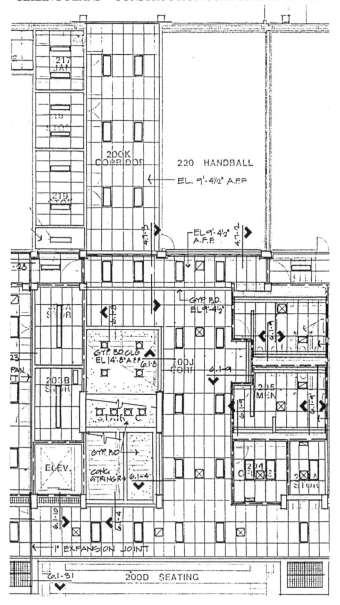

CEILING PLANS -- CONSTRUCTION COMPONENTS continued

√ Dbl√

__ __ INTEGRATED CEILING (13070)
 __ dimensions/spacing __ detail keys __ notes/refs
 coord check: __ struct __ fin sched __ mech __ elec

__ __ CEILING CONSTRUCTION AND FINISHES
 __ WOOD PANELING (06420)
 __ MIRRORS (08830)
 __ SUSPENSION SYSTEM (09120)
 __ ACOUSTICAL SUSPENSION SYSTEM (09130)
 __ GYPSUM LATH AND PLASTER (09202)
 __ METAL LATH AND PLASTER (09203)
 __ GYPSUM WALLBOARD (09260)
 __ TILE (09310-09370)
 __ ACOUSTICAL TILE (09512)
 __ materials __ dimensions __ detail keys __ notes/refs
 coord check: __ struct __ clg anch __ fin sched

__ __ SPECIAL CEILING TREATMENTS
 __ WATERPROOFING IN WET ROOMS (07100)
 __ DAMPPROOFING (07150)
 __ THERMAL INSULATION (07200)
 __ FIREPROOFING (07250)
 __ ACOUSTICAL (09500-09513)
 __ X-RAY AND RADIATION SHIELDING (13090)
 __ ELECTROMAGNETIC SHIELDING (16650)
 __ materials __ dimensions __ detail keys __ notes/refs
 coord check: __ code __ specs __ struct __ fin sched

__ __ SLOPE OF CEILINGS
 __ direction of slopes __ low/high elevation points
 coord check: __ cross sect __ int elev __ mech

__ __ CHANGES IN CEILING PLAN
 __ dividing lines __ heights/elevation points
 __ materials __ dimensions __ detail keys __ notes/refs
 coord check: __ cross sect __ int elev __ mech

__ __ FURRED CEILINGS AND SOFFITS
 __ edge lines __ heights/elevation points
 __ materials __ dimensions __ detail keys __ notes/refs
 __ coord check: __ cross sect __ int elev __ mech

__ __ ATTIC OR CEILING SPACE SEPARATORS
 __ draft or fire stops
 __ attic limit lines
 __ broken-line indications
 __ heights/elevation points
 __ materials __ dimensions __ detail keys __ notes/refs
 coord check: __ code __ struct __ cross sect __ mech

CEILING PLANS -- CONSTRUCTION COMPONENTS continued

√ Dbl√

__ __ EXPANSION JOINTS (05801)
 __ materials __ dimensions __ detail keys __ notes/refs
 coord check: __ specs __ struct __ cross sect

__ __ RECESSES
 __ edge lines __ heights/elevation points
 __ materials __ dimensions __ detail keys __ notes/refs
 coord check: __ clg anch __ fin sched __ mech __ elec

__ __ COFFERS
 __ edge lines __ heights/elevation points
 __ materials __ dimensions __ detail keys __ notes/refs
 coord check: __ clg anch __ fin sched __ mech __ elec

__ __ STAIRS
 __ soffits under stairs and landings
 __ soffits and furring at open stair ceiling penetration
 __ materials __ dimensions __ detail keys __ notes/refs
 coord check: __ struct __ stair sect __ cross sect __ int elev
 __ fin sched

__ __ THRU-CEILING ESCALATOR OPENINGS (14710)
 __ soffits under escalators
 __ soffits and furring at ceiling penetration
 __ materials __ dimensions __ detail keys __ notes/refs
 coord check: __ dimensions __ cross sect __ int elev
 __ fin sched __ elec

__ __ EXTERIOR OVERHANG SOFFIT REFLECTED PLANS
 __ fascia line
 __ louver or mesh soffit vents
 __ trim
 __ screeds
 __ control joints
 __ expansion joints
 __ edge lines __ heights/elevation points
 __ materials __ dimensions __ detail keys __ notes/refs
 coord check: __ struct __ ext elev __ cross sect

__ __ VALANCES (12500)
 __ edge lines __ heights/elevation points
 __ materials __ dimensions __ detail keys __ notes/refs
 coord check: __ clg anch __ cross sect __ int elev
 __ fin sched __ mech __ elec

__ __ DRAPE OR BLIND CEILING TRACKS (12501-12527)
 __ detail keys __ notes/refs
 coord check: __ clg anch __ int elev __ hardwr sched

CEILING PLANS -- CONSTRUCTION COMPONENTS continued

√ Dbl√

__ __ SLIDING DOORS TRACKS
 __ FIRE DOORS (08310)
 __ GLASS DOORS (08370)
 __ WOOD (08210)
 __ detail keys __ notes/refs
 coord check: __ struct __ clg anch __ int elev
 __ door sched __ hardwr sched

__ __ FOLDING DOOR TRACKS (08350)
 __ detail keys __ notes/refs
 coord check: __ struct __ clg anch __ int elev
 __ door sched __ hardwr sched

__ __ OVERHEAD DOOR SUPPORTS AND TRACKS (08331/08360)
 __ detail keys __ notes/refs
 coord check: __ struct __ clg anch __ int elev
 __ door sched __ hardwr sched

__ __ DEMOUNTABLE PARTITIONS AND TRACKS (10610)
 __ detail keys __ notes/refs
 coord check: __ struct __ clg anch __ int elev __ fin sched
 __ hardwr sched

__ __ MOVABLE PARTITIONS AND TRACKS (10616-10624)
 __ detail keys __ notes/refs
 coord check: __ struct __ clg anch __ int elev __ fin sched
 __ hardwr sched

__ __ CEILING SUPPORTED TOILET AND SHOWER STALL
 PARTITIONS (10160-10170)
 __ detail keys __ notes/refs
 coord check: __ struct __ clg anch __ int elev

__ __ HANGERS AND HOOKS (05507)
 __ location dimensions __ detail keys __ notes/refs
 coord check: __ struct __ clg anch

__ __ CEILING-MOUNTED CABINETS (06410)
 __ materials __ dimensions __ detail keys __ notes/refs
 coord check: __ struct __ clg anch __ int elev

__ __ CEILING-MOUNTED CASEWORK (12300)
 __ materials __ dimensions __ detail keys __ notes/refs
 coord check: __ struct __ clg anch __ int elev

__ __ WOOD BATTENS AND TRIM (06400)
 __ dimensions/spacing __ detail keys __ notes/refs
 coord check: __ int elev __ fin sched

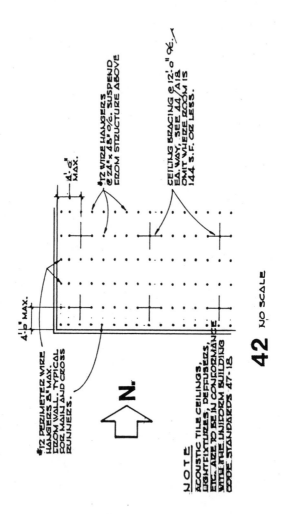

#12 WIRE HANGERS @ 24" x 48" o/c. SUSPEND FROM STRUCTURE ABOVE

4'-0" MAX.

CEILING BRACING @ 12'-0" o/c. EA. WAY, SEE 44/A18 OMIT WHERE ROOM IS 144 S.F. OR LESS.

#12 PERIMETER WIRE HANGERS 8" MAX. FROM WALL. TYPICAL FOR MAIN AND CROSS RUNNERS.

4'-0" MAX.

N.

42 NO SCALE

N O T E
ACOUSTIC TILE CEILINGS, LIGHT FIXTURES, DIFFUSERS, ETC. ARE TO BE IN CONFORMANCE WITH THE UNIFORM BUILDING CODE STANDARDS 47-18

CEILING PLANS -- CONSTRUCTION COMPONENTS continued

√ Dbl√

__ __ NOISE BARRIERS IN SUSPENDED CEILING SPACES AT LOW
PARTITION LINES (09530)
 __ materials __ detail keys __ notes/refs
 coord check: __ struct __ clg anch __ mech

__ __ LIGHT FIXTURES (16510-16515)
 __ surface mounted
 __ recessed
 __ lighting tracks
 __ dimensions/spacing __ detail keys __ notes/refs
 coord check: __ struct __ clg anch __ mech __ elec

__ __ CEILING MOUNTED SPEAKERS (16770)
 __ location dimensions where important __ notes refs
 coord check: __ clg anch __ elec

__ __ ALARMS (16720)
 __ location dimensions where important __ notes/refs
 coord check: __ clg anch __ elec

__ __ CEILING-MOUNTED CAMERAS AND MONITORS (16780)
 __ location dimensions where important __ notes/refs
 coord check: __ clg anch __ elec

__ __ SMOKE AND HEAT DETECTORS (16725)
 __ location dimensions where important __ notes/refs
 coord check: __ code __ clg anch __ elec

__ __ MANUAL OR POWERED PROJECTION SCREENS (11131)
 __ dimensions __ notes/refs
 coord check: __ struct __ clg anch __ int elev __ elec

__ __ FIRE SPRINKLER SYSTEM (15501-15510)
(Integrated with suspended ceiling, lighting, and partition systems.)
 __ dimensions/spacing __ detail keys __ notes/refs
 coord check: __ code __ struct __ clg anch __ plumb
 __ mech

__ __ CATWALKS (05530)
 __ materials __ dimensions __ detail keys __ notes/refs
 coord check: __ struct __ clg anch __ cross sect __ int elev
 __ mech

__ __ SERVICE LADDERS (05515)
 __ materials __ dimensions __ detail keys __ notes/refs
 coord check: __ struct __ clg anch __ mech

CEILING PLANS -- CONSTRUCTION COMPONENTS continued

√ Dbl√

__ __ CEILING ACCESS PANELS (10220)
 __ fold-down ladders
 __ soffit scuttles
 __ hinged or removable
 __ materials __ dimensions __ detail keys __ notes/refs
 coord check: __ struct __ clg anch __ int elev __ mech

__ __ ROOF HATCHES (07830)
 __ fusible link hatches
 __ hinged or removable
 __ materials __ dimensions __ detail keys __ notes/refs
 coord check: __ struct __ roof __ cross sect __ mech

__ __ THRU-CEILING SHAFTS
 __ dimensions __ detail keys __ notes/refs
 coord check: __ struct __ cross sect __ mech

__ __ CHASES
 __ dimensions __ detail keys __ notes/refs
 coord check: __ struct __ roof __ cross sect __ mech

__ __ CHUTES
 __ dimensions __ detail keys __ notes/refs
 coord check: __ struct __ roof __ cross sect __ mech

__ __ FUTURE SHAFTS
 __ dimensions __ notes/refs
 coord check: __ struct __ cross sect __ mech

__ __ SKYLIGHTS (07810)
 __ skylight sun screens
 __ wire mesh skylights guards
 __ fixed
 __ operable
 __ materials __ dimensions __ detail keys __ notes/refs
 coord check: __ struct __ roof __ cross sect

__ __ MONITORS/ROOF WINDOWS (08655)
 __ fixed
 __ operable
 __ materials __ dimensions __ detail keys __ notes ref
 coord check: __ struct __ roof __ cross sect

__ __ LIGHT WELLS
 __ dimensions __ detail keys __ notes/refs
 coord check: __ struct __ roof __ cross sect __ mech

CEILING PLANS -- CONSTRUCTION COMPONENTS continued

√ Dbl√

__ __ INTEGRATED CEILING RADIANT HEATING SYSTEM
(15745-15750)
__ dimensions/spacing __ detail keys __ notes/refs
coord check: __ fin sched __ mech __ elec

__ __ LOUVERS (10200)
__ grilles
__ registers
__ materials __ dimensions __ detail keys __ notes/refs
coord check: __ mech __ clg anch

__ __ AIR DISTRIBUTION (15800)
__ diffusers
__ return air vents
__ unit heaters
__ unit ventilators
__ fans
__ exhaust fans and flues
__ locations __ detail keys __ notes/refs
coord check: __ struct __ clg anch __ plumb __ elec

__ __ EXPOSED DUCTWORK (15840)
__ locations __ detail keys __ notes/refs
coord check: __ struct __ clg anch __ plumb __ elec

__ __ NOISE AND VIBRATION DAMPENING CONNECTORS FOR
FAN MOTORS AND OTHER NOISE GENERATING, CEILING-
MOUNTED EQUIPMENT (15200)
__ detail keys __ notes/refs
coord check: __ clg anch __ mech __ elec

__ __ CRANES AND HOISTS (14300)
__ location dimensions __ detail keys __ notes/refs
coord check: __ struct __ clg anch __ cross sect __ int elev
__ mech __ elec

CEILING PLANS -- CONSTRUCTION COMPONENTS continued

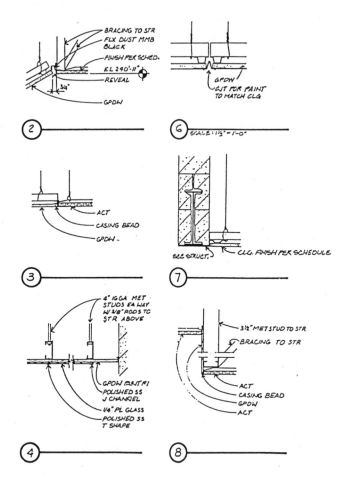

2

BRACING TO STR
FLX DUST MMB
BLACK
FINISH PER SCHED.
EL 290'-11"
REVEAL
3/4"
GPDW

6 SCALE: 1½" = 1'-0"

GPDW
CUT FOR PAINT
TO MATCH CLG

3

ACT
CASING BEAD
GPDW

7

SEE STRUCT.
CLG. FINISH PER SCHEDULE

4

4" 16 GA MET
STUDS EA WAY
W/ 3/8" RODS TO
STR ABOVE

GPDW PAINT FIN
POLISHED SS
J CHANNEL
1/4" PL GLASS
POLISHED SS
T SHAPE

8

3½" MET STUD TO STR
BRACING TO STR

ACT
CASING BEAD
GPDW
ACT

CEILING DETAILS

NOTES

Date/Initials

SCHEDULES

CHAPTER CONTENTS

DOOR SCHEDULES

√ Dbl√

__ __ DOOR TYPES DRAWN IN ELEVATION (1/2" scale is typical.)

__ __ SYMBOL AND IDENTIFYING NUMBER AT EACH DOOR

__ __ DOOR SIZES: ___WIDTHS __ HEIGHTS __ THICKNESSES

__ __ DOOR TYPES: ___ MATERIALS __ FINISHES
(The number of doors of each type and size is sometimes noted.)

__ __ OPERATING TYPE: __ SLIDING __ SINGLE-ACTING
__ DOUBLE ACTING __ DUTCH __ PIVOT
__ 2-HINGE __ 3-HINGE

__ __ KICKPLATES

__ __ FIRE RATING IF REQUIRED

__ __ LOUVERS __ UNDERCUTS FOR VENTILATION

__ __ SCREENS

__ __ MEETING STILES

__ __ DOOR GLAZING __ TRANSOMS __ BORROWED LIGHTS

__ __ DETAIL KEY REFERENCE SYMBOLS:
__ SILLS
__ JAMBS
__ HEADERS

__ __ MANUFACTURERS __ CATALOG NUMBERS
(If not covered in Specifications.)

__ __ METAL FRAMES:
__ ELEVATIONS
__ SCHEDULE
__ DETAILS

DOOR SCHEDULES

DOOR SCHEDULE								
DOOR MARK	OPENING SIZE	TYPE (NOTE 2)	THICKNESS (3)	CONSTRUCTION (4)	FACING & FINISH (5)	GLASS (6)	RATING (7)	FRAME (8)
I	3'-6" x 7'-0"	A	✓	✓	✓	CW	1½	26

1. "✓" SHOWN ON SCHEDULE INDICATES TYPICAL
2. DOOR TYPES:

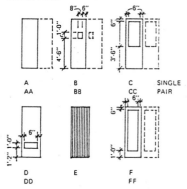

| A | B | C | SINGLE |
| AA | BB | CC | PAIR |

| D | E | F |
| DD | | FF |

3. ALL DOORS 1¾" THICK UNLESS OTHERWISE NOTED
4. DOOR CONSTRUCTION:
 TYPICAL = SOLID CORE
 HC = HOLLOW CORE
 HM = HOLLOW METAL
 AL = ALUMINUM & GLASS
5. FACING & FINISH:
 TYPICAL = RED BIRCH, TRANSPARENT
 PT = PLASTIC LAMINATE, TEXTURED
 MP = METAL, PAINTED
6. GLASS:
 TYPICAL = CLEAR PLATE
 SG = SHEET GLASS
 CW = CLEAR WIRE
 TP = TEMPERED PLATE
 LG = LEAD GLASS
7. ¾, 1, 1½ ETC. INDICATES HOURS OF FIRE RATING.
8. TYPICAL FRAMES SHOWN "✓". NUMBER INDICATES
 DETAIL SHOWN ON SHEET_____.

DOOR SCHEDULES

HARDWARE LOCATION NOTES

HINGE LOCATIONS: WHERE FOUR OR MORE HINGES SHALL BE USED, THE TOP AND BOTTOM HINGES SHALL BE LOCATED AS SHOWN, WITH INTERMEDIATE HINGES BEING EQUALLY SPACED BETWEEN THEM.

DEADLOCK LOCATION: WITH PUSH PLATES THE LOCATION SHOWN IS NOT MANDATORY. USE A 48" DIMENSION WHEN A DEADLOCK IS USED W/ PUSH/PULL PLATES.

LOCATION FOR OTHER HARDWARE ITEMS: KICK, MOP, AND ARMOR PLATES, UNLESS OTHERWISE SPECIFIED, SHALL EXTEND TO WITHIN 1/4" FROM THE BOTTOM OF THE DOOR AND THEIR HORIZONTAL LENGTH SHALL BE AS FOLLOWS: ON SINGLE DOORS, THE NOMINAL DOOR WIDTH LESS 2" ON THE PUSH SIDE AND THE NOMINAL DOOR WIDTH LESS 1" ON THE PULL SIDE; ON DOORS OF PAIRS, THE NOMINAL DOOR WIDTH LESS 1" ON EACH SIDE.

SILENCERS ON SINGLE DOOR FRAMES SHALL BE PLACED OPPOSITE THE HINGES, AND ON DOUBLE DOOR FRAMES, SHALL BE LOCATED 6" EACH SIDE OF THE CENTER OF THE HEAD STOP.

FINISH FLOOR LEVEL: FINISH FLOOR LEVEL IS DEFINED AS THE TOP SURFACE OF THE FINISH FLOORING MATERIAL, EXCEPT WHEN RESILIENT TILE OR CARPET IS USED, THEN IT IS THE TOP SURFACE OF THE UNDERLYING FINISH CONCRETE.

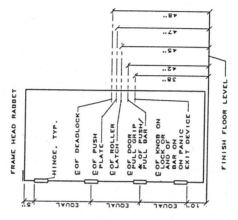

HARDWARE LOCATIONS
NTS

FRAME HEAD RABBET

HINGE, TYP.

℄ OF DEADLOCK

℄ OF PUSH PLATE

℄ OF ROLLER LATCH

℄ OF DOOR PULL OR GRIP & OF PUSH/PULL BAR

℄ OF KNOB ON LOCK OR AND OR BAR ON ON PANIC EXIT DEVICE

FINISH FLOOR LEVEL

48" 47" 45" 42" 38"

5" EQUAL EQUAL EQUAL 10"

WINDOW SCHEDULES

√ Dbl√

_ _ WINDOW TYPES DRAWN IN ELEVATION
 (1/2" scale is typical.)

_ _ WINDOW SYMBOL AND IDENTIFYING NUMBER AT EACH
 DRAWING

_ _ WINDOW SIZE _ WIDTH _ HEIGHT

_ _ WINDOW TYPE
 _ DIRECTION OF MOVEMENT OF OPERABLE SASH AS
 SEEN FROM EXTERIOR
 (Number of windows of each type and size is sometimes noted.)

_ _ GLASS THICKNESS AND TYPE

_ _ NOTE: FIXED _ OBSCURE _ WIRE _ TEMPERED
 _ DOUBLE GLAZING _ TINTED

_ _ SCREENS

_ _ DETAIL KEY REFERENCE SYMBOLS: _ SILLS _ JAMBS
 _ HEADERS

_ _ MANUFACTURERS _ CATALOG NUMBERS
 (If not covered in Specifications.)

_ _ METAL FRAME STOREFRONT OR CURTAIN WALL SYSTEM:
 _ ELEVATIONS _ SCHEDULE _ DETAILS

NOTES Date/Initials

WINDOW SCHEDULES

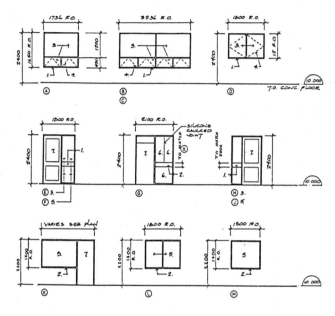

SEE SHEET A4.6 FOR
CONCESSION WDW. INFO.

2 WINDOW SCHEDULE
2.4 0 1M 2M

KEYNOTES TO WINDOW SCHEDULE

1. NATURAL ANODIZED ALUM. THERMALLY BROKEN WINDOW FRAME.

2. PRESSED STEEL FRAME - THROAT TO MATCH WALL THICKNESS.

3. H.S.D.G. OUTBOARD LITE - SOLEX
 INBOARD LITE - CLEAR

4. AWNING OR CASEMENT OPENERS AS SHOWN C/W SCREENS.

5. SINGLE GLAZED CLEAR.

6. SINGLE GLAZED WIRED GLASS.

7. DOOR - SEE DOOR SCHEDULE.

WINDOW SCHEDULES

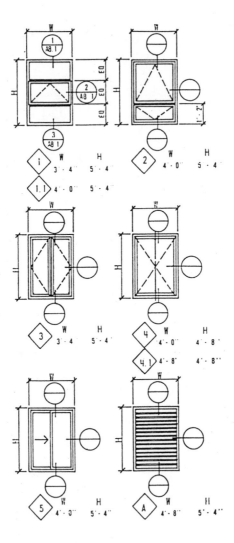

FINISH SCHEDULES

√ Dbl√

__ __ ROOM NAME AND/OR IDENTIFYING NUMBER

__ __ FLOOR: THICKNESS __ MATERIAL __ FINISH

__ __ BASE: HEIGHT __ MATERIAL __ FINISH

__ __ WALLS: MATERIALS __ FINISHES
(Walls may be identified by compass direction code symbol if
finishes vary wall by wall. Note waterproofing and waterproof
membrane wall construction.)

__ __ WAINSCOT: HEIGHT __ MATERIAL __ FINISH

__ __ CEILING: MATERIAL __ FINISH

__ __ SOFFITS: MATERIAL __ FINISH

__ __ CABINETS: MATERIAL SPECIES AND GRADE __ FINISH

__ __ SHELVING: MATERIAL __ FINISH

__ __ DOORS: MATERIAL __ FINISH
(If not covered in Door Schedule.)

__ __ TRIM AND MILLWORK: MATERIAL SPECIES AND GRADE
__ FINISH

__ __ MISCELLANEOUS REMARKS OR NOTES

__ __ COLORS: STAIN AND PAINT __ MANUFACTURER AND
TRADE NAMES OR NUMBERS
(If not covered in Specifications. Sometimes left for later decision
with provision for paint allowance by bidders.)

__ __ EXTERIOR FINISHES: __ EXTERIOR WALLS
__ SILLS __ TRIM
__ POSTS __ GUTTERS AND LEADERS
__ FLASHING AND VENTS __ FASCIAS __ RAILINGS
__ DECKING __ SOFFITS
(Included in Finish Schedule if not covered in Specifications.)

FINISH SCHEDULES

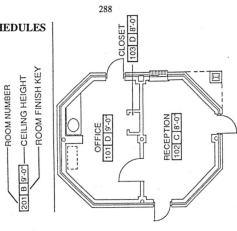

ROOM NUMBER — CEILING HEIGHT — ROOM FINISH KEY

201 B 9'-0"

OFFICE
101 D 9'-0"

CLOSET
103 D 8'-0"

RECEPTION
102 C 8'-0"

FINISH SCHEDULE

FINISH KEY	FLOOR	BASE	WALLS	CEILING	REMARKS
A	CONCRETE	NONE	CMU	NONE	ROOM 102 NOT TO BE PAINTED
B	CONCRETE W/HARDNER	VINYL	CMU	24" X 24" ACOUSTICALBOARD	OMIT HARDNER IN ROOM107
C	CARPET	VINYL	GYPSUM BOARD	ACOUSTICAL TILE	
D	CARPET	VINYL	GYPSUM BOARD	GYPSUM BOARD	
E	VINYL	VINYL	GYPSUM BOARD - CMU	GYPSUM BOARD	
F	TERRAZZO	TERRAZZO	GYPSUM BOARD	GYPSUM BOARD	
G	ACCESS FLOORING	VINYL	WOOD PANELING	GYPSUM PLASTER	SEALER ON CONC. BELOW ACCESS FL.
H	BRICK PAVERS	WOOD	WOOD PANELING	ACOUSTICAL PLASTER	
J	CERAMIC TILE	CERAMIC TILE	VINYL WALL COVERING	24" X 48" ACOUSTICAL BOARD	
K	QUARRY TILE	QUARRY TILE	CERAMIC TILE	ACOUSTICAL TILE	

NOTES

FOUNDATION AND FRAMING PLANS

CHAPTER CONTENTS

FOUNDATION AND FRAMING PLANS

PROCEDURAL CHECKLIST

FOUNDATION PLAN LAYOUT AND DRAFTING, STEP BY STEP

PHASE 1 -- "OUTLINE" INFORMATION

AND INFORMATION REQUIRED BY CONSULTANTS

First, update and verify ground floor room sizes in the floor plan. Using the updated floor plan as your guide, proceed with the following steps.

__ Decide on the desirable scale, size, and positioning of the Foundation Plan on the working drawing sheet(s). Consider locations of Keynote legend, General Notes, Symbols Legend (if any), Titles, Key Plan, and foundation details.

Layout & Linework

__ Use the Floor Plan (lower-level if a multi-level building) -- at the stage showing walls, partitions etc. as the base sheet or base layer for the Foundation Plan.

__ Draw perimeter foundation wall or slab lines matching exterior perimeter floor plan wall line.

__ Rough in girder lines and pier locations; or interior footing/foundation wall lines. Locate foundation support and girders under bearing walls; locate double joists under parallel partitions.

__ Rough in columns, posts, other structural members that are supported by piers or footings.

__ Show any portions of wall that cantilever over foundation walls.

__ Show changes in ground floor level.

__ Rough in floor openings for plumbing chases, etc.

__ Show dash lines for relevant hidden construction above the foundation level.

__ Rough in drainage locations.
Coordinate with Site Plan, Plumbing Plan, and Roof Plan.

__ Cross-coordinate structural components with:
__ Cross Sections
__ Finish and excavated grades in Site Plan
__ Drains and utility lines in Plumbing Plan
__ Crawl-space equipment and ducts in HVAC Plan.

FOUNDATION AND FRAMING PLANS
PROCEDURAL CHECKLIST continued

PHASE 2 -- "HARDLINE" INFORMATION

AND DETAILED ARCHITECTURAL CONSTRUCTION DATA

Construction Elements

__ Confirm ground floor level wall locations.

__ Confirm footing and pier lines and draw solid line indications for
 foundation lines, dash lines for below-grade footings.

__ Hardline girder and joist line indications.

__ Show chimney footings.

__ Show thru-wall foundation vents and scuttle access.

__ Show slab floor drains.

__ Show rodent-proofing and termite shields.

__ Show footing ledges to support masonry.

__ Show shear walls at ground floor level as dash lines and reference to
 structural notes, details, and/or specifications.

Dimensioning

__ Draw overall dimension lines.
 Coordinate and cross-check with floor plan dimensions. Floor
 plans do not have to repeat construction dimensions for foundation
 work that will completed at the time of first floor framing.

__ Draw dimension lines as required for slab-mounted equipment.

__ Add dimension numbers in feet and inches.
 Avoid unrealistic small fractions of an inch; 1/2" is usually
 minimum, 4" increments preferred.

__ Show reference start points of dimension strings; reference for the
 convenience of framer. Cross check overall dimension strings
 with partial dimensions.

__ Add small dimensions such as for exterior planter footings, fireplace
 footings, etc.

FOUNDATION AND FRAMING PLANS
PROCEDURAL CHECKLIST continued

PHASE 2 -- "HARDLINE" INFORMATION continued

Titles, Labels, & Referencing

__ If using structural or modular grid, check that coordinate numbers match the latest floor plan.

__ Add Foundation Plan drawing title and scale.

__ Add materials and Keynote numbers or identification notes.

Notation

__ Add reference notes to special areas shown elsewhere at larger scale.

__ Write materials identification notes or keynote reference numbers.

__ Note tie downs, anchor bolts, etc. and reference to structural details and/or specifications.

__ Where elements or dimensions are highly repetitive, note or dimension one and add "Typical" or "Unless Noted Otherwise" notes:

__ Write construction assembly notation and note references to specifications and details.

__ Add final clarification reference notes regarding equipment in crawl-space or on slabs.

__ Edit and update the Keynotes legend.

__ Add, edit, and update any General Notes that pertain to ceiling construction.

Referencing & Symbols

__ Show partial indications of floor framing and subfloor or refer to floor framing plans.

__ Show floor framing directions arrow with size and spacing notes or refer to floor framing plans. Refer to separate framing plans or structural drawings, if provided.

__ Show shear walls at ground floor level as dash lines and reference to structural notes, details, and/or specifications.

__ Add detail reference bubbles for foundation construction details.

FOUNDATION AND FRAMING PLANS
PROCEDURAL CHECKLIST continued

PHASE 2 -- "HARDLINE" INFORMATION continued

__ Key slab-mounted equipment to Equipment and Fixtures Schedules.

__ Show cross-section cut lines.

__ Show key plans with elevation references and cross section cut lines.

__ The floor plan may be printed as a screened back ground image with
 foundation elements shown in solid line or show walls and
 partitions as dash lines.

PHASE 3 -- CHECKING

__ Use transparency prints to cross check and coordinate Foundation Plan
 with Floor Plans, Electrical Plans, Plumbing Plans, and HVAC
 plans.

__ For check prints, attach a blank transparency on the Foundation Plan
 and mark changes and additions in red and data that's correct in
 yellow.

__ In each later phase of checking, remove the transparency from the first
 check print and attach to the next phase check print. Verify that
 required changes and additions have been completed as required,
 and mark with yellow over the red marks.

__ To minimize oversights, checking for errors and incompleteness should
 be separate from checking for progress.

__ Checking for changes and additions is often more complete and
 accurate if done by a third party who has not been working on the
 project.

FOUNDATION AND FRAMING PLANS continued

CONCRETE SLAB ON GRADE

√ Dbl√

__ __ SLAB PERIMETER OUTLINE AND DIMENSIONS
__ __ BROKEN LINES SHOWING PERIMETER FOOTING

__ __ INTERIOR FOOTINGS:
 __ PIERS
 __ COLUMNS
 __ BEARING WALLS

__ __ FOOTING SIZE AND LOCATION DIMENSIONS

__ __ ELEVATION POINTS AT BOTTOMS OF FOOTINGS

__ __ EXISTING AND NEW FINISH GRADE LINES
__ __ FINISH GRADE ELEVATION POINTS AT CORNERS OF
 BUILDING

__ __ PERIMETER 4" DRAIN TILE WITH CRUSHED-ROCK BED

__ __ PERIMETER THERMAL INSULATION AT JUNCTURE OF
 SEPARATELY POURED SLAB AND FOOTING

__ __ PERIMETER MUD SILL
__ __ SIZE, DEPTH, AND SPACING OF SILL ANCHOR BOLTS
 (Anchor bolts typically at 6'0" and 2'0" from corners. Bolts
 spaced so as not to be under studs.)

__ __ GARAGE PERIMETER SLAB CURB:
 ___ THICKNESS
 ___ HEIGHT

__ __ GARAGE SLAB SLOPED TO APRON (Typical slope is 2".)
__ __ CONSTRUCTION JOINT AT SLAB AND APRON

__ __ TERMITE SHIELDS

__ __ ADJACENT SLAB
__ __ SPACING OF DOWEL CONNECTIONS BETWEEN SLABS

__ __ FILLED, TAPED, AND PUDDLED SOIL UNDER PORCH
 SLAB AND RAISED CONCRETE LANDINGS

__ __ PATIO OR TERRACE SLAB FROST CURB
 (6" edge of slab turned down 12" or more below finish grade.)

FOUNDATION PLANS continued

CONCRETE SLAB ON GRADE continued

√ Dbl√

__ __ CONCRETE SLAB CONTROL JOINTS, CONSTRUCTION
JOINTS (Typical is 1/2" construction joints every 40' both
ways. Tooled joints every 20' both ways and at piers and
columns.)

__ __ BROKEN-LINE OUTLINE OF FLOOR PLAN ON SLAB,
INCLUDING PLUMBING FIXTURES

__ __ CHANGES IN SLAB FLOOR ELEVATION

__ __ SLAB DEPRESSIONS FOR MASONRY, TILE, OR
TERRAZZO FINISH FLOORING

__ __ SHOWER, SUNKEN TUB:
 __ SLAB DEPRESSIONS
 __ SIZES
 __ DEPTHS
 __ NOTES
 __ DETAIL KEYS

__ __ FIREPLACE FOOTING:
 __ LOCATION AND SIZE DIMENSIONS
 __ REINFORCING NOTE
 __ BROKEN-LINE OUTLINE OF FIREPLACE ABOVE

__ __ FIREPLACE ASH PIT AND CLEANOUT

__ __ UNDER-FLOOR OR PERIMETER DUCTWORK

__ __ RADIANT HEATING PIPE PLAN (May be separate drawing.)

__ __ CANTILEVERED SLAB SECTIONS
__ __ CHANGE IN TENSILE REINFORCING FROM BOTTOM TO
UPPER PORTION OF SLAB NOTED

__ __ SLAB THICKNESS
__ __ REINFORCING
__ __ VAPOR BARRIER
__ __ ROCK SUB-BASE
__ __ SUB-GRADE COMPACTION
__ __ PARTIAL PLAN OF FINISH FLOOR:
 __ MATERIAL
 __ SLEEPERS
 __ PATTERN
 __ SLOPE
 __ THICKNESS OR HEIGHT OF FLOORING ABOVE
 SLAB

FOUNDATION AND FRAMING PLANS continued

03308 CONCRETE SLABS ON GRADE

CONCRETE SLAB ON GRADE T & G Joint
1"=1'-0" 03308-1

CONCRETE SLAB ON GRADE Butt Joint
1"=1'-0" 03308-2

CONC. SLAB ON GRADE Construction Joint
1"=1'-0" 03308-3

CONC. SLAB ON GRADE Control Joint
1"=1'-0" 03308-4

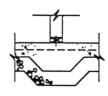

CONCRETE SLAB & FOOTING
1"=1'-0" 03308-5

CONCRETE SLAB ON GRADE
1"=1'-0" 03308-6

FOUNDATION AND FRAMING PLANS continued

CONCRETE SLAB ON GRADE continued

✓ Dbl✓

__ __ DETAIL SECTION KEYS:
 __ FOOTINGS
 __ CONNECTIONS TO OTHER CONSTRUCTION
 __ POST AND COLUMN CONNECTIONS AT SLAB
 OR PIERS
__ __ OVERALL BUILDING CROSS-SECTION ARROW AND
 REFERENCE SYMBOLS

NOTES Date/Initials

FOUNDATION AND FRAMING PLANS continued

PERIMETER FOUNDATION, JOIST FRAMING continued

√ Dbl√

__ __ PERIMETER FOUNDATION WALL AND FOOTING OUTLINE
__ __ MATERIAL INDICATIONS
__ __ WALL THICKNESSES
__ __ FOOTING WIDTH
__ __ OVERALL DIMENSIONS
__ __ DETAIL KEYS

__ __ FOUNDATION WALL LIP TO SUPPORT MASONRY VENEER
__ __ NOTE AND DETAIL KEY
__ __ STEPPED FOOTINGS AND FOUNDATION WALLS
__ __ ELEVATION POINTS
__ __ DETAIL KEYS

__ __ ELEVATION POINTS AT BOTTOMS OF FOOTINGS (Footing
 depths are typically below frost line and 12" below
 undisturbed soil.)

__ __ NOTE VERTICAL AND HORIZONTAL FOOTING AND
 FOUNDATION WALL REINFORCING (May be shown
 separately in detail wall section.)

__ __ EXISTING AND NEW FINISH GRADE LINES
__ __ FINISH GRADE ELEVATIONS AT CORNERS OF BUILDING

__ __ PERIMETER DRAIN TILE AND CRUSHED-ROCK BED

__ __ BROKEN-LINE OUTLINE OF FLOOR PLAN ABOVE,
 INCLUDING PLUMBING FIXTURES

__ __ GRADE BEAMS
__ __ SIZE AND LOCATION DIMENSIONS
__ __ DEPTH INTO SOIL
__ __ REINFORCING

__ __ INTERIOR FOUNDATION WALLS, DWARF WALLS, AND
 FOOTINGS AT BEARING WALLS WITHIN BUILDING
__ __ SIZE AND LOCATION DIMENSIONS

__ __ DECK SUPPORT PIERS AND FOOTINGS
__ __ SIZE AND LOCATION DIMENSIONS
__ __ MATERIALS
__ __ DEPTH INTO SOIL
__ __ DETAIL KEYS

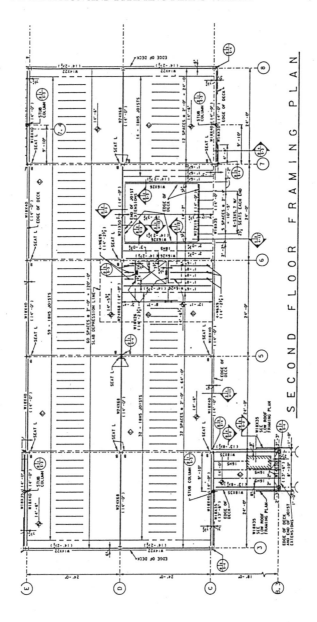

SECOND FLOOR FRAMING PLAN

FOUNDATION AND FRAMING PLANS continued

PERIMETER FOUNDATION, JOIST FRAMING continued

✓ Dbl✓

__ __ GIRDER LINES
__ __ GIRDER SIZE AND MATERIAL
__ __ DETAIL KEYS

__ __ GIRDER SUPPORT PIERS
__ __ SIZE AND LOCATION DIMENSIONS
__ __ WOOD CAPS OR POSTS AT CONCRETE PIERS
__ __ DETAIL KEYS

__ __ GIRDER LINES
__ __ GIRDER SIZE AND MATERIAL
__ __ DETAIL KEYS
__ __ GIRDER SUPPORT PIERS
__ __ SIZE AND LOCATION DIMENSIONS
__ __ WOOD CAPS OR POSTS AT CONCRETE PIERS
__ __ DETAIL KEYS

__ __ GIRDER SUPPORT RECESSES IN FOUNDATION WALLS
(44" bearing minimum, 1/2" air space at ends and sizes of wood
girders)

__ __ DETAIL KEYS

__ __ FOUNDATION WALL MUD SILL:
__ SIZE, DEPTH AND SPACING OF ANCHOR BOLTS .
(Anchor bolts typical at 6'0", and 2'0" from corners.
Bolts spaced so as not to be under joists.)

__ __ MUD SILL:
__ SIZE
__ MATERIAL
__ GROUT LEVELING

__ __ CRAWL SPACE ACCESS PANEL THROUGH FOUNDATION
WALL (A 24" x 18" opening is typical. Footing shown
continuous below access panel.)

__ __ CRAWL SPACE VENTILATION (Use of 16" x 8" screened or
louver vents between joists is typical. Usually 2 sq. ft. of vent
is required for each 24 sq. ft. of crawl space area, with one
vent within 3' of each building corner.)

FOUNDATION AND FRAMING PLANS continued

PERIMETER FOUNDATION, JOIST FRAMING continued

√ Dbl√

__ __ CRAWL SPACE ACCESS THROUGH INTERIOR
 FOUNDATION WALLS

__ __ SCUTTLE TO CRAWL SPACE FROM FLOOR ABOVE

__ __ TERMITE SHIELDS

__ __ ADJACENT SLABS
__ __ SIZE AND SPACING OF DOWEL CONNECTIONS BETWEEN
 SLABS, AND BETWEEN SLABS AND FOUNDATION WALL

__ __ FIREPLACE SLAB
__ __ FOOTING

__ __ ASH PIT
__ __ CLEANOUT
__ __ SIZE AND LOCATION DIMENSIONS
__ __ OUTLINE OF FIREPLACE ABOVE
__ __ NOTE ON SLAB THICKNESS AND REINFORCING
__ __ DETAIL KEY

__ __ CONCRETE RODENT BARRIER OVER CRAWL SPACE SOIL

__ __ HERBICIDE AND/OR TERMITE SOIL TREATMENT
 (Indicated in drawings, then detailed in specifications.)

__ __ VAPOR BARRIER WITH SAND COVER OVER CRAWL
 SPACE SOIL (used mainly in wet-soil areas.)

NOTES Date/Initials

FOUNDATION AND FRAMING PLANS continued

PERIMETER FOUNDATION, JOIST FRAMING continued

√ Dbl√

__ __ FLOOR JOISTS:
 __ SIZE
 __ TYPE
 __ MATERIAL
 __ SPACING
 __ ARROWS SHOWING DIRECTION OF SPANS

__ __ JOIST BLOCKING OR RIDGING:
 __ LOCATIONS
 __ MATERIAL
 __ SIZE

__ __ DOUBLE JOISTS;
 __ UNDER PARALLEL PARTITIONS
 __ AT BATHTUBS
 __ AT OTHER CONCENTRATED LOADS

__ __ DOUBLE HEADER JOISTS TO FRAME THRU-FLOOR
 OPENINGS

__ __ INDICATIONS, NOTES, AND DETAIL KEYS:
 __ FRAMING CLIPS
 __ ANCHORS
 __ BOLTS
 __ JOIST AND BEAM HANGERS
 __ POST AND GIRDER CONNECTIONS
 __ LEDGERS

__ __ PARTIAL PLAN OF SUBFLOORING, SHEATHING, OR
 DECKING SHOWING MATERIAL AND PATTERN

__ __ CONSTRUCTION NOTES

__ __ FLOOR DIAPHRAGM SHEATHING WITH NAILING
 SCHEDULE AND CALCULATIONS

__ __ DETAIL REFERENCE KEYS:
 __ FOOTINGS
 __ FOUNDATION WALLS
 __ SLABS
 __ CURBS
 __ CONNECTIONS TO OTHER CONSTRUCTION
 __ FLASHING

__ __ OVERALL BUILDING CROSS-SECTION ARROW AND
 REFERENCE SYMBOLS

FOUNDATION AND FRAMING PLANS continued

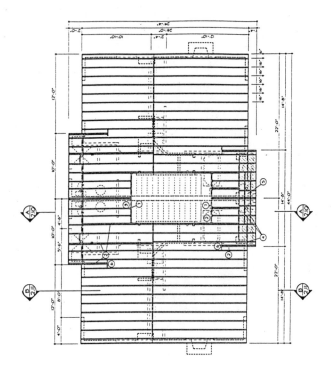

FOUNDATION AND FRAMING PLANS continued

BASEMENT

The basement plan includes many elements also found on the previous
foundation plan lists. Relevant elements are repeated here. All components
normally shown in basement plans are included, although they do not pertain
to foundation work or structure.

√ Dbl√

__ __ BASEMENT WALL OUTLINE
__ __ MATERIAL INDICATIONS
__ __ WALL THICKNESS
__ __ OVERALL DIMENSIONS
__ __ DIMENSIONS OF OPENINGS

__ __ BASEMENT WALL FOOTING OUTLINES IN BROKEN LINE
__ __ WIDTH AND THICKNESS OF FOOTINGS
__ __ ELEVATION POINTS AT BOTTOM OF FOOTINGS
__ __ CHANGES IN LEVEL OF FOOTINGS

__ __ NOTE VERTICAL AND HORIZONTAL FOOTING AND
 BASEMENT WALL REINFORCING (may be shown
 separately in detail wall section.)

__ __ BASEMENT WALL OPENINGS (DOORS, AREAWAYS,
 WINDOWS, VENTS):
 __ SILL HEIGHTS ABOVE FINISH FLOOR OR
 ELEVATION POINTS NOTED
 __ SCHEDULE AND DETAIL REFERENCE KEYS

__ __ AREAWAYS
__ __ AREAWAY FLOOR ELEVATION POINTS
__ __ SLOPE
__ __ DRAINAGE

__ __ SLEEVES FOR HOUSE SEWER MAIN, GAS, WATER, AND
 ELECTRIC SUPPLY:
 __ NOTED __ SIZED
 __ LOCATION AND HEIGHTS DIMENSIONED
 __ DETAIL KEYS AT SLEEVES AND PIPES THAT
 PASS THROUGH WATERPROOFING MEMBRANE

__ __ PERIMETER BASEMENT WALLS:
 __ WATER PROOFING
 __ CAULKING
 __ INSULATION
 __ PARGING
 __ FURRING
 __ INTERIOR FINISH
 __ DETAIL KEYS

FOUNDATION AND FRAMING PLANS continued

BASEMENT continued

√ Dbl√

__ __ EXISTING AND NEW FINISH GRADE LINES
__ __ FINISH GRADE ELEVATION POINTS AT CORNERS OF
 BUILDING

__ __ FINISH FLOOR ELEVATION POINTS
__ __ FLOOR SLOPES

__ __ PERIMETER DRAIN TILE AND CRUSHED-ROCK BED
__ __ SLOPE

__ __ PERIMETER MUD SILL ANCHOR BOLTS ATOP BASEMENT
 WALL:
 __ SIZE
 __ DEPTH
 __ SPACING

__ __ MUD SILL SIZE AND MATERIAL
__ __ NOTE GROUT LEVELING

__ __ TERMITE SHIELDS

__ __ BROKEN-LINE OUTLINE OF FLOOR PLAN ABOVE,
 INCLUDING PLUMBING FIXTURES

__ __ UNEXCAVATED FLOOR AREA WITH ACCESS SCUTTLE
 AND FOUNDATION VENTS
__ __ SIZES AND LOCATIONS OF SCUTTLE AND VENTS

__ __ CONCRETE RATPROOFING OVER SOIL
__ __ VAPOR BARRIER AT UNEXCAVATED FLOOR AREAS

__ __ ADJACENT SLABS:
 __ FOOTINGS
 __ DIMENSIONS
 __ MATERIAL INDICATIONS
 __ SIZE AND SPACING OF DOWEL CONNECTIONS
 __ REINFORCING
 __ SOIL PREPARATION

__ __ BASEMENT FINISH FLOOR MATERIAL

__ __ FLOOR DRAINS
__ __ SUMP PIT AND PUMP (Water supply to keep drain traps full
during extended periods of non-use.)

__ __ FLOOR SLAB CONSTRUCTION JOINTS
__ __ TOOLED JOINTS

FOUNDATION AND FRAMING PLANS continued

BASEMENT continued

✓ Dbl✓

__ __ CAULKING AT JUNCTURE OF SLAB AND WALL
__ __ CONSTRUCTION JOINT DETAIL KEYS

__ __ CONTROL JOINTS IN SLAB AT PIERS AND COLUMNS

__ __ FLOOR ANCHORS
__ __ PEDESTALS
__ __ CURBS
__ __ SLAB DEPRESSIONS

__ __ CHANGES IN FLOOR LEVEL

__ __ STEPS AND STAIRS:
 __ NUMBER OF RISERS
 __ STAIR WIDTH
 __ HANDRAIL
 __ MATERIALS
 __ DETAIL OR STAIR SECTION KEYS

__ __ COLUMNS AND POSTS
__ __ SIZE
__ __ MATERIAL
__ __ FOOTING SIZES AND DEPTHS
__ __ FOOTING CAPS OR BASE PLATES
__ __ CONNECTION DETAIL KEYS
__ __ CENTERLINE DIMENSIONS

__ __ STEEL PIPE COLUMNS
__ __ SIZE
__ __ BASE PLATE
__ __ NON-SHRINK CEMENT GROUT BASE

__ __ WOOD COLUMNS AND POST SUPPORT PIERS (Minimum of
2" above floor. Noncorrosive metal barrier between pier and
bottom of untreated wood.)

__ __ CONCRETE OR MASONRY PILASTERS
__ __ SIZES AND CENTERLINE DIMENSIONS (Minimum 4"x12"
for girder bearing.)

__ __ GIRDER BEAM LINES
__ __ TYPE
__ __ MATERIAL
__ __ SIZES

FOUNDATION AND FRAMING PLANS continued

BASEMENT continued

√ Dbl√

__ __ GIRDER SUPPORT RECESSES IN WALLS (Minimum of 4"
 bearing, 1/2" air space at ends and sides of wood girders.)
__ __ DETAIL KEYS

__ __ WOOD BEAMS, GIRDERS, AND JOISTS EDGE-BEVELED
 WHERE THEY ENTER MASONRY OR CONCRETE, SO
 TOP EDGE OF MEMBER IS 1" MAXIMUM INTO WALL
 RECESS

__ __ METAL WALL BOXES FOR WOOD BEAMS, GIRDERS,AND
 JOISTS ENTERING MASONRY OR CONCRETE WALL
 BELOW GROUND LEVEL
__ __ WOOD PRESERVATIVE TREATMENT

__ __ FIREPLACE FOUNDATION AND FOOTING
__ __ ASH PIT
__ __ CLEANOUT
__ __ SIZE AND LOCATION DIMENSIONS
__ __ OUTLINE OF FIREPLACE ABOVE
__ __ NOTE ON SLAB THICKNESS AND REINFORCING
__ __ DETAIL OR FIREPLACE SECTION KEYS

__ __ OPENINGS IN BASEMENT CEILING FRAMING
__ __ DUMBWAITER
__ __ LAUNDRY CHUTE
__ __ CHASES
__ __ DUCTWORK

__ __ FLOOR JOISTS:
 __ SIZE
 __ TYPE
 __ MATERIAL
 __ SPACING
 __ ARROWS SHOWING DIRECTIONS OF SPANS

__ __ JOIST BLOCKING OR BRIDGING:
 __ SIZES
 __ LOCATIONS
 __ MATERIAL

__ __ JOIST LEDGERS:
 __ SIZE
 __ MATERIAL
 __ SIZE AND SPACING OF BOLTS TO WALL

FOUNDATION AND FRAMING PLANS continued

BASEMENT continued

√ Dbl√
__ __ DOUBLE JOISTS LOCATED UNDER PARALLEL
 PARTITIONS, BATHTUBS, AND OTHER
 CONCENTRATED LOADS

__ __ DOUBLE JOISTS LOCATED UNDER PARALLEL
 PARTITIONS, BATHTUBS, AND OTHER
 CONCENTRATED LOADS

__ __ DOUBLE HEADER JOISTS TO FRAME THRU- FLOOR
 OPENINGS

__ __ INDICATIONS, NOTES, AND DETAILS KEYS:
 __ FRAMING CLIPS
 __ ANCHORS
 __ BOLTS
 __ JOISTS AND BEAM HANGERS
 __ POST AND GIRDER CONNECTIONS

__ __ PARTIAL PLAN OF UPPER FLOOR SUBFLOORING,
 SHEATHING, OR DECKING, SHOWING PATTERN
 AND MATERIAL
__ __ CONSTRUCTION NOTES

__ __ COAL BIN AND CHUTE

__ __ SPACE FOR FIXTURES OR EQUIPMENT PROVIDED BY
 OWNER
__ __ N.I.C. NOTES

__ __ ELECTRICAL: SEE ELECTRICAL PLAN

__ __ HOSE BIBBS, SINKS, OTHER PLUMBING:
 SEE PLUMBING PLAN

__ __ FURNACE AND AIR-CONDITIONING EQUIPMENT:
 SEE FURNACE ROOM

__ __ DOOR AND WINDOW SCHEDULE SYMBOLS

__ __ INTERIOR ELEVATION ARROW SYMBOLS AND
 REFERENCE NUMBERS

FOUNDATION AND FRAMING PLANS continued

BASEMENT continued

√ Dbl√
___ ___ DETAIL REFERENCE KEYS:
 ___ FOOTINGS
 ___ FOUNDATION WALLS
 ___ WATERPROOFING
 ___ SLABS
 ___ CURBS
 ___ CONNECTIONS TO OTHER CONSTRUCTION
 ___ FLASHING

___ ___ OVERALL BUILDING CROSS-SECTION ARROW AND
 REFERENCE SYMBOLS

NOTES Date/Initials

NOTES

Date/Initials

CONSTRUCTION DETAILS

CHAPTER CONTENTS

CONSTRUCTION DETAILS PROCEDURAL CHECKLIST

Here are the most widely tested and accepted procedures and standards for creating top quality construction details.

RULES FOR DESIGN AND SKETCHING

1 __ Details and detail types should first be listed as part of a miniature mock-up working drawing set. Draw cartoon miniatures of plans and elevations, then indicate bubble keys at joints, junctures, and typical sections where details will be needed.

2 __ Make miniature cartoons of needed details on one-fourth size mock-up sheets to show their approximate size, positioning and coordination with one another. Name the details.

3 __ Search your standard or master detail file for possibly usable details for the project at hand. Make office copier prints and assemble them on a paper carrier sheet as a rough checkprint.

4 __ Search your reference detail library for details that will aid in design of exceptional and non-standard details. Assemble office copier prints onto carriers for review.

5 __ Search the office technical library for published details, such as product manufacturer and trade association literature and drawings.

6 __ Proceed with rough design sketches on 8-1/2" x 11" sheets as necessary to develop new original details. Copy the wholly new details and assemble the checkprint copies on carrier sheets.

7 __ Use red pencil or pen to show revisions, additions, and deletions on the full-size detail checkprint sheets.

This essentially completes the research and planning groundwork.

NOTES Date/Initials

CONSTRUCTION DETAILS PROCEDURAL CHECKLIST continued

SYSTEMATIC PRODUCTION PROCEDURES

1 __ When creating new details, such as wall sections, watch for opportunities to use common background data as base sheets and overlays or CADD layers to show the unique detail situations in context.

2 __ Watch for opportunities to use oversized, freehand-sketched details as photo reductions instead of redrafting them from scratch.

3 __ Use a standardized 8-1/2" x 11" detail format sheet identical to your standard detail file format sheets for ALL new detail final drawing. Remember, new details that aren't suited for direct reuse in your standard file are still reusable as sources of ideas and technical information in a separate reference detail file.

4 __ Set details within a consistent cut-out/paste-up "window" (6" wide by 5-3/4" high is a preferred paste-up module and detail format sheet window size).

NOTES Date/Initials

315

CONSTRUCTION DETAILS PROCEDURAL CHECKLIST continued

THE STANDARD DETAIL FORMAT SHEET

DETAIL FILE NUMBER:

dim. lines break line notation boundary break line

cut mark

dim. line

dim. line

break line

℄— —

dim. line/
break line

dim. line

title
space

cut mark

DETAIL INFORMATION
References, jobsite feedback, job history

CONSTRUCTION DETAILS PROCEDURAL CHECKLIST continued

SAMPLE SHEET

Below is the detail drawing space. The recommended module, and the module used for the Guidelines Master Details, is 6" wide x 5 - 3/4" high. If you prefer another module, you can still use this format sheet for detail modules of 6 - 1/2" x 5 - 3/4" high maximum, and 5 - 1/2" x 5 - 1/4" high minimum.

(Space for the detail name, scale and file number.)

DETAIL FILE NUMBER: 03305-51

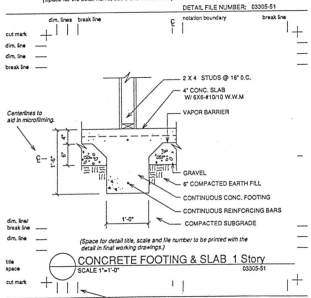

2 X 4 STUDS @ 16" O.C.

4" CONC. SLAB
W/ 6X6-#10/10 W.W.M

VAPOR BARRIER

GRAVEL

6" COMPACTED EARTH FILL

CONTINUOUS CONC. FOOTING

CONTINUOUS REINFORCING BARS

COMPACTED SUBGRADE

1'-0"

(Space for detail title, scale and file number to be printed with the detail in final working drawings.)

CONCRETE FOOTING & SLAB 1 Story

SCALE 1"=1'-0" 03305-51

DETAIL INFORMATION
References, jobsite feedback, job history

Marks show various cut lines, notation, dimension, and face of construction lines. Exterior face of construction is normally at the left, notation blocks normally on the right-hand side. These suggested spacings aid visual consistency throughout your detail system but should be ignored if using them interferes with clarity and ease of detail drawing.

CONSTRUCTION DETAILS PROCEDURAL CHECKLIST

DRAFTING STANDARDS FOR CONSISTENCY AND CLARITY

Besides seeking general sharpness and high contrast, contemporary
design and working drawings have to be designed for special reproduction
processes. Elements may be photo-reduced, for example, so elements
in the original drawing have to be extra large to remain readable. Or drawing
components may be copied through several generations of reproduction, so
they have to be extra crisp, clear and black to begin with,
or they'll fade away.

1 __ All lettering should be a minimum of 1/8" high. 3/32" to 1/8" spacing
between lines of lettering. Major titles: minimum 1/4" high letters.
Minor titles: minimum 3/16" high.

2 __ Line work must be consistently black and vary only by width, not by
"darkness" or "lightness." "Light" lines or grey lines disappear
during printing.

3 __ Use dots or lines to indicate materials, not greys. Greys don't
reproduce properly with the new graphic repro systems.

4 __ All symbols such as arrowheads, feet/inch marks, circles, etc. must be
large and unmistakably clear. Small symbols, small circles, etc. tend
to clog up during reproduction.

5 __ Line work or cross hatching must be spaced at least 1/16" apart. If
lines and patterns are too close together, they'll run together in
printing.

6 __ No hand poche should be applied on the back of a drawing sheet.

7 __ Don't let line work touch letters or numerals. Don't let fractional
numbers touch their division line. Otherwise they tend to run
together and blob up.

NOTES Date/Initials

CONSTRUCTION DETAILS PROCEDURAL CHECKLIST

GRAPHIC LAYOUT FOR CONSISTENCY AND CLARITY

1 __ Draw from the general to the particular and from the substructure or structure outward to the finish materials.

2 __ Draw in layers, so that a detail drawing is substantially a completed composition at any point along the way.

3 __ Draw in sequence from the primary to the secondary -- detail component first, size dimensions second, notation third. Add textures, cross hatching and profiling last.

4 __ In general, keep the exterior face of construction facing to the left, interior to the right.

5 __ In general, notation should be in a column down the right-hand portion of the detail window. Some notes can and should be located elsewhere if necessary to avoid crowding or enhance clarity.

NOTES Date/Initials

CONSTRUCTION DETAILS PROCEDURAL CHECKLIST

NOTATION

1 __ The primary purpose of notation is to identify the pieces of the detail by generic material name and/or construction function. Leave all extensive material descriptions, brand names, tolerances, and construction standards to specifications. On a small job that combines specification information with notes, follow the above rule but add general or "assembly" notes, as a short-form specification on t he drawing sheets.

2 __ In general, the first part of a note states the size of the material or part, tells material or part name second, and names position or spacing third. If using keynoting, the keynote legend will identify the names of materials or parts, and the size and sometimes spacing will be tagged onto the keynote reference bubble in the field of the drawing.

3 __ Follow office guides on nomenclature and abbreviations. The office should follow recommended guides of the professional societies and print their versions of such guides as part of working drawing General Information.

DIMENSIONING

1 __ Avoid fractions where possible. When using fractions, never use those that can't be measured with normal scales.

2 __ Don't draw dimension lines to the face of material. Unless you have no other option, draw only to lines extended from the material or detail part.

3 __ Add terms such as "Hold," "Min.," "Max.," "N.T.S.," "Equal," "Varies," etc. to clearly state your intent on the accuracy or absoluteness of your dimensions.

4 __ Avoid double dimensions that show a size on one side of the detail and repeats the sizing on the other side.

LEADER LINES FROM NOTES TO DRAWING ELEMENTS

1 __ Preferred line style is straight-line, starting horizontally from the note and breaking at an angle to the designated material or detail part.

2 __ Curve lines are acceptable if preferred as office style, but they should be done with french curves or large circle templates, not freehand.

3 __ Don't use leader lines from a note to more than one detail or section.

CONSTRUCTION DETAILS PROCEDURAL CHECKLIST

RULES ON LINE WEIGHTS

1 __ Break-lines, dimension lines and cross hatching are narrowest. General background construction is medium width. The primary detail object should be "Profiled" with the widest line. Equivalent pen tips would be: 000 or 00 for narrow lines, 0 to 1 for medium, 1,2 or 3 for profile lines. Exact choice of line widths is variable depending on the scale of the detail. The wider lines look excessive in small-scale details, and the lesser line widths look weak with the larger scale details.

2 __ Lines are to be uniformly opaque and differentiated by width, not lightness and darkness.

SCALES AND SIZING

1 __ Use 1" or 3/4" scale only for the most elementary details such as simple residential or light frame footings and fireplace sections, plain standard cabinet sections, and simple landscaping.

2 __ Use 1-1/2" and 3" scales for most common architectural construction. The 3" scale is especially preferred for conditions such as door and window sections and for small elements and connections such as brackets, tracks, curtain wall connectors, handrails, thresholds, etc.

3 __ Avoid using one-half size or full size details unless you are preparing detailed design studies or shop drawings. These size drawings are time consuming and they rarely show more data or show it more clearly than possible with 3" scale details.

4 __ Use 1/2", 3/4" and 1" scales for wall sections. Some full height wall sections for smaller low height buildings can be done adequately at 1/4" scale.

NOTES Date/Initials

NOTES

Date/Initials

STANDARD DETAIL INDEX BY CSI NUMBER

Other working drawing checklists will identify all the likely details you'll
need to include in working drawings. This list serves a different purpose.
It lists general detail types in sequence according to their CSI coordinated
detail file numbers to aid you in filing and reusing details in
a standard or reference detail library.

DIVISION 1 (Not applicable in this list.)

DIVISION 2 SITEWORK

02200	EARTHWORK
02350	PILES
02400	DRAINAGE
	02410 Subdrainage and Foundation Drain
	02420 Surface Run-off (Area Drain, Storm Drain)
	02431 Catch Basin
	02435 Splash Block
02440	SITE IMPROVEMENTS
	02444 Fencing, Chain Link
	02446 Fencing, Wood
	02447 Planter
	02451 Guard rail (Bollard, Stancheon)
	02452 Signage
	02455 Signage
	02455 Parking
	02457 Bicycle Rack
	02460 Play Equipment
	02470 Site Furniture
	02477 Shelter (See also, Protective Covers 10530)
02480	LANDSCAPING
02500	PAVING AND SURFACING
	02515 Concrete Paving
	02516 Asphalt Paving
	02528 Concrete Curb
	02577 Paving Marking
02600	PIPED UTILITY MATERIALS AND METHODS
	(Includes manholes, cleanouts, hydrants, etc.)
02700	PIPED UTILITIES
	02721 Storm Sewerage
	02722 Sanitary Sewerage
	02730 Water Well
	02743 Septic Tank
02800	POWER AND COMMUNICATION
	(Includes towers, poles, underground lines, etc.)

STANDARD DETAIL INDEX BY CSI NUMBER

DIVISION 3 CONCRETE

03250	CONCRETE ACCESSORIES (Includes anchors, joints, waterstops.)
03300	CAST-IN-PLACE CONCRETE (Includes retaining walls, piers, footings, walls, columns, beams, etc.)
03400	PRECAST CONCRETE (Includes deck, plank, beams, tilt-up, etc.)
03500	CEMENTITIOUS DECKS (Includes gypsum deck and plank, concrete, wood fiber, asphalt and perlite.)

DIVISION 4 MASONRY

04150	MASONRY ACCESSORIES (Includes anchors, control joints, etc.)
04200	UNIT MASONRY 04201 Cavity Wall (Brick and Concrete Block) 04210 Brick 04212 Adobe 04220 Concrete Unit Masonry (H.M.U.)
04400	STONE

DIVISION 5 METALS

05100	STRUCTURAL METAL FRAMING
05300	METAL DECKING
05500	METAL FABRICATION 05510 Metal Stair 05514 Exterior Fire Escape 05515 Ladder 05521 Stair Handrail 05530 Grating 05531 Floor Plate
05700	ORNAMENTAL METAL (Includes ornamental stairs and handrail, prefab spiral stair, and ornamental sheet metal.)
05800	EXPANSION JOINTS

STANDARD DETAIL INDEX BY CSI NUMBER

DIVISION 6 WOOD AND PLASTIC

DIVISION 7 THERMAL AND MOISTURE PROTECTION

DIVISION 8 DOORS AND WINDOWS

STANDARD DETAIL INDEX BY CSI NUMBER

DIVISION 9 FINISHES

STANDARD DETAIL INDEX BY CSI NUMBER

STANDARD DETAIL INDEX BY CSI NUMBER

STANDARD DETAIL INDEX BY CSI NUMBER

NOTES

Date/Initials

5

330

STANDARD DETAIL INDEX BY DETAIL TYPE

02 SITEWORK	CSI #
EROSION CONTROL	02270
Concrete, Stone, Wood Grid	
FRENCH & TRENCH DRAINS	02401-10
SUBDRAINS & UNDERDRAINS	02410
DRAINAGE	02420
Flumes, Inlets, Paving Edge	
CATCH BASINS	02431
SPLASH BLOCKS	02435
CHAIN LINK FENCE	02444
WOOD FENCING	02446
METAL FENCES	02447
FLAGPOLES	02448
MASONRY YARD WALLS	02449
BOLLARDS	02451
Concrete, Metal, Metal Pipe, Wood	
SIGNS	02452
PARKING BUMPERS	02456
Concrete, Asphalt, Wood	
BICYCLE STANDS	02457
HANDICAP RAMPS	02458
WHEELCHAIR RAMPS	02458
BENCHES	02471
Concrete, Masonry, Marble, Wood	
RETAINING WALLS	02478
Concrete, Masonry, Stone	
WOOD PLANTERS/RETAINING WALLS	02479
TREE PLANTERS	02491
PAVING & PAVERS	02507-18
Wood, Brick, Asphalt, Asphaltic Concrete, Stone	
WOOD CURBS & EDGE STRIPS	02521-22
WOOD STEPS (LANDSCAPING)	02523
STONE CURBS, PAVING EDGES	02524
CONCRETE CURBS	02526-28
CONCRETE WALKS & PAVING	02529
CONCRETE STEPS	02529
SPORTS PAVING	02530

STANDARD DETAIL INDEX BY DRAWING & DETAIL TYPE

03 CONCRETE CSI

CONCRETE PIERS	03303
CONCRETE GRADE BEAMS	03304
CRAWL SPACE ACCESS & CONCRETE FOOTINGS	03305
CONCRETE FOOTINGS	03305
CONCRETE FOOTINGS W/BRICK VENEER	03305
CONCRETE FOUNDATION WALLS	03306
CONCRETE SLABS ON GRADE	03308

04 MASONRY CSI

BRICK & BLOCK CAVITY WALLS	04201
BRICK AND BLOCK CAVITY WALLS	04210-14
BRICK VENEER	04215
BRICK WALLS	04216
CONCRETE BLOCK CAVITY WALLS	04220
CONCRETE BLOCK FOUNDATION WALLS	04229
CONCRETE BLOCK WALLS	04230
MASONRY PARAPETS	04260
GLASS BLOCK	04270
MASONRY COPINGS	04420
STONE VENEER	04450

05 METALS CSI

METAL FASTENINGS	05055
METAL DECKS	05310
Floors & Roofs	
METAL FRAME CHASE WALLS	05420
METAL STAIRS	05511-12
SHIPS LADDERS	05516
ROOF LADDERS	05517
METAL HANDRAILS	05521
Railings & Stair Handrails	

STANDARD DETAIL INDEX BY DRAWING & DETAIL TYPE

06 WOOD CSI

WOOD POST @ BASE	06102
WOOD POST @ BEAM	06104
WOOD BEAM SPLICE &	06105-06
WOOD BEAM @ GLUE LAM BEAM	
FLOOR @ WALL	06111
INTERIOR PARTITION @ FLOOR/CEILING	06116-18
WOOD FRAME WALLS (2X4 & 2X6)	06116-24
INTERIOR WALL FRAMING (2X4)	06120
WOOD FRAME WALLS/WOOD FRAMING	06121
ROOF OVERHANG	06160-61
ROOF FLUSH @ WALL (2X4 & 2X6 FRAMING)	06162
SHED ROOF @ WALL ROOF @ PARAPET	06167-68
ROOF RIDGE	06169
WOOD SHELVING	06412-13
WOOD SHELVING, BASE CABINET	06412-15
BASE CABINETS	06414-16
OVERHEAD CABINETS	06417
CABINET DOORS	06418
CABINET DRAWERS	06419
WOOD PANELING	06421
WOOD STAIRS	06432
WOOD BASEBOARDS	06455

07 THERMAL & ROOFING CSI

ROOFING TILE	07321-22
FLASHING @ PARAPETS	07603
ROOF EXPN. JOINTS @ WALLS/PARAPETS	07604
VENT FLASHING	07606
SHEET METAL ROOFING	07610
GUTTERS	07631
Including Wood Gutters, Downspouts	
SCUPPERS	07633
GRAVEL STOPS	07660
METAL COPINGS	07665
SKYLIGHTS	07810
ROOF DRAINS	07822
BREATHER VENTS	07825
ROOF HATCHES	07830
ROOF CURBS	07850-52
ROOF EXPANSION JOINTS	07860-61
PITCH POCKETS	07870
GUY WIRE CONNECTION	07871

STANDARD DETAIL INDEX BY DRAWING & DETAIL TYPE

NOTES

Date/Initials

CONSULTANT DRAWING CHECKING AND COORDINATION

CHAPTER CONTENTS

CONSULTANT DRAWING CHECKING AND COORDINATION

COMMON ARCHITECTURAL DRAWING ERRORS AND COORDINATION PROBLEMS

__ Existing work, work to remain or to remove, and new work are not clearly identified and differentiated

__ Exterior elevations don't match doors, windows, roof lines, and expansion joints on the plans

__ Building cross sections lag behind and aren't coordinated with plans and elevations

__ Rough openings for doors and windows are too large or too small (especially in masonry)

__ Expansion joints aren't continuous throughout the building

__ Room wall/floor/ceiling construction doesn't match the finish schedule

__ Door, window, and frame schedules don't reflect changes in doors and windows on the plans

SPECIFICATIONS COORDINATION

__ Items that are to be bid.

__ Point by point, do specs agree with the drawings?

__ Construction phases.

　　__ Are the phases clearly defined?

__ Items that are included in the finish schedule.

　　__ Are finish materials specified?

__ Items referenced to other sections of the specifications.

　　__ Are they elsewhere in the specs as referenced?

CONSULTANT DRAWING CHECKING AND COORDINATION
continued

CIVIL ENGINEERING COORDINATION

__ Check site plans for interferences of underground utilities.

 __ Do they allow for:
 __ Power __ Telephone __ Water __Sewer __Gas
 __ Storm drainage __ Fuel lines __ Grease traps
 __ Fuel tanks

__ Check site plans for interferences between new drives, sidewalks, and
 other new sitework.

 __ Do they allow for:
 __ Telephone poles __ Pole guy wires __ Street signs
 __ Drainage inlets __ Valve boxes __ Manholes

__ Check civil earthwork grading and excavation plans.

 __ Are they coordinated with architectural and landscape plans for:
 __ Clearing __ Grading __ Sodding, grass, and mulch
 __ Other landscaping

__ Compare civil drawings with fire hydrant and street light pole
 locations.

 __ Are they coordinated with other drawings:
 __ Architectural sitework __ Electrical __ Plumbing

__ Check profile sheets showing underground utilities.

 __ Are conflicts avoided in elevation as well as plan?

__ Check plan and profile sheets of drainage systems and manholes.

 __ Do scaled dimensions match with written dimensions:
 __ In plans __ In profiles

__ Check final finish grade and pavement elevations relative to manholes
 and valve boxes.

 __ Will tops of manholes/utility boxes be flush with finish grade,
 pavement, walks, streets:
 __ Sewer __ Power __ Telephone __Drains

__ Check that all existing and final grades are noted at every point of
 change.

 __ Are dimensions reasonable, without widely varying differences?
 __ Do they allow for run-off drainage without danger of ponding?

CONSULTANT DRAWING CHECKING AND COORDINATION
continued

STRUCTURAL DRAWINGS COORDINATION

__ Overlay and compare:
 __ Column lines on structural and architectural.
 __ Column locations on structural and architectural.
 __ Perimeter slab on structural and architectural.
 __ Depressed and raised slabs on structural and architectural.
 __ Slab elevations on structural and architectural.

 Structural drawings:
 __ Foundation piers are identified.
 __ Foundation beams are identified.

__ Roof framing plan column lines and columns, and foundation plan
 column lines and columns.

__ Perimeter roof line matches Architectural roof plan.

__ All columns and beams are identified and listed in column and beam
 schedules.

__ Column lengths are all shown in column schedule.

__ All sections are properly labeled.

__ All expansion joint locations match Architectural.

__ Dimensions agree with Architectural.

__ Drawing notes agree with Specifications.

CONSULTANT DRAWING CHECKING AND COORDINATION
continued

MECHANICAL AND PLUMBING COORDINATION

__ All new electrical, gas, water, sewer, etc. lines connect to existing.

__ All plumbing fixture locations coordinated with architectural.

__ All plumbing fixtures coordinated with fixture schedule and/or specs.

__ Storm drain system against architectural roof plan.

__ Pipes are sized and all drains are connected and do not interfere with foundations.

__ Wall chases are provided on architectural to conceal vertical piping.

__ Sanitary drain system pipes are sized and all fixtures are connected.

__ HVAC floor plans match architectural.

__ Sprinkler heads are shown in all rooms.

__ All sections are identical to architectural/structural.

__ Adequate ceiling height exists at worst case duct intersections.

__ All structural supports required for mechanical equipment are indicated on structural drawings.

__ Dampers are indicated at smoke and fire walls.

__ Diffusers are coordinated with architectural reflected ceiling plan.

__ All roof penetrations (ducts, fans, etc.) are indicated on roof plans.

__ All ductwork is sized.

__ All air conditioning units, heaters, and exhaust fans match architectural roof plans and mechanical schedules.

__ Mechanical equipment will fit in spaces allocated.

CONSULTANT DRAWING CHECKING AND COORDINATION
continued

ELECTRICAL COORDINATION

__ All plans match the architectural.

__ Light fixtures match the architectural reflected ceiling plan.

__ All powered equipment has electrical connections.

__ All panel boards are properly located and are shown on the electrical
 riser diagram.

__ There is sufficient space for all electrical panels to fit.

__ Electrical panels are not recessed in fire walls.

__ Electrical equipment locations are coordinated with site paving and
 grading.

__ Motorized equipment:

 __ Equipment shown is coordinated with Electrical Drawings.

 __ Horsepower ratings are verified.

 __ Voltage requirements verified.

CEILING PLAN COORDINATION

__ Verify reflected ceiling plan against architectural floor plan to ensure
 no variance with rooms.

__ Ceiling materials match finish schedule.

__ Light fixture layout matches Electrical.

__ Ceiling diffusers/registers match Mechanical, including all soffits and
 vent locations.

KITCHEN PLAN COORDINATION

__ Equipment layout agrees with architectural plans.

__ All equipment is connected to utility systems.